THE SOCIETY OF
THE BANANA
IN OHIO

THE SOCIETY OF
THE BANANA
IN OHIO

A HISTORY OF THE BLACK HAND

SHANE W. CROSTON

THE
History
PRESS

Published by The History Press
Charleston, SC
www.historypress.com

First published 2022

Manufactured in the United States

ISBN 9781467152006

Library of Congress Control Number: 2022939476

Notice: The information in this book is true and complete to the best of our knowledge. It is offered without guarantee on the part of the author or The History Press. The author and The History Press disclaim all liability in connection with the use of this book.

In memory of
Dorothy Marie (Lombardo) Vicario
(1927–2020)

Ecclesiastes 3:1–8

CONTENTS

ACKNOWLEDGEMENTS

Aspecial thanks to my grandmother Dorothy Vicario (1927–2020) for endless memories and countless hours of sharing stories about her life and family, including stories about her dad, John Lombardo; her mom, Antoinette Iannarino; stepmom, Grandma Lombardo; her grandfather Agostino "The Banana King" Iannarino; and her memories of Tony Vicario, Grandma Vicario, Uncle Charlie, Aunt Mary, Sam DeMar and Grandma Cira.

Thanks to Agusta "Aunt Peggy" (Iannarino) Passero (1921–2022) for sharing memories of her father, Agostino Iannarino.

Jeanne A. (Henry) Vicario (1929–2017) introduced me to our family history and the story of the Black Hand in the early 2000s. Thanks to Jeanne, her extensive research and her preservation of family records, this book was possible.

Thank you to:

Mike and Diana (Vicario) Hawkey (great-granddaughter of Salvatore Cira). They shared so much and gave me photos and records that helped immensely when putting this book together. I enjoyed every moment of hearing about the history of our family and Diana's memories of her grandfather Charles Vicario.

My parents, Brian Croston and Karen Vicario, who continue to support me in everything that I do. My mom, Karen, is a granddaughter of Tony

Vicario, great-granddaughter of Salvatore Cira and great-granddaughter of Agostino Iannarino.

My sister Devyn for her artwork and my sister Kylie for all of her help throughout the years.

Maria Scandurra, who has supported me every step of the way and helped with everything from start to finish.

Teresa Mangia (great-granddaughter of Agostino Iannarino) for sharing our family history, family photos and the research of Stephanie (Iannarino) Seigla and Mary Jo Mangia (1960–2015).

John Vicario (grandson of Tony Vicario) and all of the Vicario family for their memories and stories.

Jennifer (Entsminger) Butler (great-granddaughter of Tony Vicario) for her help proofreading.

Beth Marshall and all of the staff at the Logan County Historical Society/History Center in Bellefontaine, Ohio. They were extremely helpful and provided me with many photos, newspaper articles and documents.

Paul Pardi (great-great-grandson of John Amicon) and the Pardi family for contributing photos and sharing their extensive research on the Amicon family.

Cheryl Bliss Ellinger (great-granddaughter of Saverio Ventola) for her photo contributions.

Catherine Anne (Seger) Roberson (great-granddaughter of Sebastian and Catherine Lima) for sharing her family stories and memories.

John Rodrigue for supporting the project.

Everyone at The History Press.

Marion County (OH) Historical Society; Logan County (OH) Library; Columbus Metropolitan Library; U.S. National Archives at Chicago, Kansas City and Philadelphia; New York State Archives; and the Library of Congress.

Thank you all!

INTRODUCTION

Woe unto you if you turn to the police. We are brigands escaped from Italy, and the police look like flies to us....Read the newspapers and see what we have done in New York, Chicago, New Orleans, and Pittsburgh....We advise you that we have dynamite, a double load, that will send your house up in the air and kill all who are within....Either money or your life.
Signed,

The Human Butchers

This was a segment from one of the many threatening letters received by Italian immigrant John Amicon in early 1909. He was told that he must pay $10,000 or forfeit his life. It was not uncommon for Italians all across the United States to encounter similar threats. Newspapers often described accounts of kidnappings, bombings and murder. In every major city in the country, these crimes were attributed to a secret group known as the Black Hand Society.

After the murder of New Orleans police chief David Hennessy in 1890, people became accustomed to reading about crimes of the "Mafia." From then on, most Italian crime was attributed to the Mafia, and many Americans often looked at all Italians as being involved in some sort of secret organization. Then in 1903, a New York newspaper published a story about a dreaded Italian society, detailing the contents of threatening letters that were signed "La Mano Nera," which was translated to "The Black Hand."[1]

Italian newspapers ran with the new term and were glad to use something other than the word *Mafia*. Week after week, people read about the Black Hand under horrific headlines, and the group became notorious worldwide. The unfavorable reputation of Italians became so widespread that in 1908, the King of Italy Victor Emmanuel III spoke out, calling the Black Hand a "mythical creation."[2] Lieutenant Joseph Petrosino of the New York Police Department and head of the Italian Squad also claimed that there was no existence of a "well-organized" society. He said that there was no national or local head of the Black Hand Society having control over smaller groups and only petty crimes were being committed.[3] Many Sicilians in America denied the existence of the group. It was also not uncommon in the cities of Palermo and Messina, Sicily, to hear the existence of the Mafia denied.[4]

Sicilians lived by a distinct code called *omertà*. This code was explained by Palermo public security officer Antonio Cutrera, who said, "All private differences should be settled privately, either in a fair fight or by murder." If a man went to the police, he was not considered a "man of honor."[5] These ideas were engrained into Sicilian culture and resulted in Sicilians being evasive when interacting with police.

The Sicilian mentality was rooted in a long history of oppression and foreign domination. In America, many Sicilian immigrants continued to live by the archaic principles of omertà, refusing to speak to the police under all circumstances. In small Midwest towns, there were men like Salvatore Cira, who always carried a shotgun slung over his shoulder in case of the need to settle a dispute the traditional way, without a need for police.[6]

Along with their codes of honor, bandits and Mafiosi from the Palermo area brought their criminal practices to America. They were known for counterfeiting and committing acts of extortion.[7] In 1908, Sicilian fruit dealers living throughout Ohio formed a secret partnership and were believed to be conspiring together to prey on well-to-do Italian and Sicilian immigrants.[8]

There were Black Hand outrages all over the state, and police investigations almost always ended unsuccessfully. In 1909, the U.S. Postal Inspection Service was granted the opportunity to investigate the Black Hand crimes, and Inspector J.F. Oldfield vowed that he would take the society head on.

Post office inspectors and law enforcement agents—with the help of courageous immigrants like John Amicon, Ignazio Gentile and Agostino Iannarino—would attempt to bring down Ohio's Black Hand criminals, who called themselves "The Society of the Banana."

1

FRUIT DEALERS

As crowds of people rushed down the busy city streets, it was impossible to not hear the Italian vendors engaging with the public and negotiating the prices of their fruits. Italian immigrants were first known for doing hard physical labor, but eventually, one man decided to take a basket filled with bananas and sell them in the city. People could not get enough of the golden colored fruit. The bananas sold out so fast that the peddler had to build a wagon to hold enough fruit to meet the demands of the Americans.[9]

Many Italian immigrants began to follow suit, and banana peddling became a common trade among their countrymen. They formed unions and made sure to rotate their days working the busiest streets so that they all had an equal opportunity to make a living for their families. It was common for the women to sell produce at a fruit stand while the men and boys pushed the carts through the streets of the towns and cities.

The peddlers bought the bananas at wholesale from fruit commission houses. They would see a bunch of bananas for sale for $1.00 and would follow a salesman around the store offering him $0.25. The salesmen would get so tired of the peddlers being in there that they would sell the bananas for a cheap price just to get the persistent men out of the store. On a good day, a street vendor could make upward of $1.50.[10]

Opening a commission house was the goal of many Italian peddlers, as they would be able to make substantial amounts of money. Peddlers and

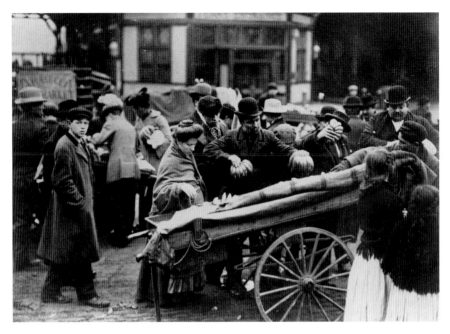

An Italian immigrant selling bananas from his cart, circa 1900. *Library of Congress.*

commission salesmen were in cities all over Ohio. In Columbus, John Amicon and Agostino Iannarino were well known in the industry. There were fruit dealers in the smaller towns as well, Salvatore Cira in Bellefontaine and Salvatore Lima in Marion.

Salvatore Lima

Salvatore Lima was a gardener, born in Trabia, Sicily, on February 24, 1878. His parents were Antonio Lima and Annunziata "Nunzia" Cancilla. He was married to Maria Panzica. In 1902, he left Sicily with Sebastian Lima and went to America to visit a cousin, Salvatore Ignoffo, in Johnstown, Pennsylvania. Salvatore stayed for only a short while but realized that the opportunities were endless. He returned to Trabia and continued working as a gardener until 1906, when he left for America again—this time with the plan to stay. He took the SS *North America* with the LaVeloce Navigation Company. The steamship departed Palermo and arrived at Ellis Island on May 3, 1906.[11]

His brother, Francesco, was living in Johnstown, and brother-in-law Salvatore Greco lived in Pittsburgh. Greco worked as a fruit dealer in the city, so Salvatore Lima joined him and started learning about business operations in America. In 1907, Salvatore found a grocery store for sale in Marion, Ohio, where his sister lived. Having the desire to start his own business venture, he seized the opportunity. A Marion lawyer wrote up a contract, and Salvatore bought the store for $800.[12]

Joe Ignoffo, who was married to Pietra Lima, Salvatore's sister, had a shoe repair shop in Marion. Joe arrived in the United States in 1893.[13] At thirteen years old, he went to work with his brother Salvatore Ignoffo in Johnstown, Pennsylvania, and eventually made his way to Marion.[14] Pietra had been living in Trabia with her parents, and in 1908 she came with her father, Antonio, and two small children, Maria and Antonio, to the United States on the SS *Martha Washington*.

Sebastian Lima, who was married to Caterina Lima (Salvatore's sister), was in Marion helping with the new business. Salvatore bought two mules and a horse and began selling imported fruit and produce at 235 North Main Street, in the Hermann Block. The building was once used by the Schulman Clothing Store and was the location of a saloon and general store owned by Louis Giofritta. The address had a history of involvement in illegal activities, and the city of Marion was not unfamiliar with instances of Italian vendetta.

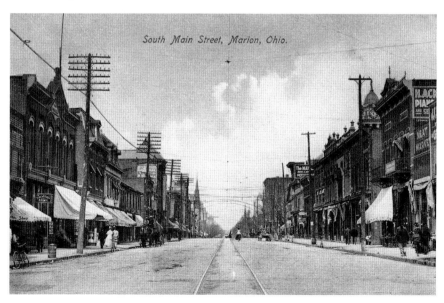

An early 1900s scene of Marion, Ohio. *Provided by the Marion County (Ohio) Historical Society.*

In 1905, Louis Giofritta got into a gunfight with James Farretto in front of the store but managed to escape injury. The two had been in a feud dating back to their lives in Italy.[15] The same year, police raided the building because it was being used for illegal gambling.[16] *Ohio's Black Hand Syndicate* details the events of 1906 when Louis was shot down in an alley near his residence.[17] His brother Joseph was arrested and charged with the murder. Joseph was a poor fruit peddler with no money, but counsel defended him and covered heavy expenses. There was a sensational trial, and he was eventually found not guilty of the crime. Soon after, Lima found the grocery store for sale.[18]

John Amicon

Giovanni Amicone, known as John Amicon, was born in 1868 in Forlì del Sannio, Molise, Italy. He came to America at the age of fourteen and worked as a water boy for a section gang, carrying buckets of water to trestle workers on the railroad. The section crews rode on handcars to maintain and repair the tracks. As the workers got farther out on the trestle each day, John had to walk back and forth to bring them drinking water. It was dangerous work, and John did not enjoy the job. Each day he became more afraid of heights since the trestles were built so high off the ground, sometimes over one hundred feet.

One day after walking out on the wooden structure, John looked over the edge and saw a horse and buggy below. The buggy looked so small from a distance that it made his head swim.[19] He decided that the job was not for him and did not return to work the following day. He had not made much money, but he managed to save thirty dollars, which was enough for him to make his way to Chillicothe, Ohio.

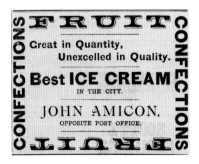

An 1890s Amicon Bros. advertisement. *Author's collection.*

John began to work for a grocery store and assisted in selling produce, making ten dollars per month. He was interested in entrepreneurship and even began a small business on his own. Buying big sacks of peanuts and repackaging into smaller bags, he would re-sell them at a roadside stand for a small profit. For the next three years, John learned the ins and outs of the produce business and worked his way up to making forty dollars a

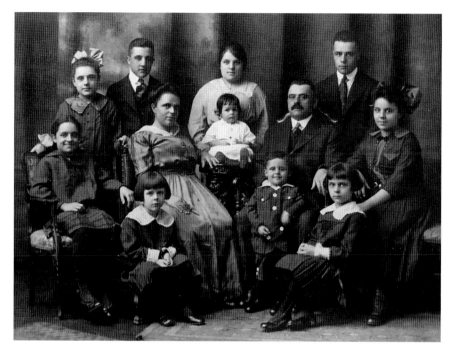

The family of John Amicon. *Courtesy of the Pardi family.*

month. He saved his money and purchased a half interest in his employer's company. Just six months later, he bought out the entire firm.

John's brother Charles was working in Perry County, Ohio, with a section gang, when he decided that he would also move to Chillicothe.[20] By 1887, their commission house John Amicon Brothers & Company was a well-established firm. The partners sold fruits, candies and groceries. Their business grew fast, and the Amicon brothers employed many people in the city. They often posted lively ads in the newspaper to attract residents. Their Christmas ad of 1891 read, "Come one, come all, and see the immense stock of holiday dainties and novelties displayed at the famous establishment of John Amicon & Bros!"[21]

Chillicothe was a profitable city for businessmen, and they had many years of success, but they wanted to expand. Columbus presented many more opportunities. The city had an abundance of growing businesses and a large population, so in 1896 the brothers made the move. They established themselves at 135–37 East Town Street. The location had many other commission houses nearby, and the local American proprietors were not fond of another Italian opening up for business.

Even though the locals were not overjoyed at first, their opinions changed as John provided many jobs for the community. Herman Holland, an American, was hired as a manager for the firm. He had a few years of experience in fruit and vegetable distribution and would be credited for helping grow their business bigger than they had ever planned.

It was not long before they were outgrowing the Town Street location, so they opened another store at the corner of Naghten and Third Streets in 1903. The warehouse was called the "Amicon Block" and became their headquarters. It was one of the newest and most up-to-date structures in the entire country. The building was four stories tall and had a large basement. The banana rooms could hold 12 cars, which meant almost 5,000 bunches of bananas could be stored. In its entirety, the warehouse could keep 275 cars of fruits and produce. Eventually, John Amicon Brothers & Company had two locations in Columbus, one in Springfield and one in Marion. There were out-of-state establishments in Bluefield, West Virginia; Parkersburg, West Virginia; and Seneca Castle, New York.[22]

The company employed over 350 men across the seven different branch houses. In addition to their commission houses, they also dealt specifically with potatoes in Michigan, seed potatoes in Wisconsin and onions in Indiana. The company was active in so many places that the populations of the cities and towns combined totaled to numbers greater than four million people.[23]

AGOSTINO IANNARINO

Agostino Iannarino was born in 1874, in Termini Imerese, Sicily. His father, Michele, was a fisherman who worked off the north coast of the island. Like many Sicilians, Agostino had always wanted to experience life in America. In 1886, Michele and Agata (Agostino's sister) boarded the SS *Archimede* and left for the United States.

When Michele returned to Sicily, he was excited to share his recent experiences from Ohio, and the young men of the Iannarino family were eager to hear about the new opportunities in America. In 1890, Agostino's brother Ignazio went to Palermo and got on board a ship en route to the new country. The following year, seventeen-year-old Agostino boarded the SS *Washington* and made the journey himself.[24] He went to Columbus, Ohio, and began working for his brother-in-law's fruit business.

Agostino's mother, Marianna Rocca, became sick in 1896, so his sister Agata, who was pregnant and with four children, returned to Sicily to care

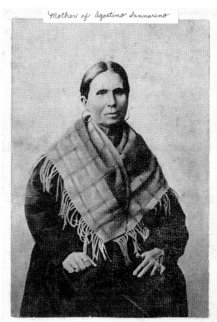

Left: Agostino Iannarino, 1895. *Courtesy of Teresa Mangia.*

Right: Marianna Rocca, mother of Agostino Iannarino. *Iannarino family collection.*

for her until she passed away on July 7, 1897. After their mother's passing, Agata returned to America with five kids, including the four-month-old baby she gave birth to in Termini. She was also accompanied by her father, Michele, and her brother Leonardo on the SS *Ems*.

Agostino had been working hard for years and decided that it was time he started a family. In December 1899, with his father, he went back to Termini and married Maria Purpura. She was promised to him through an arranged marriage. After they were married, he quickly wanted to return to America. Agostino, Maria and both of their fathers (Michele Iannarino and Salvatore Purpura) took the SS *Archimede* to New York. They planned on staying in Mount Vernon, New York, a suburb of New York City, but it seemed too busy for Maria, as she was expecting a child.

They decided to go to Columbus, and Agostino went back to his job peddling fruit. He purchased green bananas and would hang them from the ceiling in his house. He used gas fuel to ripen them and then took the bananas out on a wagon to make his sales. Times were not easy, and Agostino worked strenuous hours to help provide for his entire family. Agostino and Maria lived at 330 North Lazelle Street with his father, Michele; his sister,

Agata, and brother-in-law, Giovanni, and their six children; as well as his brother Ignazio, his wife and their two children.

Agostino's business picked up rather quickly, and he began selling bananas faster than he ever imagined. Before long, he was known by many in Columbus as "The Banana King." The governor even gifted him a golden charm to recognize his accomplishments. It was a small golden bunch of bananas. Agostino had quickly become a well-known and well-respected businessman.[25]

Salvatore Cira

Biagio "Salvatore" Cira was born in Termini Imerese, Sicily, on June 7, 1864.[26] It was believed that Salvatore had twelve brothers and sisters, seven of whom died of a plague. He was only three years old when his father passed away, so he worked as a gardener as a young boy to help provide for his family. As an adult, he established himself in Termini as an honorable and highly respected man. He married Maria Demma in 1893, and together they made plans to move to America.[27]

Maria's stepfather Antonino Demma was the first from the family to move to the United States. He arrived in 1896 and traveled around Ohio, trying to make money to send back to Termini. A few years later, Salvatore arrived. They worked odd jobs for a short time in Cincinnati and saved enough money to bring the rest of their family.

In 1901, Salvatore's wife, Maria, took a steamship from Italy to New York City. After arriving, she took a train to Cincinnati, Ohio, with her three children and nephew Charlie. She waited for Salvatore to meet her at the station, but he never came. She gathered up her kids and took a taxi to the address that Salvatore had given her. When she arrived, she found him sitting outside reading her letter. It had been brought over on the same ship that she was traveling on.[28]

The Cira family stayed in Cincinnati for six months, living in a lower-middle-class second-floor apartment. They did not live in an Italian community as many Italians did. They lived in an ethnically mixed neighborhood, but as the area became rundown, they decided to move to Dayton.

Salvatore and Antonino began working for a fruit commission house and delivered fruits and vegetables to the stores in the surrounding area. They lived at 24 East New Market Street.[29] Maria's brother and sister Salvatore

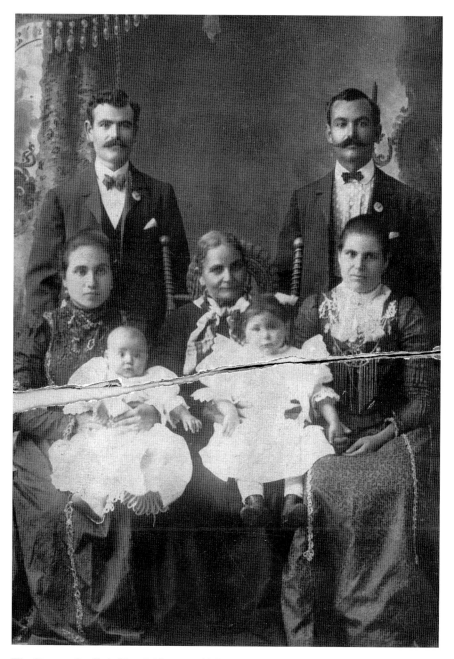

The Demma family in Termini Imerese, Sicily. Providence Amodeo Demma (*center*). Salvatore Cira (*left*) is behind Maria Demma Cira. *Author's collection.*

"Sam" Demma and Anna Demma and her nephews Tony and Charlie also lived with them.[30]

After a few years, Salvatore Cira decided that he would start his own business. The family moved to Bellefontaine, Ohio, in 1903 and opened a downtown fruit store. It was called Salvatore Cira & Co. The members were Salvatore Cira and the Demma family, including Antonino, Salvatore "Sam," Tony, Charlie and Antonino "Joe."[31] Anna Demma married Frank Comella in Bellefontaine. He had a shoe shop downtown, not far from the Cira store.

Soon after the firm was established, they opened a second store in the neighboring town of Marysville. It was located on Fifth Street in the Centennial building next to Schalip's saloon, then later moved to the Union Block.[32] Salvatore hired local Italians to work there. The manager was an aggressive man, and there was an occurrence when roadworkers wanted to plow and asked that he move the company's banana wagon, to which he refused. When the workers hit the wagon to move it, he ran out into the street waving his gun around, threatening to kill someone and was arrested and charged with carrying a concealed weapon.[33] In 1905, Salvatore sold the Marysville store to an Italian employee and then focused solely on his business in Bellefontaine.[34]

Salvatore Cira & Co. was Bellefontaine's first commission merchant and wholesale fruit dealer. They sold oranges, lemons, bananas, apples, vegetables and more. They delivered to all of the surrounding towns and became well known throughout the city. Their store was located at 103 West Chillicothe Avenue.

In 1906, a man by the name of John Cullen was walking past the store when he saw a bulldog that he believed had been stolen from him. He took the dog from outside of the fruit store and hurried toward home. Nineteen-year-old Tony Demma and a friend from Marysville, Salvatore Dinovo, followed the man and fired two shots from a revolver, hitting him in the leg. The entire police force was searching for Demma, and he was in hiding for some time.[35]

Making an effort to become more "Americanized," the Demma family started to go by the name of DeMar. Sam Demma would be called Sam DeMar—Joe Demma, Joe DeMar. The young members of the family were eager to become American and learn the English language. They all lived in the home of Salvatore Cira on the corner of Limestone and Williams Streets.

Termini Imerese and Trabia neighbor each other on the north coast of Sicily. *Author's collection.*

After a few years of business, their fruit commission house was doing well, so Salvatore purchased the ten lots surrounding his house. He eventually moved the store to the Powell Block, which was behind the Logan County Courthouse. While the men were working at the store, Salvatore's wife, Maria, was at home cooking, cleaning and taking care of their children. They owned four wagons and had horses and other animals. They got their milk from the goats, eggs from the chickens and the fruits and vegetables came from the commission house. Maria made bread for the family, and they had pasta every night.[36]

Because of Cira's work ethic and the efforts of the DeMar family, Salvatore Cira acquired the reputation of a very successful man and established himself as a prominent Italian in Ohio.

2

THE OVERCOAT

In Bellefontaine, it appeared that Salvatore Cira was running an honest and successful business. Though his fruit commission house seemed to be doing well, he had a second source of income. When Salvatore was living in Sicily, he was not only a gardener but also said to be the "hand of the benefactor."[37] He was active in Mafia circles and was committed to his traditions.

Salvatore was a man of high standing and a leader in the Italian community. He was of a stout build with a mustache and was said to have carried a stiletto on his belt and a gun on his shoulder. His appearance and demeanor could have easily made people feel timid. It was common in Sicily for mafiosi to dress in a way that would make an onlooker fearful.[38]

His home was where all the local Italians would gather for festivities, and he frequently held gatherings where people came from all over the Central West to be his guests. He was often visited by Italians from Cincinnati, Cleveland, Pittsburgh and Buffalo.[39] He was always hospitable and made sure everyone was well taken care of.

Salvatore was typically pleasant toward Americans, but inside his store was a different story. He was always gruff toward his partners, complaining that they did not have any money. The entire family worked many hours day in and day out. While the DeMars were operating the store, Salvatore would often take trips around Ohio and to Pittsburgh. He carried a shotgun every day and always carried a revolver when traveling. All of the men in the family were known to carry revolvers.[40]

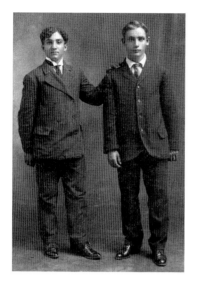

Charlie and Antonino "Joe" Demma. *Author's collection.*

Salvatore was often seen in Springfield, where there was a large Italian community. It usually appeared that he was there buying fruit, but it was believed that he was having meetings with the local associates of the Black Hand. The community was having many problems with the gang. Springfield police estimated that $25,000 had been handed over to the society within one year.[41]

In 1907, several prominent Springfield Italians received threatening letters from the Black Hand Society telling them that they were to meet a man in Bellefontaine who was the head of a fruit company and pay him $1,400. They went and met Salvatore Cira and confessed that they did not have the money. He told them to come back again after his upcoming trip to Pittsburgh. When they returned, Salvatore claimed that he had convinced the Black Hand gang to cut the demands in half, and they handed over $700.

Another group of Italians received threatening letters that demanded $3,000 had to be paid or they would be killed. These letters were marked with daggers drawn in red ink. They were instructed to bring the money to Urbana, which was halfway between Springfield and Bellefontaine. Salvatore showed up in Urbana and told them that he "knew some of these people" and he was "not afraid to talk to them." They settled the amount at $500, and the money was collected. Believing that he was helping them out and playing the role of a hero by trying to convince the Black Hand to lighten their demands, Salvatore convinced them to pay him a $200 commission along with the $500.[42]

Italians were receiving similar letters throughout the state and country. In Cleveland, there was an Italian American by the name of Matteo "Martin" Rini. He was American born, but his parents were immigrants from Termini Imerese. He ran a successful fruit business in the city at East Ninth Street and Orange Avenue. In December 1906, he received a letter demanding that he pay tribute to the Black Hand. Martin was told to leave $5,000 on his doorstep or the building would be blown up.[43]

Martin was not willing to pay. He said that he would rather die than hand over his hard-earned money. Being sure that someone was going to

try to harm him, he had his family stay home for weeks. He believed that his children might be kidnapped since he often read of similar accounts in the newspapers. On the night that the money was supposed to be collected, his family stayed in their little kitchen and waited. Martin's wife and five children, along with his father, huddled together in the corner opposite the door. Martin paced back and forth while carrying a finely sharpened twelve-inch butcher knife. Fortunately for the Rinis, the Black Hand did not follow through with the promise and their family was safe.[44]

While Salvatore Cira was busy with his business in Bellefontaine and his frequent traveling, he was having problems with his partners/nephews Charlie and Joe DeMar. It was believed they did not want to be involved in the business, so Salvatore and his friend Domenico Galbo went to Urbana to see Sam Toosa. Sam wanted to purchase interest in the company, and Salvatore was considering selling him Joe's share. Joe did not approve of the proposition.[45]

Joe had been spending much of his free time away from the store and was interested in becoming an American. He was studying English and spending time with non-Italians. Dr. R.W. Chalfant, of Bellefontaine, was teaching him how to read. Every day, the doctor tried to spend a little time teaching him one thing or another. Joe had mastered the alphabet and was able to read short words. Dr. Chalfant worked in the medical office across the street from the fruit commission house.[46]

Joe had left Bellefontaine for an extended period of time, staying in Cleveland and Marion. Charlie sometimes went with him. Salvatore was not happy about them leaving, as there was work to be done at the store and at home. Joe's mother and sisters were still living in Italy, and he wanted to bring them to America. Joe's father Antonino, being the stepfather-in-law of Salvatore Cira, was the oldest partner in the firm.[47]

On the night of March 23, 1907, Joe and Charlie were both in Bellefontaine, and after a busy day of working, they prepared to close the store for the night. The two boys cleaned up the store, and Salvatore counted the daily profits. Salvatore was always concerned about keeping the money safe. A few years prior, when they had a store in Marysville, they were robbed of one hundred dollars by an Italian man there named Tony Jolli.[48]

There were numerous instances of money turning up missing in the store, so Salvatore carried the money home each day, avoiding keeping money in the store safe. Before locking up, he put two hundred dollars in the pocket of his overcoat and, with his nephew Charlie and young brother-in-law Joe, started for home at around 11:00 p.m.

They walked along their normal route, heading down West Columbus Avenue. The three of them crossed the railroad tracks onto Garfield Street and then turned north on Troy Road. Joe carried Salvatore's overcoat with the money just ahead of the other two. They weren't far from the Cira home on Limestone Street. Joe was about three hundred feet north of Garfield Avenue when a shotgun blast rang out. Joe fell to the ground, pulled out his revolver and fired three shots toward the incoming gunfire.

Salvatore saw two men running west across the open lots toward the stone quarry. He fired all six rounds from his revolver but was unable to pursue the shooters after running out of ammunition. He ran to the house on the corner of Troy and Williams, which was the home of Lucy Reed. In distress, he told her he needed more ammunition for his gun, but she was unable to help. Salvatore and Charlie raced home without looking back. After the eruption of gunfire, there were only a few seconds of silence before everyone in the neighborhood could hear Joe crying in agony.

A neighbor, Mrs. McWade, thought it might have been her son since he had not yet returned from work. In her nightgown, she grabbed a jacket and ran outside shouting "Walter! Walter! Is it you?!" Once she made her way to the street, she saw that it was Joe DeMar. He told her that the men came from behind a bank on the west side of the street and shot him. He said that there was money in the pocket of the overcoat and asked her to keep it safe.

Mrs. McWade's husband, David, and their daughter also went to see what happened, and the three of them carried Joe back to their house. There were nine wounds from the shot that came from about thirty feet away. Some of the balls passed through his arm and entered his side. All the wounds were on his left side, three in the arm, two in the hip and thigh and four in the side.

Tim Tynan, a neighbor, notified the police and doctors. Drs. Young, Chalfant and Wilson soon arrived at the McWade house. The only thing Joe kept saying was, "I can't get my wind." Along with the doctors, many neighbors started to crowd into the house. Everyone wanted to know what had happened and who had been shot. The Cira and DeMar families had also rushed over.

They called for Dr. Giuseppe Romano of Cleveland, who had been a close friend of the family in Sicily. He left for Bellefontaine immediately, but there was not much time. The gunshot wounds were fatal, and the doctors knew that there was nothing they could do. Joe seemed to have found relief when Reverend Father Adolf F. Sourd showed up. He was the priest of St. Patrick Catholic Church and administered Joe's last rites. He stayed at Joe's side until he passed away in the McWade home.[49]

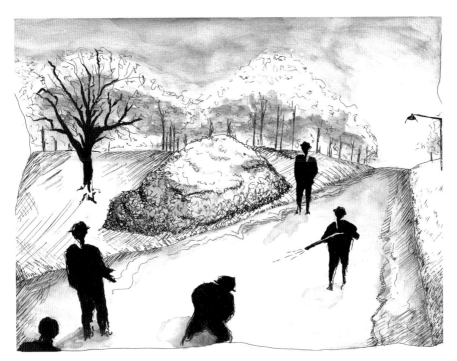

Street scene of the assassination of Joe Demma, by Devyn Croston. *Author's collection.*

The Bellefontaine police expected that there was more to the story and the next day arrested Sam and Tony DeMar, brother and cousin of Joe. The two were taken into custody and brought to the jail. Tony had spent the entire day sitting next to the bier that held the body of his cousin before the police took him away. They found Sam at the Cira home.

Sergeant Victor Churches arrived from Columbus to help assist Chief Edward Faulder and Sheriff E.P. Humphreys in the investigation. Vittorio P. Curcio, known as Victor Churches, came to the United States from Italy in 1884, served as an infantryman in the U.S. Army and then joined the police force. He had extensive experience in dealing with Sicilian brigands in Columbus. He inspected two black hats that were found near the shooting. One was marked with "Canton, Ohio" while the other was marked "Columbus." They were found lying on the path where the assassins escaped. Churches believed that the two hats belonged to Sam and Tony DeMar.

After Joe had been shot, Sam and Tony arrived on the scene quickly and were without their usual hats. Even though they were suspects, both seemed to be in great distress. Sam had multiple fits in the room where Joe was dying.

He would have a spasm every time he entered the room, and after three fits, one of the doctors escorted him outside.

Along with the two hats, footprints were believed to be found coming from the brush pile where the shooters appeared. These tracks appeared to lead to the Cira home. Police believed that Sam and Tony ambushed Joe and ran home and then returned to the scene.[50]

Salvatore Cira seemed greatly worked up about the murder and that night patrolled his property with a shotgun. He told the police that he believed that the assassination was a robbery attempt, suggesting it was likely that Italians came from another city to try to run his business out so they could move in. Salvatore made calls all over the country to inform other Italians what had happened to Joe.

After police searched the family's home, they confiscated Salvatore's shotgun along with a belt of ammunition. At the police headquarters, the shells were emptied, and each of them was found to be home-loaded. Some of them were filled with buckshot and others with BB shot. Both were large, and the number of BBs in each shell totaled nine. Police were sure that the shells used in Joe's murder had come from his own home and now had no doubt that Joe's brother Sam and cousin Tony were involved.

News reporters from *The Examiner* went to the Cira home to try to get details of the events that took place. Mary, Salvatore's daughter, who was about fourteen years old, acted as an interpreter, as he was unable to speak English. Salvatore was yelling and spoke with many gestures, saying, "If the policemen find the man who shot Joe, I will kill him!" Mary approved of his statements by saying, "And papà is right, too. You would do the same."[51]

Investigators interviewed all of the neighbors. Raymond Focht was a fourteen-year-old boy who lived on the corner of Garfield and Troy. He was not far behind Salvatore, Charlie and Joe as they walked home. He said that the Italians had a dog with them. He saw the dog heading toward a nearby barn, and his focus was there, since he had Belgian hares kept inside.

Raymond said that he saw gunfire come from over a bank and then saw Salvatore and Charlie run down the street. He saw two men run away from the west side of the road and immediately after he ran to his own home to tell his family what had happened and to calm the panic coming from his mother.[52]

When Maria Demma Cira, the wife of Salvatore and the sister of Joe, was questioned, she told police that she believed Sam and Tony were both in their beds when the shooting occurred. Prosecutor Chamberlain, Sheriff Humphreys and Coroner J.P. Harbert, along with the city police

department, were questioning everyone, trying to understand why the shooting might have happened. The police learned from Salvatore that there were three suspicious Americans in his store before closing that night. He thought that maybe they could have seen him counting money and decided to follow them home.

The only other people of suspicion were two men who were seen on Troy Street that afternoon. They asked a boy if he would drive them uptown for forty cents, and his mother told them to call a cab. But it was unknown who they were.[53]

All of the attention was turned back to the DeMar family. The hats, the footprints to their house and the fact that there were nine holes in Joe's body all pointed at Sam and Tony. Sergeant Victor Churches went to the jail to conduct an interrogation. Sam explained that Joe was not only his half brother but also his double cousin. Joe and Sam were sons of the same mother, and their fathers were brothers. Sam's father had died in Sicily, and his mother remarried. Churches explained to Sam that the police were there to help him find his brother's killer. Sam had no interest in letting the law work; he said that he would kill the men himself if he found out who killed Joe.[54]

Sam was in the downstairs area of the jail, and Tony was being held in the female quarter. They were kept separate so they could not speak to each other. Churches tried using the tactic of saying that Sam had confessed to the shooting. Tony didn't believe it. He told Churches that if Sam said that, then he had nothing to say in response because it was either a lie from Sam or a lie coming from Churches.

They were interrogated intensely, and the two declared that they had no knowledge of the crime. They continued to say that if they knew who the killer was, they would find and kill him. It was already known that the Sicilian community was secretive, and they were notorious for not complying with the law. It was rare that they ever testified in court against another of their own race since they believed in a code of silence and a code of vendetta: omertà.[55]

Joe's funeral was the following Monday afternoon at Calvary Cemetery. Father Sourd led the service, and remarks were made at his grave by Dr. Romano. Sheriff Humphreys and Chief Faulder personally escorted Sam and Tony to the funeral. Originally, the two were told that they could not go, but the chief decided it was necessary to allow them to see Joe laid to rest. Charlie chose a monument, and they paid one hundred dollars for it.[56]

Sergeant Churches was sure that even if the two Sicilians in jail had not committed the murder themselves they had information about it. The police could not continue to hold the men without sufficient evidence to send in front of a jury, and it was up to Coroner Harbert to decide if the men would be set free. At 3:30 in the afternoon he discharged both Sam and Tony, and the verdict was that the death of Joe DeMar was at the hands of the unknown.[57]

The investigation continued, and Chief Faulder did not trust the word of the family. He was determined to find out why the young man was killed. Some library patrons who had read F. Marion Crawford's *Corleone* recalled the vengeance of the Sicilian Mafia. They thought Joe might have tried to break away from the brotherhood and then became an object of vengeance.[58]

Just a few months later, on July 1, 1907, another fruit dealer named Vincent Costanino was killed in Dayton. He was a forty-five-year-old banana peddler who lived at 828 East Second Street. He was in a barn in the back of his residence where he was shot dead. Police arrived and talked to a young Italian by the name of Corso who was with Vincent when he was shot. The young man said that he did not see who killed him.

It was 9:00 p.m., and the two left a barbershop, had two glasses of beer in a saloon and then went to the barn to see Vincent's horses. As he lit a candle, someone fired through the window. Vincent walked out of the barn and fell dead in the yard. There were around ten bullet wounds near his heart. Corso said that only one shot was fired. Soon after, police found a sawed-off double-barreled shotgun under a gate nearby.[59]

They also found an overcoat hanging on the fence in front of a nearby residence. The coat was dark unfinished worsted, sprinkled with gray, and had a black velvet collar. Across the inside pocket were two straps with a buckle, the same that would be used in the back of a pair of trousers. It appeared to be designed to hold a shortened shotgun. The barrels fit in the pocket and the straps held down the stock. Police were convinced that the murder was the work of the Black Hand.[60]

Two months later, a Dayton laborer, Domenico Gregiolio, was killed in a similar fashion. Police were convinced that the person who shot Costanino also killed Gregiolio.[61] The Italian Consulate at Cincinnati was ordered to institute an investigation into the deaths of both Vincent Costanino and Joe DeMar. After hearing testimony from the coroners and reviewing details, it was believed that the same parties operated in Dayton and Bellefontaine.[62]

3

TEN DAYS TO LIVE

The Cira and DeMar families continued to conduct business as usual after Joe DeMar was killed, but Charlie DeMar had a difficult time. Joe and Charlie were not only cousins but also best friends. Charlie replayed the events of the night of Joe's murder continuously for the entire year after. He recalled the event vividly:

> We were walking home about 11 o'clock on the night of March 23, 1907. Three of us: my cousin Joe, and our uncle, and myself. When we got down by Hover's grocery my uncle said, "excuse me a minute boys" and went back in the dark and talked to two men. We watched and could not hear.
>
> When we started on, my uncle asked Joe to carry his overcoat containing the money. He never did that before and I suppose he had told the two men who fired from the bush to hit the one carrying the coat. When we got on Troy Street, Joe was killed. My uncle and I ran at the noise of the shots and when we got up to the corner of Williams Avenue, my uncle stopped and told me that if I ever said anything about what had happened, he would kill me.[63]

Salvatore Cira had always been hard on the younger partners, and all of the DeMars claimed that they never received their fair shares of the money made from their business. They all lived in the Cira house, so Salvatore was able to get away with paying them very little. Mrs. Cira knew her husband

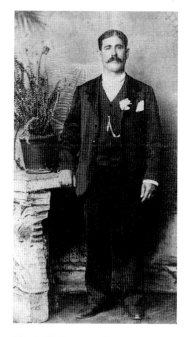

Biagio "Salvatore" Cira was known as the "Godfather." *Vicario Family Collection.*

was a man of high temper, and she feared that he would hurt the others. Sometimes the men were too afraid to even return home after work. Joe once ran away from home because of the poor treatment, and Salvatore repeatedly said that if he found Joe, he would kill him.[64] Every day, Charlie thought about the idea that Salvatore might actually kill him, as well.

On the morning of April 9, 1908, Charlie opened the store with Antonino Demma (Joe's father), while Salvatore went to the Jackson Barbershop to receive a hot shave. After he was cleaned up, he walked to their fruit store on the corner of the Powell Block. He was accompanied by his black dog, which had just been sent to him from a friend in Italy. It was a slow morning, and by about ten o'clock, Antonino was in the front of the store and the other two in the back sitting at a table.

Eighteen-year-old Charlie and Salvatore, forty-four, began to discuss business matters, which quickly turned into an argument. Charlie had delivered bananas to some merchants and forgot to get receipts. Salvatore started to curse at him, and Charlie tried to be respectful and only responded by saying, "You are unjust."[65] Salvatore was extremely heated and got up from the table, rushing toward the room where he kept his gun. Charlie was sure that Salvatore was going to shoot him.

The previous day, Charlie received a Black Hand letter telling him that he had only ten days to live. In the days leading up to the letter, Salvatore had been out of town attending what Charlie believed were Black Hand meetings.[66] Charlie thought that the letter came from Salvatore, and since he was back from his "meetings," the threat was going to be carried out.

As Salvatore rushed toward the back room, before even having the chance to get his gun, Charlie pulled out his .88-caliber revolver and fired two shots from about ten feet away. Both bullets went through Salvatore's back, piercing his heart. Charlie ran toward the door and fired two more wild shots. Even after being shot in the heart, Salvatore, in a towering rage, chased Charlie for nearly thirty feet and made it out the front door to the pavement.[67] He

A depiction of Salvatore Cira's commission house in Bellefontaine, by Devyn Croston. *Author's collection.*

fell back into the doorway of his store and then to the ground. Antonino Demma placed a small bundle of burlap under his head, and people started to gather around. Doctors ran over from across the street, but by the time they arrived, Salvatore Cira was dead.[68]

Sheriff Humphreys came to the scene immediately, and police cleared the room. Witnesses saw Charlie run from the store across East Columbus Avenue with a smoking revolver still in his hand. He went up the alley past Dr. Chalfant's office to the back door of Frank Comella's shoe shop on North Main Street. He was captured there by Sergeant Willis Polley and taken to jail.[69] Police began rounding up all of the Italians in the city. They searched all of the men and found revolvers on every last one of them.[70] The mayor did not think highly of Salvatore Cira, and after hearing that Domenico Galbo was there from out of town and a close friend of Salvatore, the mayor had him arrested on a concealed weapons charge. Sam DeMar and Frank Comella acted as interpreters and paid Galbo's fifty-dollar fine.

Mayor William R. Niven told Sam and Frank that he would not tolerate them carrying weapons any longer and stressed that they did not consider human life as highly as they should. He told them that Americans had no patience with the frequent murders committed by Italians.[71]

You people do not realize what a serious thing murder is in America. We have no occasion in this country for carrying revolvers and knives, and if

any of the Italians have fear of harm, all they have to do is inform the police and they will be granted protection. I must warn you again, the practice of carrying weapons must cease.[72]

At the jail, police sat down with Charlie to get to the bottom of what had happened. Charlie quickly explained that he killed Salvatore Cira in self-defense and that he believed that Salvatore was going to kill him.[73] He told them, "It was either for me to die or kill, and I shot my uncle....If I am taken to death, I am satisfied."[74] After his cousin's murder, he was just glad that his uncle paid for what he had done.

They continued questioning him and asked about his family and their fruit business. Everyone had always kept quiet about Salvatore and his background. Charlie confessed to the police that Salvatore Cira was the

Frank and Anna (Demma) Comella in Bellefontaine. *Author's collection.*

leader of a Black Hand gang and that he was responsible for the assassination of Joe DeMar. He said Joe was not the only one and that Salvatore had also been connected with many other Black Hand outrages in the state for at least the past five years.[75]

Police were not surprised—they had a suspicion about Salvatore Cira for a long time. After the police left, reporters came into the jail to talk to Charlie. "I have prayed to the Lord for months to give me strength to do this when the time came," he told them, "and he answered my prayer. If I have to go to the electrocution chair tomorrow, I am satisfied that I saw Mr. Cira die first."[76] Charlie was relaxed and enjoyed a peaceful meal while chatting with the reporters. He said he had not enjoyed a meal in months. "I have been afraid that Mr. Cira would kill me some way and my food tasted like poison for I didn't know but that each meal would be my last."[77]

Meanwhile, Chief of Police Ed Faulder placed all members of the Cira colony under surveillance. Police officers visited the Cira home, where Salvatore had a wife and six children. After Charlie told them that Salvatore Cira was the leader of the Black Hand, they immediately wanted to search Cira's house. There they found many short-barreled shotguns, knives and revolvers, all in a box under his bed. Along with weapons, shells were found where the shot had been removed and replaced with leaden balls.[78] All of the knives were more than six inches long, and one was ten inches. It was said that Cira was worth a large amount of money, but only $300 was found.

Salvatore's body was taken to be examined by Coroner Harbert. He found that in his pockets were two letters. Both letters were written in red ink and had drawings of daggers piercing hearts. They were signed "La Mano Nera, The Black Hand." The coroner brought the letters directly to the chief. Charlie DeMar, from behind bars, was asked to translate them.

One letter was postmarked Buffalo, January 18, 1908. It informed Salvatore that he must report at the corner of Michigan and Scarlet Streets at a saloon near the market house. Someone would be there waiting and ask him if he had a watch. Cira was supposed to reply, "Yes, and $175."[79] He was told to deliver the $175 or he would be killed.

The other was postmarked Pittsburgh, December 1, 1907. The letter mentioned the death of Joe DeMar and said that Salvatore should expect a similar fate or have his property dynamited if he didn't comply with the terms. Both letters indicated that he had answered previously in a disinterested manner. Charlie claimed that Salvatore had the letters written to him by friends to cast suspicion elsewhere if something were to happen in Bellefontaine.[80]

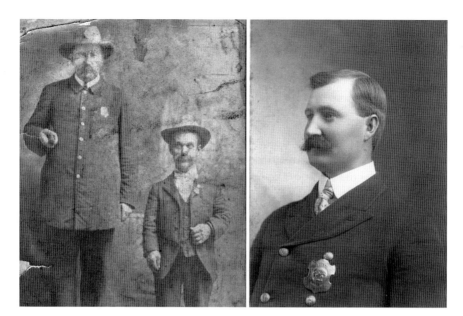

Bellefontaine police officer Willis Polley (*left*) pictured with an unknown man. Bellefontaine Chief of Police, Edward Faulder (*right*). *Courtesy of the Logan County (Ohio) Historical Society.*

The chief of detectives of Buffalo, New York, was informed of the letters. According to authorities, there was no street named "Scarlet" in the city. That report supported the claim that Salvatore Cira had the letters mailed to himself by other members of the Black Hand and there was no intention of going to a "Scarlet Street."[81]

Salvatore's funeral was three days later, on April 13. It was set to be at 8:30 a.m. at St. Patrick Church but was changed to a private ceremony at the Cira home. Due to the circumstances surrounding Cira's death, Father Sourd refused to give him a Catholic funeral.[82] People gathered at the home and then followed the funeral car to the burial ground.[83] Some friends came from Pittsburgh, and they made a few remarks in Italian during the burial. He was buried in the potter's field section at Calvary Cemetery in Bellefontaine, not far from the grave of Joe DeMar.[84]

On April 17, Charlie was brought to court, where there was a large crowd outside. Prosecutor Chamberlain appeared for the state, and attorneys Jay Miller, T.M Shea and E.M. Hamilton represented Charlie. He did not seem fazed by anything at all while sitting next to Frank Comella and Sam DeMar. City solicitor E.K. Campbell testified to hearing the shots and running into the store, where he found Salvatore Cira lying in the front doorway. He

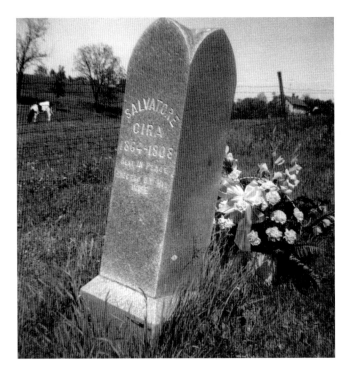

Salvatore Cira was buried in the north (potter's field) lot at Calvary Cemetery in Bellefontaine. *Author's collection.*

came from the office of West & West, next to the store. Cira died about as soon as Campbell arrived. Next, Coroner J.P. Harbert was called to the stand. He read the signed statement that Charlie made to him confessing to the shooting.

Police Sergeant Willis Polley followed by saying that Charlie also made the same admission to him. He showed the court the revolver that he had taken from Charlie. He recalled the young man saying that he prayed for months for strength to commit the act.[85] The defense did not offer any testimony and consented that Charlie DeMar should be held to the grand jury. The trial was set to begin on May 4, 1908, with a charge of first-degree murder. Charlie was held without bond by Mayor Niven after the preliminary examination, and he was taken back to the county jail by Chief Faulder.[86]

The grand jury consisted of:

Milton Bushong, Perry
J.W. Long, Monroe
William Hall, Rushcreek
H. Windsor, Bellefontaine, First Ward
DeVincey Weatherby, Perry

Henry Foust, Liberty
Abner W. Morton, Zane
Calvin Ruble, McArthur
David Roberts, Rushcreek
Noah Miller, Washington
E.E. Binegar, Miami, Quincy
Lyman A. Dean, Miami, DeGraff
Thomas P. Corwin, Richland
George W. Endsley, Bokescreek, north
Everett N. Hathaway, Bokescreek, south
Charles D. Campbell, Bellefontaine, Second Ward[87]

Prosecuting Attorney Chamberlain brought all of the witnesses that he could find to the trial, but the grand jurors decided that Charlie acted in self-defense. There were rumors immediately around town that there would be a special grand jury called to reconsider the case. Chamberlain caught wind and said, "This Grand Jury was made up of 15 solid men, and I presented the case to them fully, and feel that I have done my duty and there will be no special Grand Jury called."[88]

Sheriff Humphreys, with Frank Comella and Sam DeMar, went to the jail to release Charlie. Frank talked to reporters and told them that the act of Charlie killing Salvatore Cira had prevented about six other murders. He said, "Cira had intended to kill all of us." Frank was asked if he thought any friend of Cira might attempt to avenge his death and he said no, "they no come around here." While Frank talked with reporters, the sheriff went to the cell to tell Charlie that he was free to go.[89]

Charlie picked up his things, grabbed his guitar, shook hands with the other prisoners and stepped out into the lobby. He was quiet but beaming with happiness. He shook hands with the sheriff, newspapermen, Frank and Sam. He said goodbye and left the jail to go directly to the fruit store. He stood in the doorway for a moment and then went right to work and started soliciting orders for bananas.[90]

The Italian community of Bellefontaine prepared a feast in celebration of Charlie's release. Many people came from all over the state, and many business owners were pleased that Cira was no longer around.[91] It had been an Italian custom that after a friend or relative passed away, men would grow their beards out for thirty days. When Joe DeMar was killed, all of the local Italian men followed this tradition as a sign of respect toward Joe. When Salvatore Cira was killed, in similar fashion, men permitted their beards to

TRANSCRIPT FROM CRIMINAL DOCKET.

Criminal Action, before *W R Niven* _____ Mayor of the
City of *Bellefontaine* , *Logan* _____ County, Ohio.

Form W

The State of Ohio, *No.*

No. *vs.* CHARGE OF *Murder*

Charles Demar

THE STATE OF OHIO, *Logan* COUNTY,}
The City of *Bellefontaine* } ss.

Before me, the undersigned Mayor of said Municipal Corporation, personally came E.P.Chamberlin, Prosecuting Attorney of Logan County, Ohio, who being duly sworn, according to law, deposeth and saith, that on or about the 9th day of April, 1908, at the county aforesaid, Charles Demar, in and upon one Salvatore Cira, then and there being, did unlawfully, purposely, and of deliberate and premeditated malice, make an assault, in a menacing manner, with intent him, the said Salvatore Cira, unlawfully, purposely and of deliberate and premeditated malice, to kill and murder; and that the said Charles Demar, a certain revolver then and there charged with gun powder and two leaden bullets, which said revolver he, the said Charles Demar, then and therein his right hand had and held, then and there, unlawfully, purposely and of deliberate and premeditated malice, did discharge and shoot off to, against and upon the said Salvatore Cira, with the intent aforesaid, and that the said Charles Demar with the leaden bullets aforesaid, out of the revolver aforesaid, by force of the gun powder aforesaid, by the said Charles Demar, then and there discharged and shot off as aforesaid, him, the said Salvatore Cira, in and upon either side of the spinal column between the eighth and ninth ribs through the body, penetrating the heart and left lung, one of the bullets lodging in the sternal bone, and the other bullet lodging just under the skin over the sternum, the said Salvatore Cira, then and there unlawfully, purposely, and of deliberate and premeditated malice did strike, penetrate and wound, with the intent aforesaid, thereby then and there giving to him, the said Salvatore Cira, with the leaden bullets aforesaid, so as aforesaid discharged, and shot out of the revolver aforesaid, by the said Charles Demar, in and upon either side of the spinal column, between the eighth and ninth ribs, through the body, penetrating the heart and left lung, of him, the said Salvatore Cira, one mortal wound as aforesaid, of which said mortal wound he, the said Salvatore Cira then and there died; and so the affiant aforesaid, upon his oath, does say that the said Charles Demar, him, the said Salvatore Cira, in the manner and by the means aforesaid, unlawfully, purposely, and of deliberate and premeditated malice, did kill and murder, contrary to the form of the statute in such case made and provided and against the peace and dignity of the State of Ohio.
(Signed) E.P.Chamberlin.
Sworn to and subscribed before me and signed in my presence this 10th day of April, 1908.
W.R.Niven, Mayor.

(SEAL)

"Transcript from Criminal Docket." The *State of Ohio v. Charles DeMar. Courtesy of the Logan County (Ohio) Historical Society.*

"No indictment having been found against defendant [Charles DeMar]." *Courtesy of the Logan County (Ohio) Historical Society.*

grow, but they did not allow them to grow for the full thirty days. Instead of a full month, they shaved after only two weeks, indicating that they did not have full respect for Cira.[92]

The DeMars changed the name of Salvatore Cira & Co. to the DeMar Fruit Company. Antonino, Sam, Tony and Charlie were now running the commission house. They immediately welcomed Charles Vicario into the Cira home, and he would help with the business. Calogero "Charles" Vicario had been living in Dennison, Ohio, a small town halfway between Bellefontaine and Pittsburgh. He was there with his younger brother Antonio, who was called "Tony." The two were working for Agostino Marfisi, who was a fruit merchant and had a confectionery store in Dennison.

Agostino Marfisi came to the United States in the mid-1890s. He was a native of Termini Imerese, Sicily, where he was a shepherd and a friend of Salvatore Cira. Charles and Tony Vicario were from Galati Mamertino, a small town in the mountains of Messina, Sicily, where their father, Giacomo "Jacob," was a shepherd. Charles was born on August 19, 1885, and Tony was born on November 26, 1888.[93]

In Galati, the boys helped their father herd sheep in the mountains. When Tony was around twelve years old, for an unknown reason, he was beaten up by a man from town. When sixteen-year-old Charles found out, he went searching for the man. Charles beat him so badly that he had to skip town to avoid being captured by the police. He was advised to make his way to Termini Imerese and find the Cira family for help. Salvatore Cira was known to have been a member of the Mafia and would certainly be able to assist. Cira took care of Charles's problem with the police, and from then on, the Vicario brothers owed him their services.[94]

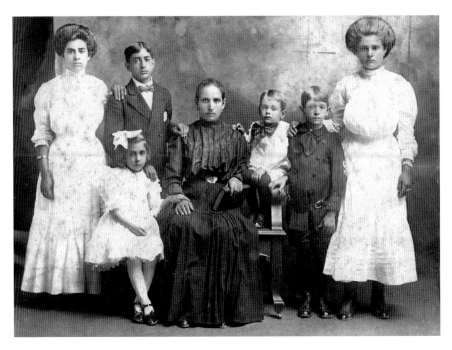

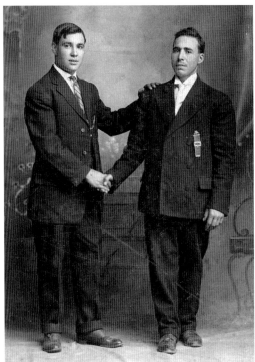

Above: Maria (Demma) Cira (*center*) with her children: Mary, John, Josephine, Anthony, Salvatore and Providence. *Author's collection.*

Left: Tony Vicario (*left*) and Charles Vicario in Dennison, Ohio, July 1907. *Author's collection.*

After the Ciras moved to the United States, Charles soon followed. A relative helped him get a passport and arranged for him to move to America. On August 20, 1903, he arrived in New York City with his cousin Calogero Emanuele. They stayed with Gaetano Parafioriti in Cleveland until Charles moved to Steubenville, Ohio, and then Dennison, to work for Agostino Marfisi. In 1906, Tony took the SS *Sicilia* to New York. He went directly to Steubenville and began working with his brother Charles.[95]

The Vicario brothers had a close relationship with the Cira and DeMar families. After the murder of Salvatore, Charles took on the responsibility of taking care of the Cira family and was romantically involved with the eldest Cira daughter, Mary. Charles moved to Bellefontaine, and Tony continued working in Dennison. In very little time, Charles became an important partner in the DeMar Fruit Company. He was making $60 per month and bought the Cira residence and the adjoining lot for $1,300.

Charles was a good businessman and took over the position that Salvatore Cira once had, making certain that the company would continue to be profitable. Sam DeMar continued working at the store but spent much of his time out of town. He would travel with Salvatore Dinovo on business trips and spent much of his time working in Columbus for Joe Lombardo. He was engaged to marry Joe's daughter Katie.[96]

The members of the DeMar fruit firm had business relationships with proprietors from all over the state, including men from Cincinnati and Columbus and Salvatore Lima of Marion.

4

DYNAMITE IN COLUMBUS

Black Hand outrages did not slow down after the death of Salvatore Cira. Italians continued receiving threatening letters and sometimes worse. There were still reports of Black Hand activities in Dayton, Springfield, Columbus and every large city around the state. The letters always gave a clear instruction not to inform the police or there would be a punishment.

When someone received a letter, they usually kept it quiet. Reporters were always after the next Black Hand story and would publish any rumors or hearsay about the secret society. It was unfortunate for Joe Papania, who in April 1908 was said to have received a letter demanding $3,000. Word spread, and it was published in a Springfield newspaper. Joe denied having ever received any letter, but as soon as he read the reports, he sent his family away to Lexington, Kentucky. A few days after their departure, he closed his fruit stand and left the city.[97]

Ignazio "Frank" Gentile was a fruit dealer of Dayton and a native of Termini Imerese. He had been in Ohio for more than twenty years and was well experienced in the fruit industry. He was wealthy and well connected with the popular Catalano Fruit Company, which resulted in him becoming no stranger to extortion letters. In 1908, two letters arrived demanding $10,000, and he ignored both.[98]

On May 4, at 11:45 p.m., after the Gentile family had all gone to bed, a large explosion shook their house. The sound of crashing timbers and breaking glass was heard throughout the entire neighborhood. Frank jumped out of bed to find his small kids screaming in terror. He went to the back

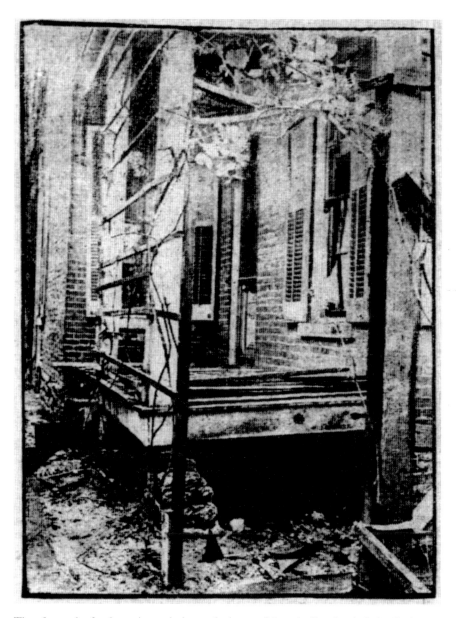

The aftermath of a dynamite explosion at the home of Ignazio Gentile. *Author's collection.*

of the house, where the explosion happened, to find the porch blown to pieces. All of the lights and windows were shattered, and even the home next door had heavy damage. After years of demands and empty threats, Ignazio never expected that something serious would happen.[99]

LETTERS FROM "BLACK HAND" CONTAINED VICIOUS THREATS

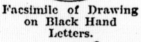

"We will cut you up and pack you in a barrel if you do not pay the money," said one of the letters received by the Iannarino brothers.

"We can make you fly," promised another. This is interpreted to mean that they knew how to use dynamite.

A letter received shortly after the stick of dynamite was first found on the doorstep said: "We placed the dynamite there, but cut out the fuse. We wanted you to know that we are always at your shoulders."

Facsimile of Drawing on Black Hand Letters.

All the letters were filled with dire threats of death and torture if the demand for money was not complied with by April 1.

A facsimile of a drawing and letter received by Agostino Iannarino. *Author's collection.*

Occurrences of bombings started to become more frequent. Agostino Iannarino was another man of success, with a reputation of being a leading banana salesman in Columbus. He was an ideal target for the Black Hand. The first letter that Agostino received said that the society needed funds and that they were confident that he would comply with the request, since he was known to be generous. The letter said that he should bring $10,000 in gold to a bridge in Pittsburgh. If he did not bring the gold, it was promised that he and his brother would be cut up and placed in barrels.[100] He ignored the letter and, soon after, began receiving them regularly.[101]

The letters were postmarked in various places, two of which were Columbus. One was from Leechburg, Pennsylvania; another from Chicago; and three from Pittsburgh. They were written in red ink and had drawings of men with stilettos through their hearts. One of the letters even included a newspaper clipping from New York about a fruit stand that had been blown up. A set of rules for the society was also attached. It said that no member should show sympathy or fail to carry out dictates of the society. Failing to follow the rules would result in being stabbed in the back with a knife.[102]

After ignoring the demands for months, Agostino found a stick of dynamite with an unlit fuse in front of his house. It was a warning, but he still refused to pay. Two months later, on May 13, 1908, at 3:00 a.m., the

entire neighborhood was awakened when a powerful detonation shook the ground like an earthquake. A bomb had exploded outside of the Iannarino home. The blast was so big that the Black Hand surely intended to blow up the entire house on North Grant Avenue and everyone inside it. The family was fortunate that the dynamite exploded downward so only the steps and foundation of the house were seriously damaged, but the amount of dynamite was so large that the concussion shattered every window.

Agostino's wife, Maria; their five children; and his father, Michele, were all inside the home. When police arrived, they said that there was no doubt that it was the work of the Black Hand. Sergeant Peter Albanese of the Columbus Police Department opened an investigation. He spoke with Agostino's family and learned that his brother, Ignazio, of 335 East Naghten, had also been receiving letters for more than four months. He was also told to bring large amounts of money to Pittsburgh. Sergeant Churches was called to review and translate the letters. They looked familiar, and he quickly realized that he recognized the handwriting. They matched the letters that were found in the pockets of Salvatore Cira after he was killed in Bellefontaine.[103]

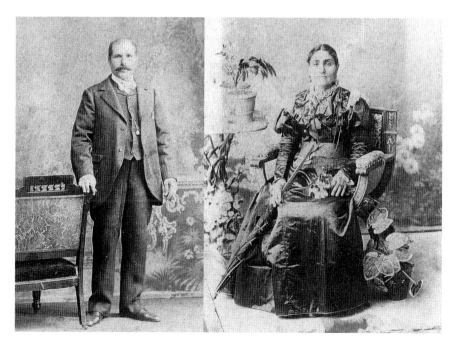

The Iannarino family stayed with Salvatore and Marianna Purpura upon their return to Sicily. *Iannarino family collection.*

CITY OF COLUMBUS, OHIO.

DEPARTMENT OF PUBLIC SAFETY

DIVISION OF POLICE

ADDRESS ALL COMMUNICATIONS
TO THE
CHIEF OF POLICE

DIRECTORS

WILLIAM S. CONNOR
FOSTER G. BURDELL

WM. R. DIEHL
Secretary

CHARLES A. BOND
Mayor

JOHN F. O'CONNOR
Chief

JAMES A. DUNDON
Chief of Detectives

Columbus, Ohio, May 27th, 1908.

To Whom It May Concern:

This is to certify that the bearer, Agostino Iannairino and his brother Ignazio Iannairino, are respectable citizens of this city and are on their way to their old home in Italy.

On account of several threatening letters sent them by the Black Hand Society, and an attempt made to kill them by placing dynamite under their house in the night season in this city just recently, they have deemed it advisable to leave this country for awhile.

On account of this threatening attitude of the Black Hand society, I have advised both of these men to carry a loaded revolver for their personal protection.

Any courtesies extended these men by any of the authorities along their route from this city to their destination in Italy, will be appreciated by,

Yours respectfully,

John F. O'Connor
Chief of Police.

OC-OR.

Above: Agostino and Ignazio Iannarino were advised to carry revolvers for protection as their families left Columbus in 1908. *Courtesy of Teresa Mangia.*

Opposite, top: Agostino Iannarino with his children Mike, Antoinette, Josephine, Mary and Bill in Termini Imerese, Sicily, 1908. *Courtesy of Teresa Mangia.*

Opposite, bottom: The Iannarino families returned to America from Sicily in late April 1909. *Author's collection.*

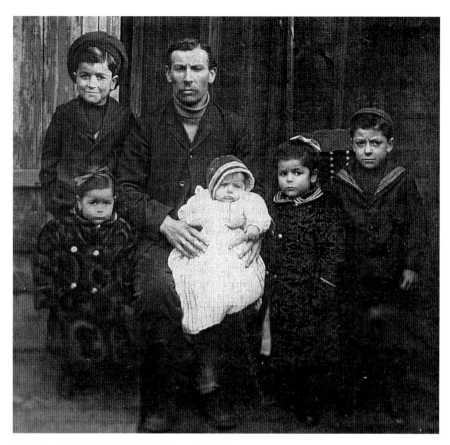

LIST OR MANIFEST OF ALIEN PASSENGERS FOR THE UNITED

Required by the regulations of the Secretary of Commerce and Labor of the United States, under Act of Congress approved February 20, 1907, to be delivered

S. S. *Carpathia* sailing from *Palermo* , *April 27th*, 1909

Family Name	Given Name	Age	Sex	Married or Single	Calling or Occupation	Read.	Write.	Nationality (Country of which citizen or subject)	Race or People.	Last Permanent Residence Country	City or Town.	The name and complete address of nearest relative or friend in country whence alien came.	State.	City or Town.
Filicicchia	Giuseppe	32	m	m				U. S.	American	Citizen			Home	Columbus Ohio
Filicicchia	Santa	23	f	m				U. S.	American	Citizen			"	"
Tannarino	Agostino	31	m	m				U. S.	American	Citizen			"	"
Tannarino	Maria	27	f	m				U. S.	American	Citizen			"	"
Tannarino	Michele	8	m	s				U. S.	American	Citizen Born			"	"
Tannarino	Salvatore	6	m	s				U. S.	American	Citizen			"	"
Tannarino	Maraumina	4	f	s				U. S.	American	Citizen			"	"
Tannarino	Antonina	1	f	s				U. S.	American	Citizen			"	"
Tannarino	Ignazio	38	m	m	merchant	yes		Italy	Italian South	Palermo	Termini	nobody	Ohio	Columbus
Tannarino	Cosima	30	f	m		yes		Italy	Italian South	Palermo	Termini	nobody	Ohio	Columbus
Tannarino	Michele	8	m	s	no			Italy	Italian South	Palermo	Termini	nobody	Ohio	Columbus
Tannarino	Nicolina	6	f	s		no		Italy	Italian South	Palermo	Termini	nobody	Ohio	Columbus
Tannarino	Leonardo	4	m	s	no			Italy	Italian South	Palermo	Termini	nobody	Ohio	Columbus
Tannarino	Marianna	2	f	s	no			Italy	Italian South	Palermo	Termini	nobody	Ohio	Columbus
Tannarino	Giuseppa	1	f	s				Italy	Italian South	Palermo	Termini	nobody	Ohio	Columbus

Sergeant Albanese asked Agostino why he had not notified the police after finding the stick of dynamite, and his reply was that he believed he could unearth the perpetrators better himself. One of the letters even foretold that a stick of dynamite would be left at his home as a warning and then a bomb would be next. For many weeks following the attack on the Iannarino family, Chief of Police John F. O'Connor instructed patrolmen to watch the family's properties and make sure members of the Black Hand did not attempt anything else. The chief also ordered that the stick of dynamite be dropped into the Scioto River.[104]

Agostino and Ignazio decided that it was for the best that they move their families back to Termini Imerese. Sergeant Churches escorted them out of the state, where they boarded a ship and returned to Sicily.[105] Their brother Leonardo and their father, Michele, stayed in Columbus with Agata (Iannarino) Mercurio's family.[106] Agostino, along with his wife, Maria, and their children, Mike, Bill, Mary, Antoinette and Josephine, moved in with Maria's parents. Not much time passed before they started receiving more letters in Sicily. The letters came from America, and it was clear that whoever was after them in Columbus had connections in Sicily. In April 1909, Agostino decided that he would not be intimidated and brought the family back to America.

Others continued to get similar letters. In Dennison, Ohio, on May 30, 1908, Biagio Bonanno received a letter stating that the Black Hand knew he had $3,000 and that he must pay $2,000. He was instructed to take the money to Pittsburgh, Pennsylvania. On June 20, he was supposed to go to the Union Station, where seven men would be waiting for him. He was told to be smoking a cigar and have one hand wrapped in a red handkerchief. After seeing what the Black Hand was capable of in Columbus, Bonanno was so terrified that he closed his store and left town.[107]

5

THE DIRECTORATE

While there were frequent reports of Black Hand threats and bombings around the state, Salvatore Lima's fruit business was reaching high levels of success in Marion. Lima's family and the family of his brother-in-law Sebastian were living comfortable lives, while the two of them were working tirelessly at the store. They weren't only making orders and selling fruit but were also in the back of the store orchestrating many of the terrible events that were being read about in the papers. Salvatore Lima, with the help of his friends from all around the country, was writing and sending Black Hand letters from the back room of his business and then returning to the front and selling bananas.

There were small Black Hand gangs operating in every major city throughout the country. In New York City, Lieutenant Joseph Petrosino was leading an Italian Squad of investigators who were focused solely on Black Hand crimes. In most of their investigations, they found that gangs usually consisted of only two or three people.[108] Many of these men were low-level criminals, only looking for a quick pay-day. The Ohio operation appeared to be much larger and more organized.

There were many changes in 1908. After the death of Salvatore Cira, Charles Vicario relocated to Bellefontaine and Sam DeMar went to Columbus. Antonio Lima, Salvatore's father, arrived in the United States from Sicily on October 27.[109] Then on November 3, 1908, a meeting was held in Marion. An official roster was made for the partnership of the Ohio

"fruit dealers." The roster was titled "The Society of the Banana." Salvatore Lima, Sebastian Lima, Antonio Lima and Giuseppe "Joe" Ignoffo were listed first as "The Directorate." This bracket was followed by a list of twenty-five people, including the following names:

Orazio Runfola
Pippino Galbo
Saverio Ventola
Salvatore "Sam DeMar" Demma
Antonio "Tony" Vicario
Calogero "Charlie" Vicario
Agostino Marfisi
Salvatore Rizzo
Salvatore Arrigo
Vincenzo "Vincent" Arrigo
Francesco "Frank" Spadara.[110]

These official members of the Society of the Banana worked together to extort money from wealthy Italians who were residing all over the region. An extortion letter would be written and sealed, then placed in another envelope and mailed to an associate. That associate would re-mail the letter to a potential victim. Salvatore Lima could mail a letter from Marion to Columbus, and when it arrived, it would be postmarked "Pittsburgh," with no indication that it was ever in Lima's hands.

The society also had connections in Cleveland, Chicago and even towns in states as far as South Dakota. With the technique that Salvatore Lima used, he could send multiple letters to one victim, all in the same handwriting, and the letters would all come from different cities. He had the society's movements concealed.[111]

Salvatore Lima tried to keep the operations outside of Marion so that he would never be suspected of criminal involvement. Marion was an active town, which kept his store busy, but there were also nearly ten other grocery stores in the area. Klinfelter's was on South Main, Robinson's on East Center, and Chas Turner ran the Big City Market.[112] This meant that there was a lot of competition for Lima.

Everyone in the society wanted their legitimate businesses to be successful, even if they had to use threats and sometimes violence to eliminate their competitors. One of Salvatore Lima's biggest competitors was the John Amicon & Bros branch. This store was located on the Big Four and Erie

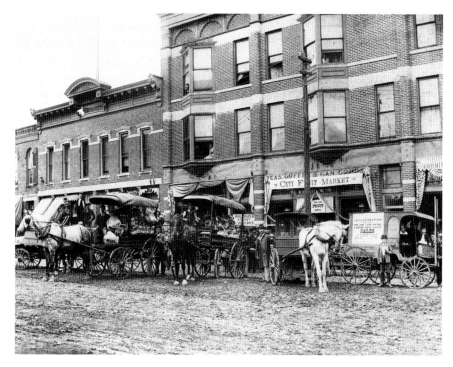

The City Fruit Market, Marion, Ohio. *Provided by the Marion County (Ohio) Historical Society.*

railroad tracks. John Amicon was one of the most successful Italians in the country, and his store in Marion was taking business away from Lima's.

On the morning of January 15, 1909, John's niece Francesca was leaving for school and found a package on the front doorstep of the Amicon house in Columbus. She carried it inside to show Teresa Amicon. The parcel was wrapped in a *Pittsburgh Dispatch* newspaper and no larger than a box of Sicilian pastries; she could have never guessed what was inside. Mrs. Amicon quickly unwrapped the package and immediately realized what it was. Francesca had found a bomb, neatly wrapped in paper, like a gift for the Amicon family.

She immediately placed it in a pan of water and nervously waited for John to return home. He took the suspected bomb to the sporting goods store, and they confirmed that it was dynamite.[113] John, his brother Charles and their employees all tried to figure out who was responsible for the letters and the bomb.

Immediately, John Amicon thought of Salvatore Lima. Just after he would receive a threatening letter, Salvatore was always seen hanging out

around the fruit yard at Amicon's store with his associates, who were also competitors of Amicon. Lima was usually accompanied by Saverio Ventola, of Columbus, and Sam DeMar, formerly of Bellefontaine.[114] Ventola, like DeMar, was from Termini Imerese, Sicily. He was nearly sixty years old and had been working in the fruit industry for years. He started in Cincinnati and eventually moved to Columbus. He lived at 324 East Spring Street, just a few minutes' walk from where Sam DeMar stayed at 386 East Naghten.

One stick of dynamite was enough for Amicon, and he decided to turn the letters in to Postmaster Harry Krumm.[115] John Amicon was not at all worried about his own safety, but he knew that he had to keep his family safe from harm. Ventola had been watching and knew that Amicon had turned the letters over to authorities. He approached Amicon about the issue and assured him that the letters were not from him. John Amicon told Ventola, "If I thought you wrote them, I wouldn't have to go to court, I would shoot you right here on the sidewalk."[116]

Postmaster Krumm and Post Office Inspector J.F. Oldfield opened an investigation, and Francis P. Dimaio of the Pinkerton Agency of Pittsburgh was brought in to help. Dimaio was highly experienced in gang infiltration. He had talked to some Black Hand men in Pittsburgh, and one claimed to be a member of a criminal band called the Society of the Banana. He told Dimaio that he worked under the orders of Salvatore Lima.[117]

Since the leaders of the group had cut him short on his shares of the profits, he decided to betray Lima and his associates by telling secrets of

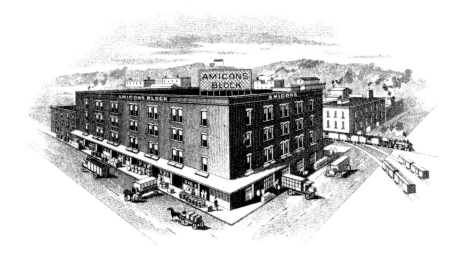

The Amicon Block, Columbus, Ohio. *Courtesy of the Pardi family.*

their society. The unnamed man told Dimaio that the headquarters of the Black Hand Society was in Marion, Ohio, and that on March 9, 1909, there was going to be a division meeting.[118]

The information was a big lead for post office inspectors. Oldfield had been trying to uncover the Black Hand organization since the death of Salvatore Cira but had hit a dead end. Oldfield and Inspectors George Pate, Edward Hutches and Raleigh Hosford arrived in Marion one week before the meeting was going to take place and secured a room in the building that was adjoining Lima's store. They watched Salvatore Lima every day, suspecting that if their intel was true, he was a leader of the gang.

On the day of the meeting, inspectors saw Joe Ignoffo and Salvatore Rizzo at the Lima store. They lived nearby and were often seen hanging around. Some detectives were posted at the train station and watched members of the society arrive in Marion as trains came from Bellefontaine, Columbus, Cincinnati and Pittsburgh. Inspector Oldfield was across the street from the Limas and noticed Saverio Ventola as he arrived from Columbus.[119] Sam DeMar also came from Columbus. The inspectors watched as each person walked into the fruit store. The information from Dimaio appeared to be true. Inspectors knew who some of the men were, and others were unknown.

They saw Pippino Galbo, who came on the train from Pennsylvania. Galbo had a large fruit store in Meadville, located at 248 Pine Street.[120] He lived there with his wife, Angeline, and children. He was popular in Meadville with a good reputation. His countrymen looked at him as a generous and hardworking man.

Some of his neighbors did find his level of wealth somewhat suspicious. His property on Pine Street was valuable, worth somewhere between $8,000 and $10,000.[121] He had a stable and eight horses along with three brand-new carts for delivering fruits. Some of the neighbors thought that his business was not doing well enough for him to be capable of living such a lavish lifestyle.

Galbo was born on July 26, 1871, in Caccamo, Sicily, not far from Salvatore Lima's hometown of Trabia. He had moved to Meadville in 1905, from Buffalo, New York, where he was working with his brother. It was alleged that he was a fugitive from Sicily and was mixed up in some serious troubles there.[122] He escaped those problems and came to America in 1899.

Pippino Galbo had a good relationship with Lima, and they stayed in frequent contact, often writing each other letters. He often left Meadville to go on long trips. His family was not even aware of where he went or for how

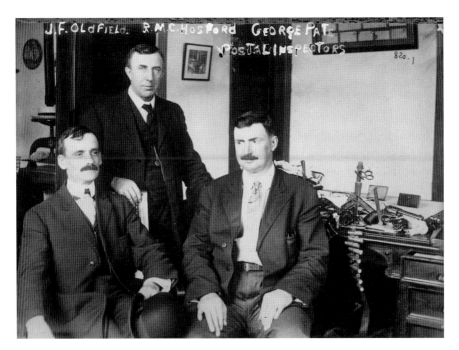

(*From left to right*) Postal Inspectors Oldfield, Hosford and Pate. *Library of Congress.*

long he was going to be gone. Sometimes he was gone for up to three weeks, likely doing work for the society.[123]

Another man from Pennsylvania was with Galbo on the train. His name was Orazio Runfola, though he was known to have several aliases. He had a cigar shop on Penn Avenue, near Twenty-Second Street, in Pittsburgh. Orazio had family in New York City, and his mother still lived in Caltavuturo, Sicily, where he owned $6,000 worth of property. Living in Pittsburgh, Orazio was a key component in the Society of the Banana's activities.[124]

Pittsburgh was a primary location in which the society had victims deliver money. Sometimes, letters from Marion were first mailed to Dennison, Ohio or Meadville, Pennsylvania, then eventually to Orazio in Pittsburgh, where he would forward the letter to the next location. At times, letters were passed around half a dozen times before arriving at the house of the intended victim.[125]

Orazio was believed to have sometimes went by the alias "Raimondo Cardinale."[126] He also had connections with Dr. Romano of Cleveland, who had close ties with the Cira family of Bellefontaine.[127]

The Vicario brothers showed up to the meeting next. Charles took the train from Bellefontaine, where he oversaw the DeMar Fruit Company and

headed the Cira house. His younger brother Tony came from Dennison, Ohio. He was still working there as a clerk in the confectionery shop of Agostino Marfisi. Because of their frequent contact with Salvatore Lima, inspectors were sure that Marfisi and the Vicario brothers had a big role in the society's operations. It was believed that Marfisi might have been a relation of the Vicarios.[128]

Salvatore and Vincenzo Arrigo arrived together from Cincinnati. They were father and son. Salvatore was from Termini Imerese, and after coming to America, he settled in Washington, D.C., where he opened a fruit stand. Both had a prior history of being involved in illegal activities.[129]

Salvatore Arrigo was the oldest member of the Society of the Banana and president of the group.[130] This role was merely a title, and he was not expected to do much work. Vincenzo, or "Vincent," was born in Sicily on December 29, 1863, to Josephine Pusateri. She passed away when he was a young teenager. In Cincinnati, he operated a fruit stand on West Twelfth Street and was known to carry a .38-caliber revolver.[131] Because of the family's criminal history, the inspectors had no doubt about their involvement.

Lastly, Frank Spadara, also of Cincinnati, arrived in Marion. He was friends with the Arrigos, and they would hang out at his saloon at 227 West Sixth Street. Frank was also a key leader for the Society of the Banana in Cincinnati. He was born on January 17, 1863, in Messina, Sicily, and was believed to have spent some time living in Termini Imerese. He was a short, stout man standing less than five foot, three inches tall and wore a large mustache covering his mouth.[132]

Union Station, Marion, Ohio. *Author's collection.*

Ohio railroad map: 1. Cincinnati, 10. Columbus, 13. Bellefontaine and Marion, 18. Dennison, 25. Cleveland. *Author's collection.*

Frank was allegedly arrested in Boston shortly after his arrival to the United States for murdering an Italian named Giuseppe Ciro. It was not confirmed if he was the same "Spadara" who was in Boston, but if he was, he managed to escape any conviction and then made his way to Cincinnati. It was believed that because of the history of his family in Sicily, the Spadara name carried considerable influence and power.[133]

Once everyone had arrived and the meeting was thought to have commenced, inspectors and detectives waited from afar, not having any idea what was being said behind the doors of the fruit store. They saw a delivery truck drop off a load of cots in the evening; then in the morning, all of the men made their way back to the train station. The inspectors were clueless about what had been discussed, but once again, someone was not happy

with the distribution of profits and Dimaio got them to talk. A low-level associate told the investigators what the meeting had been about.[134]

Salvatore Lima had called the meeting because he was not happy with the direction the society was going. Salvatore Arrigo was president but had recently appointed Frank Spadara to handle the society's affairs, and the members where not happy with how Frank was conducting business. Frank was bringing in small amounts of money, and Salvatore Lima, having bigger aspirations, had already been running larger extortion operations out of his Marion fruit store.

Salvatore wanted to extort money from the wealthiest Italians and not waste time on small-time fruit peddlers. He believed that he himself should be the one in charge of affairs. They debated the issue for hours. The arguments were heated, and Frank had no interest in giving up his position. In the end, after a vote, they decided that he would keep his rank and Salvatore would be appointed as the superintendent. From then on, Salvatore Lima would be the "overseer." Salvatore Arrigo and Frank Spadara both stepped into the background, and Lima would call the shots.[135]

6

SOCIETY HEADQUARTERS

fter the Society of the Banana's meeting, Inspector Oldfield decided that he was going to follow every letter being sent by Salvatore Lima and the other suspected Black Handers in Ohio. He instructed D.C. Mahon, postmaster at Dennison, to mark two-cent stamps with a red ink dot on the letter "O" in the word "two." They turned the stamps over to the post office clerk with instruction to give them to no one other than Agostino Marfisi and the Vicario brothers. One was eventually found on a Black Hand letter that was sent to Martin Rini in Cleveland. He received letters for years, even after the news report describing how he stood guard in his home with a butcher knife in 1906.[136]

Inspectors intercepted a letter from Salvatore Lima that was written to Saverio Ventola in Columbus. It was dated March 12, 1909, and read:

I believe that Turida told us, who have the establishing, not to make any change. I pray you to see Turida as soon as you get this and see if he can leave Sunday and go to Bellefontaine as usual, as I and my father are going to see the beef. Turida has a beef to sell, and it would be a favor to me if he would be in Bellefontaine that we could buy it. Our Society of Bananas is composed. I am president here and Cleveland, and the old man Menitta president in Cincinnati. However, in case we must unite, Menitta president over all. I pray you to telephone me and let me know whether Turida will come or not.[137]

It was not known who "Turida" was, but it appeared that he was a superior of Salvatore Lima. "Turiddu" was a diminutive for the name Salvatore. Some Inspectors had their theories that Lima may have been referring to Salvatore Cira, but it did not add up since he was deceased. The letter might have instead referred to two different Turidas: Salvatore Arrigo and Salvatore Demma—since Demma, otherwise known as Sam DeMar, was living in Columbus near Saverio Ventola. Sam's sister Maria was the widow of Salvatore Cira, and it made sense that he would have been regularly going to Bellefontaine on Sundays.

Inspectors went to Bellefontaine and waited for the Limas. Salvatore and his father, Antonio Lima, arrived at the fruit store and met Sam DeMar, Charlie DeMar and Antonino Demma. The Limas spent the day at the Cira home and helped make repairs to the house. Inspectors watched until the Lima men left and never saw any purchase of beef.[138]

In the weeks following, members of the Society of the Banana sent nearly $3,200 worth of money orders to Italy. In one day, Salvatore Lima sent nineteen money orders for $100 each and one for $80 to his mother, Nunzia Cancilla, in Trabia, Palermo, Sicily.[139]

A sizeable amount of evidence had been accumulated, so on the morning of June 8, 1909, Inspectors Oldfield, Hutches and Hosford walked into the so-called headquarters of the Society of the Banana and placed Salvatore Lima under arrest. His wife and family sat quietly while detectives began searching every nook and cranny of their fruit store and residence. It was not long before they found large bundles of mail. Inspectors took the evidence away, positive that the letters would uncover Black Hand schemes.

The safe in the back room of the store was open, and inside was a stack of incriminating evidence. There were enough documents to prove that Lima's store was likely the headquarters for all of the Black Hand societies in the country. There were lists showing the names of hundreds of men throughout the country who had been paying large sums of money to the society.[140] Salvatore Rizzo, also of Marion, was in the store and taken into custody. Lima was taken directly to the city prison and Rizzo to the county jail.[141] Several hundred Italians collected in the streets, and authorities feared that the crowd might demand for the men to be released, so they heavily guarded the jail and had the militia on standby, ready for immediate action.[142]

Salvatore Lima did not learn of the exact reason that his store was raided until the following morning when he was given a newspaper in his jail cell. When Salvatore learned that he was being accused of attempting to extort money from John Amicon, he jumped from his cot and exclaimed:

Uh, Amicon, oh, I see he. Amicon jealous. That's all. He jealous of me because I sell more bananas in Ohio than he do. He tell police I do this money business to get even with me because I get more business, Black Hand: Bah! I know nothing.[143]

Lima was smoking a big black cigar and took a moment to regain his composure. He was ready to answer any and all questions. He said, "I am a hard-working businessman. I work every day, every night, and every Sunday." He explained that he was thirty years old with a wife and children and had been working hard in America for the last three years.[144]

Deputy Marshals Owens and Wagner took Salvatore from his cell to be transported to Toledo. A large crowd had gathered outside, and he yelled, with his cuffed hands held high above his head, "Black Hand? Black Hand? See my hands, they are white. My persecutors have black hands. They try to injure me and my business. They want to ruin my family!"[145] Inspectors were still on the search for Salvatore Lima's father, Antonio, and his brother-in-law Sebastian.

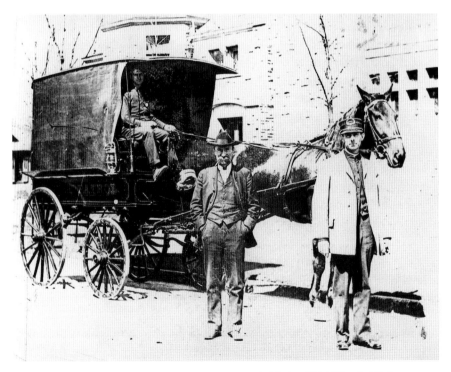

An unidentified man with Marion police. *Provided by the Marion (Ohio) Historical Society.*

Meanwhile, in Columbus, John Amicon was at his home on East Rich Street being interviewed by the press. He said:

> *They tackled the wrong fish when they got after me. I'm not afraid of any man in the United States. I wouldn't give them a cent if it cost my life. They left some dynamite and I turned it over to the postmaster. My wife found it with a letter demanding $10,000. They never got anything out of me. We got a good many letters, but turned them over to the postoffice people as they came in. I understand people in Springfield and Columbus have paid. I couldn't remember the names. Some gave $800, some $1,000. Some fixed it among themselves. They wanted $10,000, but I never paid any attention. They could kill me first.*[146]

Salvatore arrived in Toledo with a note from his attorney, Fred Guthrie, advising him to plead not guilty. He was being charged with "using the mails to defraud John Amicon."[147] His bond was set at $2,000 and was furnished by Tony Cangiamilla, a childhood friend, who was also a wealthy fruit dealer. Salvatore declared to the press that he was an honest, hardworking man, and that he spent all of his time working to support his family. He said that there was no time to mingle with lawbreakers and evil-minded people.[148] He believed that his rivals were just jealous of his success.[149]

Salvatore Lima also claimed to be the son of a Sicilian nobleman and godson of Senator Felipe, of the Roman senate. He explained that because of his success and connections, he would have no need to extort money.[150] Cangiamilla affirmed that Antonio Lima, Salvatore's father, was an active politician in Trabia, in the province of Palermo, and was in the United States visiting family. Interpreters said that Salvatore Lima could speak excellent Italian and believed that he was highly educated, whereas most of his associates conversed in their local dialects of the Sicilian language.[151]

The post office authorities viewed the arrest of Lima as a victory in a crusade against the perpetrators of Black Hand and Sicilian Mafia extortion schemes in the Midwest. They believed that Ohio was a major connection point for Mafia operations in major cities throughout the United States. The Ohio operation extended from Canada to Mexico and from the East Coast to the Missouri River, inspectors said.[152]

The arrested man who was suspected to be Salvatore Rizzo proved to actually be Joe Rizzo and was released. Later that night, Salvatore Rizzo was found and arrested, along with Salvatore Battaglia. The inspectors searched their homes and confiscated bundles of books and letters. Battaglia had

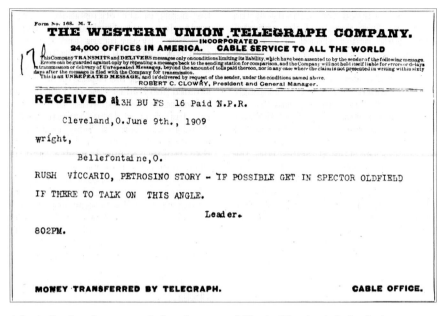

A facsimile of a telegram sent before the arrest of Charles Vicario. *Author's collection.*

money order receipts in his pockets, and they were turned over to Inspector Oldfield.[153] Concurrently, in Dennison, Tony Vicario was arrested and taken to the county jail. He remained there after his hearing before U.S. Commissioner Julius Whiting, unable to furnish his bond of $3,000. Tony Vicario also appeared to be well-spoken and highly educated.

On the same night of Salvatore Lima's apprehension, June 8, the Bellefontaine chief of police was also preparing a raid. Chief Ed Faulder and U.S. Post Office inspectors Hosford and Tate were preparing to capture Charles Vicario. He was living on Limestone Street in the home of the late Salvatore Cira. The detectives asserted that Vicario was a criminal of international reputation, calling him "The King of the Black Handers."[154] The chief allowed two reporters to accompany them on the raid. Chief Faulder told the reporters:

> *Before morning we expect to capture an Italian criminal long sought for by the Government. This man and his confederates are shrewd and desperate. An indiscreet word now and he might escape us. If you are willing to take the risk, you can accompany us on this raid. Now, I have been frank with you, and I place you all upon your honor to say nothing until the raid is over.*[155]

By 3:00 a.m. a storm had picked up, so they waited until early in the morning on June 9 to move in on the house. Chief Faulder assigned his heavily armed men to various vantage points around the property. He made his way to the door and began pounding with the handle of his revolver. Dogs started barking, and a light appeared through the window of the small cabin. Someone inside asked who was there, and Faulder responded, "Open the door! Quick!" The door opened, and Chief Edward Faulder was face to face with Sam DeMar, whom he had previously taken into custody after Joe DeMar was assassinated in 1907.

Police rushed the door and made their way inside. Vicario and the DeMar men were all downstairs and the Cira family was upstairs. Police surrounded Charles with their pistols drawn, and post office inspectors took him away. Maria Demma Cira and her children were upstairs unaware what was happening but were able to hear the chaotic commotion on the floor below. When police made their way up the steps, they found Maria and her children all heavily armed and ready to defend themselves.[156]

When searching Charles's room, police found double-barreled shotguns with the barrels sawed off, single-barrel shotguns, daggers, knives and pistols. Under his bed they found $646. Everything was confiscated. A trunk was taken from the room and sent to Inspector Oldfield in Columbus, where he later claimed that it was filled with Black Hand literature. Oldfield had also been trying to make the case that Charles Vicario was responsible for the murder of New York detective Joseph Petrosino.

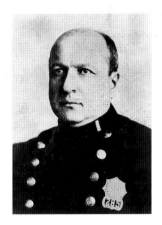

During the interrogation, otherwise known as a "sweating," Charles was told that confederates in Marion gave him up. He only cursed in discontent and would not admit that a Society of the Banana even existed. Inspectors tried relentlessly to trip him up. Oldfield showed a stack of letters and accused him of being the writer. They had ugly drawings of skulls and crossbones along with bleeding hearts that were pierced by daggers. He just shook his head and denied having seen the letters before. According to post office inspectors, Bellefontaine had sometimes been a distribution point for the members to divide extorted money.[157]

Lieutenant Joseph Petrosino, head of the NYPD's Italian Squad. *Library of Congress.*

Oldfield later said that Charles refused to admit to mailing letters that inspectors watched

him deposit. They eventually gave up and took him before Commissioner Johnson. He was then held in the Franklin County jail on a bond of $5,000.[158]

A few months prior to Vicario's capture, Lieutenant Joseph Petrosino was in Palermo, Sicily, working on a Black Hand investigation. He discovered that branches of the group had existed in Palermo and that many of the men involved were prominent members of the Italian nobility.[159]

On February 28, the New York detective checked in to Hotel de France under the name of De Simone. Then, on March 12, after eating at the Café Crete, Petrosino left in the company of two men. They walked alongside him to an area in Piazza Marina, where they shot him dead.[160] Oldfield believed that Vicario, along with Agostino Marfisi, was in Sicily at the time of the assassination.

When speaking of Charles Vicario, Oldfield told the press, "I think that we now have one of the murderers of Sergeant Petrosino, of New York, who was slain in Palermo, Italy."[161] Charlie DeMar declared that the allegation was absolutely false. Italians of Bellefontaine said that Vicario spent February and March in Dennison to mind the store of Agostino Marfisi, since he had previously been employed there along with his brother Tony.

Marfisi's mother was sick in Termini Imerese, and he claimed to have left America to visit her. Thirteen-year-old Perry Cira, daughter of the late Salvatore Cira, also spent some of that time in Dennison to help Mrs. Marfisi.[162] Detective Dimaio, of the Pinkerton Agency, did not think that Vicario was connected to the murder but believed that he had guilty knowledge of it. After further investigation, they confirmed that Vicario was in Dennison and Marfisi was the one in Sicily. Inspectors then worked on the theory that the money orders sent to Italy by Salvatore Lima were to aid in the protection of Petrosino's assassins. Inspector Oldfield was determined to link the Society of the Banana to the killing but was unsuccessful.

On the same morning that Charles Vicario was arrested, Inspector Oldfield had contacted the Dennison officials and commanded them to arrest Marfisi. During the arrest, he attempted to make an escape and was brought to a stop when an officer fired his revolver into the sky.[163] After Marfisi was placed in the county jail, a mob of Italians formed outside. Authorities believed that they would attempt to storm the building and rescue him, so guards were placed around the jail until he was transported to Canton, Ohio.

Inspector Holmes spoke to the press about the arrests and said:

The proof we have found against the Marion gang convinces us that they have worked their games successfully on many Italians, principally well-to-

do Sicilians. We have not found where they went after a single American. They meant business when they made demands for money. If their demands were ignored, they resorted to the bomb to either bring their victim to time or to avenge a persistent refusal to submit to blackmail.[164]

Petrosino and New York police officials had the theory that there was no extensive Black Hand organization, but the work of the Ohio police showed that the New York police were mistaken. The Black Hand was a national organization in the United States and directly allied with a similar organization in Sicily and was working in connection with the Mafia, allegedly sending $3,000 monthly to Sicily, Holmes said.[165]

On June 9, stories of the arrests were in newspapers in every part of the country. The *Los Angeles Evening Post-Record* read "Rounding Up 'Black Hand' Terrorists" and described the arrest of Charles Vicario in Bellefontaine.[166] "Black Hand Leaders Trapped in Ohio" was on the cover of the *New York Times*.[167]

Once word got out about the arrests, creditors of the DeMar Fruit Company began reaching out to the post office inspectors, claiming that the $646.00 found on Charles Vicario belonged to the firm and was not his. When asked about the money, Charlie DeMar said that the firm had repaid Vicario from an earlier loan. An action was filed by the John Amicon Brothers & Co. for $567.56. John Amicon claimed that the DeMar Fruit Company had obtained goods from his company by fraud. He said that they had the goods shipped to Bellefontaine, re-shipped everything to friends in Dennison and Marion and then claimed that they never received any shipment at all.[168] Federal courts permitted Charles Vicario to use the $646.00 found in his possession for legal counsel and attorney's fees rather than awarding the sum to the creditors.[169]

Mayor Niven had been trying to keep Black Hand activity out of Bellefontaine for several years. After assisting police in the capture of Charles Vicario, it was believed that he was targeted by Vicario's associates. Early in the morning on June 15, 1909, a rock shattered the front window of his home, at 220 South Main Street. Following the rock, a heavy glass whiskey bottle wrapped in tape and filled with kerosene was ignited and hurled into the house.

The mayor normally sat in the front parlor late at night reading. Fortunately, he was out of the city when the small firebomb was thrown, but his sister and two other residents were asleep in the upstairs of the house. The carpet, rocking chair and curtains in the parlor all went up in flames.

Mayor Niven's house at 220 South Main Street, Bellefontaine, Ohio. *Author's collection.*

Officer McCormick was nearby and saw the smoke, so he hurried to the house. He saw a foreign man running away from the mayor's residence and assumed that he was going to call for help, so he did not stop him.[170]

Night patrolman John Lamborn contacted Chief Blair at the central fire department, and they promptly extinguished the fire. Police then went on a search looking for the bomb thrower. Hundreds of citizens came out of their houses to help. The mayor returned home just about thirty minutes after the event and was happy to find his sister safe. He got right to work and ordered police to guard a set of tracks, believing that they belonged to the culprit. Bloodhounds were brought in to try to catch the scent, but it was impossible since so many people had already searched the area. Niven had been a strict mayor and said that he had many enemies because of his enforcement of option laws.[171] He said he doubted that it was the work of the Black Hand, but the police were sure of it.[172]

In early July, Charles Vicario was still being held on a $5,000 bond. Judge Dow of Bellefontaine went to Columbus to represent him. Postmaster Krumm was trying to get him to crack during interrogations, but Charles kept with his story and denied any guilt. He had been working tirelessly to support the family of the late Salvatore Cira and his widowed mother who still lived in Sicily. Charles said that he was in bad shape and so was his business. He just wanted to get out of the situation entirely and take care of his family.[173]

Charles and Tony had just lost their younger sister Rose during the 1908 earthquake in Messina. She was seventeen and away from home in seamstress school. In less than a year, the Vicarios' mother, Angela Emanuele, was coping with many losses. Her husband passed away in September 1908. Three months later, her daughter was killed during the earthquake and tsunami, and then six months after that both of her sons were arrested and put in jail charged with Black Hand crimes.[174]

By July 10, Charles was transferred to Toledo, with his bond still set at $5,000. One week later, Maria Demma Cira showed up in Toledo with her daughter Mary and $5,000 in cash to get Charles out of jail. They asked the young girl if Charles would run away if he was released, and she replied, "No, no, Charlie won't run away. He loves me."[175] She had been relentlessly trying to get Charles whatever he needed, and when she heard that he would be held to a grand jury, she and her mother immediately acquired $5,000 for his bond. Maria pledged all of her property, and friends helped make up the balance of the bond. The bond was signed by Maria, attorney Earnhart and a Mr. Lombardo.[176]

Tony and Charlie DeMar went to the federal building in Columbus, where Vicario had a trunk of his belongings. The DeMars retrieved the large trunk from the post office inspectors and carried it away on their backs. After he arrived in Bellefontaine, Charles went back to work and was peddling bananas from a cart downtown. He continued to declare his innocence. Secret service agents had him under constant surveillance. Every move he made, eyes were on him. If he left the country, his bond would have been forfeited. Charles had no intention of running; he wanted to work and provide for his wife-to-be, Mary Cira.[177]

While Vicario was in jail, the DeMar Fruit Company had filed for bankruptcy. Frank Comella tried to help keep the store going but with no success. Charlie DeMar was in Marion during the bankruptcy hearing, and it had to be postponed multiple times. When all of the firm's property was appraised, it had only two wagons and two horses, worth $198. The DeMars sold the last of their goods and closed the store permanently.[178] Charlie DeMar said that he would look for employment in Bellefontaine, but if he had to, he would move to another town and begin all over again.[179]

7

TROUBLE, TROUBLE, TROUBLE

Post office inspectors continued to make arrests around Ohio. In Cleveland, Antonio and Joe Nuzzo were captured. The brothers were accused of being members of the Marion gang, and their names were found on letters that were confiscated from the Lima residence. Inspector Hutches went to the Italian settlement and found the brothers driving into the fruit yard and stopped them. Joe denied his identity and was briefly let go until someone informed the inspectors of who he was. Their rooms were raided, and inspectors confiscated a vast number of letters. Revolvers were found, along with cartridges, which were also taken by the authorities. They were rushed through a crowd of Italians and put in a car and taken to the county jail. Joe admitted that he knew Salvatore Lima and that he traded with him in the handling of bananas, but both men denied any knowledge of the Black Hand.[180]

In Columbus, Inspector Oldfield and members of the police department went to the home of Saverio Ventola. They had high suspicions that he was entangled in Lima's operations. Oldfield had intercepted letters that were sent by Ventola to Salvatore Lima and Agostino Marfisi. One letter read, "Pray do not send the merchandise to Columbus. The weather is too hot here."[181] Authorities believed that the letter conveyed that Ventola suspected that he was being watched.

When questioning Ventola, they tried for more than an hour to get him to talk, but he declared his innocence and refused to say anything. He admitted only that he had served a term in the Ohio Penitentiary many years ago.

They searched his house and collected several letters.[182] He was eventually arrested and appeared before U.S. Commissioner A.H. Johnson at the federal building and pleaded not guilty. He furnished a cash bond of $5,000.[183]

Post office inspectors Oldfield and Pate needed to return to Salvatore Lima's residence, so they went to Marion and secured a warrant from the mayor's office. They went to the believed headquarters of the Society of the Banana, where Salvatore Lima had resided since he was out on bond. A small arsenal was discovered in the initial raid, and they wanted to confiscate the guns and ammunition. Weapons had been seized from the suspects at Dennison, Cleveland, Bellefontaine and Columbus, so the state's district attorney ordered the inspectors to secure the guns at Lima's place.

They took two twelve-gauge double-barreled shotguns. Both were loaded. Officers found around one hundred shells. They also found shot, powder, balls, cartridges and loading tools. Each shell contained a heavy charge of powder, buckshot and a dime-sized lead ball.

The loaded shells were marked with crosses, and the inspectors noticed that the same markings were on ammunition that was confiscated in other raids. Salvatore Lima had informed them that he kept the guns for the protection of his business to shoot in the air and frighten burglars away. One gun found upstairs was believed to be in the room where Antonio Lima was staying, and the other was in Salvatore's room.

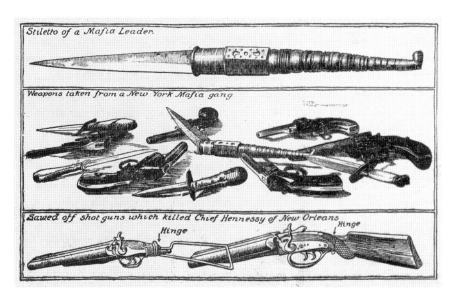

Examples of weapons that were confiscated from Italian criminal gangs. *Author's collection.*

Inspectors believed that Antonio was at the residence when they arrived. An older gentleman had answered the door and then called for Joe Ignoffo to translate the search warrant. Soon after, they believe he made his escape. A third gun was in the residence as well, and a woman escaped with it during the search. She was also said to have taken important papers and letters.[184]

That same evening at about ten o'clock, Marshals Owens and Wagner arrived in Marion from Toledo. With Chief Cornwell, Officer Bell and Officer Cusic, they went to the fruit store to arrest Sebastian Lima. When the officers arrived, they met Salvatore Lima, who was set to have a hearing in Toledo the following day. He informed them that Sebastian, his brother-in-law, was out of the house.

Officers searched the home and placed a guard there to ensure that nobody left to inform Sebastian that police were waiting for him. One of the women attempted to sneak out, but she was caught and brought back inside. The guard remained at the home for one hour until Sebastian returned. He was quickly arrested and taken to the city prison. The next morning, Deputies Owens and Wagner took both Sebastian and Salvatore to Toledo.[185]

On June 29, preliminary hearings for the Limas and Salvatore Rizzo took place. All were bound over to the federal grand jury. Bonds were set at $5,000 for Sebastian Lima and Salvatore Rizzo. Salvatore Lima's bond was set at $6,000. They all remained in the county jail, and Sebastian denounced the action in dramatic fashion.[186] Salvatore asked Tony Cangiamilla, again, to furnish the bond, but he had to refuse. He said he believed that Salvatore was innocent, but his wife would not allow him to sign the bond. Salvatore had even offered to give him a bill of sale for all his property and $1,000 that he had in the bank, but Cangiamilla could not help him.[187]

Another person of interest to police was a cousin of Salvatore Lima named Michael Angelo Lima of Portland, Oregon. He had a fruit stand with his three brothers at 104 First Street. Inspectors found letters written to Salvatore Lima that explained the financial condition of Portland's Italian community. One letter spoke of a prominent merchant named Napoleon Greco and said, "He is our blood enemy." Officers went to Michael Angelo's home but were unable to find him.[188]

During the hearings, Sergeant Churches was in Columbus in a meeting with the chief. Two Italians had been in the city from Pittsburgh and were heard saying, "We will lock Churches up and get him." It was believed that they were in the area making a collection from a local Italian. Columbus police were told to stay vigilant.[189]

In Cincinnati, Frank Spadara was not expecting that police would be coming for him. On June 17, under the direction of Inspector Oldfield, fourteen officers surrounded Spadara's saloon at 227 West Sixth Street and raided the building. When police opened the door, they found men drinking and playing cards without a worry in the world. Seventeen men, including Spadara, were taken to police headquarters. They were questioned for several hours, and all were released except for Frank. Their homes and stores were searched, and evidence was confiscated. Letters, papers and books were believed to contain valuable information.

At the same time, Inspectors Hosford and Hutches made their way to the fruit store of Vincent Arrigo at 19 Twelfth Street. Vincent was found alone in the store and quietly submitted to his arrest. He was taken to police headquarters and put in a private office to be questioned. Police did not search him before bringing him in and then discovered that in his coat pocket was a long-barreled revolver, which they confiscated immediately.[190]

After Frank Spadara and Vincent Arrigo were in custody, police went to the home of Vincent's father, Salvatore. There were no traces of the former Society of the Banana boss. His daughter-in-law said she had not seen him in days, but a granddaughter said he had been sick and left the day prior. The officers searched the house and took a pile of letters, money order receipts and account books. They found about half a dozen knifes and stilettos. Vincent claimed that his father's knives were used for cutting bananas. At the jail, Vincent and Frank both stayed silent when anything was mentioned about Black Hand activities. Both were released on a $5,000 bond.[191]

After many arrests in Ohio, efforts were shifted toward Pennsylvania. On June 19, Pittsburgh detectives, with post office inspectors and the Pinkerton Detective Agency, went to arrest Orazio Runfola at his cigar shop on Penn Avenue. The arrest was accepted calmly, and he was taken to Central Station, handcuffed to Detectives Dachroth and McDonough, accompanied by Dimaio. Runfola was sweated for hours and was said to have made damaging admissions. It was believed that he was closely associated with Salvatore Lima.[192]

The next morning, June 20, Inspectors Oldfield, Hostford, Hutches and Pate went to Meadville, Pennsylvania, to carry out a raid on the Galbo store. As soon as they arrived, Pippino Galbo opened the door, and he was quickly placed under arrest. The inspectors were only in Meadville for about fifteen minutes before they had him in custody. Members of the community were completely shocked to see Galbo being arrested, since he bore an excellent reputation there.

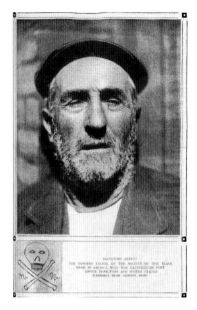

Salvatore Arrigo after his capture.
Author's collection.

His house was searched, and letters were found that were addressed to Salvatore Lima. Pippino said an affectionate goodbye to his wife and four children and was taken away. He had breakfast with the officers at a local restaurant and left shortly after on a train en route to Cleveland.[193] At his preliminary hearing, he claimed that all of his communications with Lima were business related, but there was enough evidence to hold him to the grand jury. His bail was set at $5,000 and furnished by his wealthy brother of Buffalo, New York.[194]

Inspector Oldfield was still on the hunt for Salvatore Arrigo. He knew that Arrigo had an important role in the Society of the Banana, and it was crucial to capture him. Oldfield, along with Pate and Sanderson, received information that there had been an old Italian man seen near Batavia, Ohio, and that it was possibly Arrigo. Inspectors were told that Pasquale Scantallato had a cabin in the woods by Craver Station. The locals believed that he was hiding Arrigo there. When the description was given, Oldfield was sure it was him.

On July 23, the inspectors secured a vehicle and made their way to Batavia. After getting a little lost, a farmer pointed out the narrow dirt path that would take them to the cabin. As they got close, they noticed a shotgun resting on the corner of the porch. They seized the weapon then opened the cabin door. The inspectors saw two men sitting in an open room. They walked inside and the men were taken completely by surprise. One of them had a long white beard and was clearly Salvatore Arrigo. There were two shotguns in the room, but neither man made a move. Arrigo was placed under arrest without any fight. When questioned, he only replied, "Me no understand. Bad English." Almost all of the men arrested had the same reply: "Me cannot speak English."[195]

His host Pasquale said that Arrigo had been there for a few weeks. He knew very little about him but was told by Arrigo that he was the boss of the banana dealers in Cincinnati.[196] Oldfield said that Arrigo was caught because he refused to eat the vegetables and fruits from the area. "Salvatore

Arrigo was betrayed into our hands by his preference for macaroni, spaghetti, and ravioli. Arrigo could not subsist on vegetables and fruits indigenous to Clermont County, where he went to hide. He had to have his macaroni and spaghetti every day and somebody had to take it to him. We got trace of the 'somebody,' whom we traced, and soon had Arrigo located."[197] He pleaded not guilty at his arraignment and was placed in jail when he did not have $5,000 for bond.

Salvatore Arrigo was born on July 14, 1844, in Termini Imerese, where he was dropped off at "the wheel," where unwanted babies were taken.[198] He took the name of his adopted family: Arrigo. Around 1880, when he was in his mid-thirties, he came to America. His wife, Anna Gentile, came the following year, and they settled in Washington, D.C.[199]

He operated a small fruit stand on Pennsylvania Avenue but did not have much success. He met a barber by the name of Phillips who had a vacant farm in Forestville, Prince George's County, Maryland. Salvatore asked the barber if he would allow him to work the farm on shares. The land was not being used, so Phillips told him that he could farm it. Salvatore and his family cultivated the field and began bringing wagonloads of their produce to Center Market in D.C.

The Arrigo family looked like nomads in the busy city. They had an old run-down farm wagon that was pulled by an old, worn-out mule. They wore dirty clothes and had handkerchiefs tied around their necks. They would show up at the market with not only vegetables but also pockets full of counterfeit coins. Salvatore and Anna would go into stores and make small purchases and pay with the fake money, getting legitimate money as change in return. Salvatore was often seen making purchases in the cigar stores.

In 1885, Chief Brooks of the Treasury Secret Service and his officers arrested Arrigo. Center Market was being flooded with counterfeit silver coins, most of which were being brought in on Salvatore's old farm wagon. Four others were also arrested: Salvatore's wife, Anna; his son, Vincent; Matteo Pistello; and his wife, Josephine Arrigo. Officers said they looked like Italians of low class and were incomparable to Sicilian brigands. Vincent had a stand in the market and was well supplied with the fake silver.[200]

Salvatore was convicted and spent two years at the federal penitentiary in Auburn, New York. After his release, he returned to Sicily. He eventually made his way back to the United States, where he opened a new fruit store in Cincinnati, Ohio. It was believed that Black Hand leaders assigned him to operate in the Ohio territory.[201]

SALVATORE LIMA.　　SEBASTIANO LIMA.　　GUISEPPE IGNOFFA.

FRANCISCO SPADARA.　　ORAZIO RUNFOLA.　　PEPPINO GALBO.

SALVATORE DEMMA.　　ANTONIO VICARIO.　　COLOGERO VICARIO.

Postal inspectors photographed the accused violators of postal laws. *Smithsonian Libraries.*

Months went by without any more Society of the Banana arrests; then, on December 1, 1909, federal officers returned to Marion. Deputy U.S. Marshal Owens, assisted by Inspectors Oldfield and Pate, along with Chief of Police Levi Cornwell arrested Italian cobbler Joe Ignoffo at his shop on West Center Street. Police made their way to his home on Leader Street, where they conducted their search. They found a complete arsenal at the home, discovering shotguns, a large revolver, a rifle and a large quantity of ammunition. Without hesitation, Ignoffo claimed that all of the guns were old family relics and had never even been loaded. Many letters were found, all written in Italian, some of which were unopened. They were sent to Toledo so a translator could review the contents.

Joe was seemingly upset with the entire situation. He said, "I am not a Black Hander, I work hard for my living; look at me, don't I look like an honest man?"[202] The Ignoffo family was depending solely on his income, and the arrest would leave them in much grief. Mrs. Ignoffo said that Joe would not be able to furnish the bond and that during his time away, she was not going to be able to provide for her family. When reporters interviewed him, he broke down. He said that his wife was dangerously ill, and he needed to be home.

"I never done nothing, and I don't see why they take me away from my family," Joe cried. He claimed to have no idea why he was being arrested, saying that he had been in the country for over fifteen years and had always been an honest citizen.

> *I knew Sam and Sebastian Lima in Italy and I married Sam Lima's sister. When Sam was arrested and taken to Toledo, his family came out to live with me. I provide for them and now they will have nobody to look after them. You tell the mayor that I never done nothing and that I want to go back to my family. I never wrote a Black Hand letter and know nothing about those people in the society. All the letters that I have written or received have been in connection with my business.*[203]

Three days later, marshals returned to Columbus. They were there to find Saverio Ventola. He was arrested by Marshal Shilling. Ventola was selling bananas in the wholesale district of Columbus when he was approached.

> *"Ventola I want you to come along with me," the marshal said.*
> *"What's the matter?"*
> *"You're under arrest. The post office inspectors want you."*
> *"Trouble, trouble, trouble." said Ventola while waving his hands. "Can't I sell out this cart? Can't you wait for me?"*
> *"I am sorry, but I have to take you right away."*[204]

Ventola left the bananas in the care of his friend and was taken to the post office. He was then taken to the county jail, where he would remain in default of a $10,000 bond, demanded by U.S. Commissioner A. H. Johnson. He was already out on a $5,000 bond. When he heard that the bond would then be $10,000, he threw his hands up and said, "What's the use?" He understood that the government wanted to keep him in jail and just asked that he be able to let his wife know that he would be gone for a few days.[205]

The same day, Sam DeMar was also arrested at his home in Columbus. Post office inspectors Oldfield, Hutches and Pate took him to the federal building, where he was sweated.[206] DeMar had been trying to remain unnoticed after witnessing the arrest of Charles Vicario, but inspectors had their eyes on him for many months. During the raid, they found a large number of letters, along with guns and ammunition. He refused to admit anything and was said to be as silent as a clam when going through a grueling fire of questions.

DeMar had many ties to the Society of the Banana and the Black Hand histories of Bellefontaine. He had been a suspect in the murder of his half brother Joe in 1907; his brother-in-law Salvatore Cira, a notorious Black Hand leader, was killed in 1908; and his niece Mary Cira was engaged to Charles Vicario, an arrested Black Hand suspect. Sam could not furnish the $5,000 bond that was set and was taken to the county jail by U.S. marshals.[207]

THE UNITED STATES OF AMERICA V. SALVATORE LIMA

On December 11, 1909, the federal grand jury at Toledo, Ohio, returned open indictments against the sixteen men who were said to be members of the Society of the Banana.[208] The trial was set to commence on January 10, 1910. The prosecution was going to try to bring down the first widespread organized crime ring in the United States. Postmaster Krumm, along with the other inspectors, had seized so much documentation that his office was packed full of papers, stacked from floor to ceiling. District attorney William Day believed that the vast amount of evidence would without doubt prove that the Society of the Banana was organized for the sole purpose of extorting money from wealthy Italians.[209]

Prosecutors planned to present twenty-four Black Hand letters that contained threats and were covered with skulls and crossbones. Drawings also included daggers stabbed into bleeding hearts.[210] John Amicon was set to be the star attestant, and ninety-four witnesses were called, most of whom were reluctant to testify. Several witnesses even branded the mark of the society, which was a cross carved with a knife, over one side of their faces.[211]

The defense attorneys were confident that their clients were innocent. Attorney Fred E. Guthery noted that there was a high level of difficulty for foreigners to get fair trials in the federal courts:

> *It is a hard thing for a foreigner to be brought up against the powerful machinery of the government inspectors, especially if he has little funds.*

The federal courthouse in Toledo, Ohio. *Library of Congress.*

Everything in the United States courts must be paid for and as many of the Italians have no money, the attorneys have had to pay the court fees out of their own pockets. For instance, to get a copy of the indictment it was necessary to pay into the clerk of the court, $53. Other charges are equally as high. The prosecution may summon as many witnesses as it cares to, but the prisoner has to pay his own witnesses, their mileage, and must also put up the costs in advance to have those witnesses served with subpoenas. These men are unable to do this, and their hands are practically tied. [212]

January 10, 1910, was the first day of *The United States of America v. Salvatore Lima, et al.* The appointed judge was the honorable Robert W. Tayler. The prosecutor was District Attorney William L. Day, and he was assisted by Thomas H. Gary. The criminal lawyers were led by Jay P. Dawley of Cleveland. The indictment covered 185 typewritten pages and included 24 original letters that prospective victims handed over to police.

J.J. Sullivan, who was a former U.S. district attorney, explained that simply writing a threatening letter that was never mailed did not constitute an offense. Judge Tayler responded by quashing fourteen of the fifteen counts against the accused men on grounds that they did not state a specific

offense. The first count in the indictment was sustained and was sufficient to hold the defendants in jail while the judge ordered a special grand jury to consider new indictments.[213] The fourteen counts were quashed because the prosecutors only stated that they had evidence showing that the said member of the Society of the Banana had written threatening letters but did not state that the letters had been mailed.[214]

Prosecutors had one week to present a new indictment and include that the threatening letters were sent in the mail, or all of the defendants would only be facing one count instead of the original fifteen. The prosecution team spent the week leading up to the next court date preparing the new indictments and securing a few more witnesses.

On January 18, the special grand jury arrived, consisting of:

William Axe, St. Marys
Henry C. Baltzell, Tiffin
John A Daour, Piqua
Charles Gahn, Kingsway
John P. Holland, Metamora
Edward A Kirk, Toledo

Marion Kirk, Montpelier
Thomas J. Lee, Wharton
J.W. Riley, Celina
Elias Sumner, Toledo
Martin Trout, Toledo
John Bird, Bluffton

DISTRICT COURT OF THE UNITED STATES
for the Western Division of the Northern
District of Ohio.

THE UNITED STATES

vs.

SALVATORE LIMA, ANTONIO LIMA, SEBASTIANO LIMA, GIUSEPPE IGNOFFO, SAVERIO VENTOLA, SALVATORE RIZZO, SALVATORE DEMMA, alias SALVATORE DEMAR, GIUSEPPE NUZZO, AGOSTINO MARFISI, ANTONIO VICARIO, COLOGERO VICARIO, ORAZIO RUNFOLA, PIPPINO GALBO, SALVATORE ARRIGO, FRANCESCO SPADARA and VINCENZO ARRIGO.

INDICTMENT
For Conspiracies to Commit Offenses Against the United States. (Section 5440.)

Antonio Lima and Joe Nuzzo escaped capture and avoided the Black Hand federal trial. *National Archives.*

Judge Tayler decided that the new indictments were sufficient and explained: "It is not necessary to show that the accused person himself mailed the letters in question, but that all that is necessary is to show that such letters passed from the accused and afterward, by any means, found their way into the United States mails."[215] All of the defendants pleaded not guilty to each count.

Assistant Thomas Gary made the preliminary address. After introducing the new indictments, he outlined the case in which the government expected to prove the defendants' guilt. They would exhibit a blotter that was seized from the house of Joe Ignoffo, believed to show the name of John Amicon and portions of a letter written to him. Gary attested to the jury that the defendants went to Marion in March 1909 to attend a conference at the Lima fruit store.[216]

Gary also said that there was a book found in the Lima house containing the names of the defendants and that the state possessed letters showing that Salvatore Lima had notified the men that a division of funds would be declared. It was also to be shown that large sums of money orders were bought in a single day in Marion and sent to Italy. Gary said that it would be proved that threatening letters had been written by Salvatore Lima, Pippino Galbo and Charles Vicario and that some of the letters were sent through the mails by other defendants.

The opening statement for the defense was made by Attorney John H. O'Leary. He was representing the men from Marion: Salvatore Lima, Sebastian Lima, Joe Ignoffo and Salvatore Rizzo. He denied that they had taken part in any conspiracies and stated that it would be shown that they were engaged in legitimate business ventures. He said:

> I am confident that Sam Lima was no more a leader of the band nor a member of it; that he had not the slightest connection with it. And the same statement applies to his brother, Ignoffo, and Rizzo. The two letters, one of which the inspectors claim was written by Sam Lima and the other by Joe Ignoffo, to John Amicon, were both written by the same hand and neither Ignoffo nor Lima wrote them. These Italians were hardworking, honest men and better citizens by far than many native-born Americans. They worked twelve to eighteen hours a day to make their business successful, support their families and secure a fair living. The inspectors broke up their business and in Sam Lima's case they took away his account book in which he had bills against local Italians

A subpoena issued for postal inspectors to appear at the trial. *National Archives.*

> *amounting to hundreds of dollars and even refused him a copy of the books that he might collect the money that was due him. Now with the husband and father in jail, the family is in want and may have to become county charges.*[217]

Charles F. Williams, of Cincinnati, represented Salvatore Arrigo, Vincent Arrigo and Frank Spadara. He asserted that his clients were not in any way acquainted with the other defendants.

Jay P. Dawley, of Cleveland, represented Agostino Marfisi. He called Agostino before the jury and asked them to remember his face because it would be shown that he had not taken part in any Black Hand activities. He explained that Agostino was a highly profitable businessman and had no need to resort to extortion to make a living.

Duncan Dow, of Bellefontaine, represented Charles and Tony Vicario; Augustine Connolly, of Toledo, represented Saverio Ventola; John J. Sullivan, of Cleveland, represented Pippino Galbo; James A. Allen, of

Columbus, represented Sam DeMar; and John H. O'Leary represented Orazio Runfola.

The entire first morning was spent with Inspector Oldfield on the stand, explaining the case he had built against the defendants. He identified the weapons and documents that were seized and detailed the steps of his investigation.

Oldfield said that in August 1908, he became aware that there were Black Hand letters circulating in his district. During his investigation, he learned that John Amicon had received threatening letters and the origin was traced to Marion, Ohio, where he later witnessed a conference at the fruit store of Salvatore Lima on March 9, 1909. Oldfield believed that Lima was the head of an association and the headquarters was at his store.

Inspector Oldfield testified that he had often seen Salvatore Lima, Saverio Ventola and Sam DeMar in the vicinity of John Amicon's fruit yard and that they were often observed there after Amicon received threatening letters. He explained how a letter was traced from when it was first mailed from Columbus to Agostino Marfisi in Dennison, where it was remailed to Cleveland and received by Martin Rini. Tony Vicario, Marfisi's clerk, picked up the letter from the Dennison post office and forwarded it to Rini. Oldfield detailed how he marked the stamps that had been sold to Vicario and Marfisi so that their mail could be followed.[218]

Prosecutors then started to bring witnesses to the stand to give their testimony of personal experiences with the Black Hand. Fred Cianciolo, a fruit dealer of Cincinnati, testified that he received a letter in 1908 demanding that he pay $3,000 or his three children would be kidnapped. He was instructed to go to a specific place, and when he arrived, he claimed to have met Salvatore Arrigo. He explained to Arrigo that he could produce only half of the money. Arrigo agreed to the new amount, and the following day $1,500 was handed over at Frank Spadara's saloon. Cianciolo then identified a letter that he received a few days after the payment was made. This letter was postmarked Marion, Ohio, and signed "La Mano Nera." This was said to be a receipt for the payment.[219]

Baptiste Mercurio, a fruit dealer of Columbus, told the court that he paid $800 to the Black Hand in March 1908. He received four letters postmarked Valley City, North Dakota, all demanding $5,000. Next, Francesco Canat and his wife, of Columbus, testified to receiving three Black Hand letters. The first demanded $1,000 and the second $600. The last letter said that if $400 was not paid, the Canats' home would be dynamited. Fearing that the threats were serious, they paid the money.

Agostino and Ignazio Iannarino both took the stand and related their experiences of receiving Black Hand threats and then briefly moving back to Sicily after Agostino's home was dynamited in Columbus. While in Sicily, Agostino received more threatening letters that appeared to be written in the same handwriting as the communications he had previously received in Columbus.[220]

Maria Rizzo, of Cincinnati, testified that her husband, Salvatore Rizzo, received several Black Hand letters demanding thousands of dollars. Salvatore was a fruit dealer who lived at 437 West Sixth Street. He was told to make a trip to Pittsburgh and bring $2,000 or he would pay with his life. Rizzo turned the letters over to the police. Just days later, he became verry ill, and after three days of suffering, he passed away. The doctor declared his cause of death as a "swelling of the submaxillary glands." The doctor was unable to give the cause of the swelling, but the health office was positive that the swelling could not have occurred without cause to a man of Rizzo's age.

A few days before his death, Salvatore Rizzo had been standing at the fruit market when a man came along and gave him what he said was a new variety of banana. After eating one, he was in so much pain that he could barely walk. He became dizzy, and his balance was so bad that someone had to carry him home. He stayed in his bed for days and pleaded for the pain to stop. Salvatore sat up in the bed, then began seizing and fell over dead. His friends believed that the banana contained a slow poison known to be used by the Black Hand Society.[221]

The jury continued to hear the testimonies of witnesses to include those of George Pash of Coshocton, Ignazio Fazone of Columbus, Ignazio Gentile of Dayton, Giovanni Anarino and Baptiste Fazio of Cincinnati and Martin Rini of Cleveland. Few of the witnesses who had received threatening Black Hand letters were able to read or write and had to identify the letters by the drawings on them.

Tom Wright of Dennison, a ticket agent of the Pennsylvania Railroad, testified that he recalled selling a ticket to Charles Vicario for a train en route to Pittsburgh. Others took the stand and relayed their accounts of arrests in the various cities: Edward Faulder, Bellefontaine chief of police; Willis Polley, Bellefontaine patrolman; former police chief Cornwell of Marion; Marshal J.C. Polan of Dennison; and Police Sergeant Peter Albanese of Columbus. Post Office Inspector Hosford spent several hours identifying letters and detailing conversations that he had with the defendants.

Inspector Hutches of Cincinnati testified that he disarmed Salvatore Lima while he was trying to escape through a window before being

Court cards for Agostino Iannarino and John Amicon, January 10, 1909. *National Archives.*

arrested. Hutches also talked about the society meeting in Marion. He could not positively say that there was a meeting that took place in the Lima residence, but he did see Antonio Lima, Salvatore Rizzo, Joe Ignoffo, Vincent Arrigo, Frank Spadara, Sam DeMar and Orazio Runfola in Marion that evening.[222]

A subpoena issued for witnesses to appear at the Toledo courthouse on January 24, 1910. *National Archives.*

For many hours, witnesses continued to take the stand and share their testimonies. Vincenzo Purpura, a fruit dealer of Dayton, identified threatening letters that he had received from the Black Hand. His son George explained that he gave Vincent Arrigo fifty dollars but said it was only a gift. Like the Purpuras, many seemed reluctant to speak about the situation.

O.G. Melaragno, managing editor of *L'italiano*, a weekly paper published in Cleveland, detailed a letter that he received on November 22, 1909. The sender demanded that he publish the contents of the letter, which said:

> *I swear upon the sacred cross that all the people incarcerated in Toledo are innocent. I am the one that is writing the death letters to Amicon that I will kill him. My organization is so strong that we consider those men nothing in the Toledo jail. Please give this letter to the judge when you have printed it.*[223]

Melaragno published the letter, along with his own reply:

> *If your conscience bothers you so, why don't you go before the magistrate and save those people in Toledo whom you think are innocent?*[224]

The witness testimonies lasted from Monday through Friday afternoon, and Judge Tayler announced that court would adjourn for the weekend. Attorney Day said that the prosecution would finish its case Monday night, and defense attorney J.J. Sullivan expected that the trial would go until the end of the week.

9

WE THE JURY

The defense attorneys did not believe that there was enough evidence being brought forward and motioned to dismiss the case, but Judge Tayler overruled. The judge then admitted as evidence all of the letters written to victims and the extensive correspondence between the accused, which appeared to show the existence of a well-regulated organization. One of the more important documents that was admitted was a book that was found in Salvatore Lima's safe; it had a list of the members of the Society of the Banana along with their rules and regulations.[225]

More witnesses began to take the stand. The details of John and Charles Amicon's experiences came first. John Amicon was an important witness and had become well known nationwide as the first man to go against the Black Hand. John would testify along with Charles and Lenora Amicon; their niece Francesca; and C.O. McLees, a private guard at the Amicon residence. R.H. Holland, bookkeeper for the Amicon brothers, testified to seeing the dynamite at their home. He identified Orazio Runfola and Saverio Ventola, saying that he had seen them around the store and fruit yards.[226]

Francesca Di Tara, niece of John Amicon, testified that on the morning of January 15, 1909, she found dynamite wrapped in a Pittsburgh newspaper outside of the Amicon home on the front doorstep.[227] Mrs. Amicon recalled the same account and added that they had received a threatening letter and a newspaper clipping containing a story of a Black Hand attack. Charles took the stand and explained that he had previously

had business dealings with Saverio Ventola and Sam DeMar. He recalled seeing Antonio Lima, Vincent Arrigo and Charles Vicario hanging around his store.

The Amicons' private guard, C.O. McLees, recounted that on the night of January 29, 1909, he was standing in the shadow of the grape arbor at the Amicon home when he heard someone open the back gate. While staying still, he watched a man sneak his way toward the house. When the man's face became illuminated from a streetlight, McLees immediately recognized him as someone who had been seen around the Amicon store. He chased him away from the house down an alley and fired two shots from his revolver in the man's direction. McLees identified the man as Salvatore Rizzo. He also identified Orazio Runfola as someone he had often seen in the saloon across the street.[228]

When John Amicon took the witness stand, he identified Salvatore Lima, Sebastian Lima, Saverio Ventola, Joe Ignoffo and Salvatore Arrigo as men he had seen around his store. He then told of the conversation he had with Ventola. He said that Ventola approached him about the authorship of Black Hand letters, and Amicon recalled telling him, "If I thought you wrote them, I wouldn't have to go to court. I would shoot you right here on the sidewalk." He added, "They tried all different kinds of schemes to catch me, but they didn't do it."[229]

More government witnesses came next. Columbus postmaster Harry W. Krumm gave testimony explaining his methods for tracing letters, and he identified a letter sent by Sam DeMar to Agostino Marfisi by an initial that was marked on a special stamp. The postmaster was cross-examined but unshaken. Oldfield was also unfazed by his two-hour cross-examination. D.C. Mahon, postmaster at Dennison, explained how he gave marked stamps to the Vicarios and Marfisi. During cross-examination, he said that for some months in 1909 the Vicario brothers were conducting Marfisi's business while he was gone in Italy.[230]

R.J. Pennell, a mail carrier of Marion, testified that he often handled the mail of Salvatore Lima and that he was familiar with his handwriting. He identified several letters written to John Amicon as being in the handwriting of Lima. The letters were postmarked Dennison and Pittsburgh. He testified that from the middle of March until early June 1909, Lima was frequently sending letters to Agostino Marfisi at Dennison and Orazio Runfola at Pittsburgh.[231]

After the witness testimony, the prosecutors brought out evidence to display to the jury in an effort to fasten the authorship of the Black Hand

The United States of America,
NORTHERN DISTRICT OF OHIO, SS.

THE PRESIDENT OF THE UNITED STATES OF AMERICA.

To Maria Cira, Bellefontaine, Ohio,
 Mary Cira, " "
 Frank Sommelia, " "
 Earl M. Smith, " "
 R. W. Chalfant, " "

You are hereby commanded, that, laying aside all and singular your business and excuses, you be and appear in the District Court of the United States, for the Northern District of Ohio, at the Court Rooms, in the City of Toledo, in said District, on the 26th *day of* January *A.D.1910, at* 9 *o'clock A.M., of said day, then and there to testify and give evidence on behalf of the* defendants *in a suit pending in said Court, wherein* THE UNITED STATES *is plaintiff and* Cologero Vicarrio and Antonio Vicario et al. *are* Defendants *Hereof fail not, under penalty of what may befall you thereon.*

Witness, the honorable MARTIN WELKER *Judge of the said District Court, of the United States, this* 21st *day of* January *A.D. 1910 and in the* 134th *year of the Independence of the United States of America.*

H. F. Carleton, Clerk.

By _____ Deputy Clerk.

Maria (Demma) Cira of Bellefontaine went to Toledo to testify to the good character of the Vicario brothers. *National Archives.*

letters to the defendants. The evidence included letters received by Italians from different cities throughout Ohio.

William George Pengelly, of Columbus, was a handwriting expert and proclaimed that it was his professional opinion that many of the letters displayed to the jury were written by the same hand. He believed that they were written by Salvatore Lima, Pippino Galbo, Charles Vicario and Joe Ignoffo. His opinion was based on comparing the Black Hand letters with business letters that had been signed by the men. The defense brought in its own expert, Dr. H.D. Gould, a Cleveland professor. He was a textbook author and documentary graphologist with a nationwide reputation as an expert in the field of handwriting analysis. He believed that the letters were not written by any of the defendants. He reviewed the letters under a microscope and gave a convincing explanation of the exactness of his methods.[232]

Character witnesses began taking the stand on behalf of the defendants. Citizens came from Bellefontaine, Dennison, Marion, Columbus and the hometowns of the accused Black Handers. Dr. Chalfant of Bellefontaine testified to the good character of the Vicario brothers and Sam DeMar. Mary Cira took the witness stand and was asked what her relationship was with Charles Vicario. She replied, "I am Charlie's sweetheart." Vicario had spent some time in Dennison, and she was asked, "Didn't you get a letter from him every week or so?" She replied, "Why I got a letter from him every day."[233] Mary was the daughter of the late Salvatore Cira and niece of Sam DeMar. During the first week of the trial, a Springfield man claimed that after receiving a Black Hand letter, he paid fifty dollars to Salvatore Cira.[234]

Sam DeMar took the stand on his own behalf. He told the court that it was true that he made frequent visits to Columbus, but it was only because his sweetheart Katie Lombardo lived there. Her father, Joseph Lombardo, was a proprietor, and Sam helped the Lombardo and Pusateri families with their produce businesses. He also admitted to being in Marion on March 9, 1909, to settle a dispute between himself and Vincent Arrigo. He said he only stayed for a few hours. When asked about trips to Pittsburgh, he explained that he made trips there when he needed to see his Italian doctor.[235]

The Limas, Salvatore Rizzo and Joe Ignoffo had many character witnesses there from Marion. The witnesses were bankers, blacksmiths, grocers, merchants, druggists and physicians. All of them testified to the good character of the Marion men. Joe Battaglia testified to the good character of his friend Salvatore Rizzo, and Roy Zachman said that Joe Ignoffo's handwriting did not match any of the letters. C.D. Schaffner, a bank cashier, examined the letters received by John Amicon and gave his opinion that they were not written by Lima, though during cross-examination he said some of the letters did look similar to Salvatore Lima's handwriting.

Orazio Runfola and Pippino Galbo took the stand on their own behalf. Runfola of Pittsburgh went into long explanation to interpret the phrases used in the letters that passed between him and Salvatore Lima. Runfola said that there was a Pittsburgh Society of the Banana and admitted to being a member. When asked why he signed certain letters as "President," Runfola answered, "I did it because I was ambitious to appear big before my people in the old country," but claimed he was not actually a president of any organization. He was asked the meanings of phrases used in the letters between him and Lima such as "When the machine is adjusted," and he said, "That meant 'when times are better,' we used such expressions among ourselves." When asked what Lima meant when he wrote "doing good

Salvatore Rizzo's lawyer provided a writing sample to compare to the Black Hand letters. *National Archives.*

work and making satisfactory collections," Runfola explained that he was a member of a religious beneficial society and had been collecting money among friends to replenish its funds.[236]

Pippino Galbo of Meadville, Pennsylvania, firmly declared that the unfinished Black Hand letter found in his house was part of a letter that he had received from New York. He said he hid the letter in his desk because he was afraid that if he took it to the police then the Black Hand would kill him. Galbo was also asked about the phrases used in the letters between him and Salvatore Lima. He said that "steaming the bananas" referred to an ocean steamer with a cargo of bananas.[237]

When it came to the roster found in Salvatore Lima's possession titled "The Society of the Banana, November 8, 1908," Maria Lima, Salvatore's stepdaughter, testified that the book came from a trunk belonging to Francesco Lima, who was a former boarder at the Lima house.[238] The government offered testimony that the handwriting of the roster was that of defendant Joe Ignoffo. Along with the roster, a set of bylaws were found in the book:

Bylaws and Regulations

Art. 1. The person who tries to reveal the secrets of this society will be punished with death.

Art. 2. A member who offends one of his companions, staining his honor, will be punished according to Article 1.

Art. 3. The member who tries to do harm to another branch of the society or to the family of other companions, if this harm shall have been grave, will be undressed and marked on his body with the marks of infamy, and called with words of contempt "Swindler," and if the offense is more grave, he will be stabbed.

Art. 4. The person who is a coward and does not sustain the punishment assigned to him by the society, will be punished in accordance with Article 3.

Art. 5. The member who profits by the opportunity of a plan of another member, is punished as prescribed in Article 3. If the misdemeanor is less grave, he must make restitution within twenty-four hours of that which he caused to be lost, and he will be cut off from his share of the profits for two months.

Art. 6. The member who offends another companion with offensive titles, if the offense is considered grave, will not only lose his right of membership, but will also be stabbed. If the offense is less grave, he will be cut off from his share of the profits for three months and at the same time must do his duty.

Art 7. The member who has received the insult and resents it himself without notifying the society, is punished according to Article 3.

Art. 8. The member who abandons one of his companions in the time of need will be held to be a traitor and then punished according to Article 3.

Art 9. The person appointed to inspect must always go around and maintain good order, as is prescribed, passing all the news around. Failing in this for the first time, he will be cut off from his share of the profits for three months, the second time he will be stabbed.

Art. 10. A reunion of the society cannot be called for a violating member if he is not known.

Art. 11. The person who goes away must pass the news and tell the "local" in the place where he goes and how long he will be there, and if he carries a message, he must leave his pledge. Failing to do this he will be punished according to Article 6.

Art. 12. The person who shall have been called to use the knife and does not, through fear, will be punished according to Article 3.

Art. 13. The person who deals sparingly, does not do his duty, will be punished according to Article 3 at a convenient place by the society with a brand on his face.

Art. 14. The person who refuses the call of command will, for the first time, be deprived of his share for three months: for the second time, from one to three cuts with the knife: for the third time, from two to five cuts, as the society thinks is best, and to follow his work as prescribed: if it be grave, he will be punished according to Article 3, without having any benefits from the society.

Art. 15. The person who is sent somewhere by the society will be paid by the day and for the journey.

Art. 16. There can be no excuse of failures or penalties in conformity with the articles. However, there may be extenuating circumstances in case of drunkenness.[239]

After all of the testimony, the *Toledo Blade* said:

That there was an organization known as the Society of the Banana, with rules and regulations prescribing horrible penalties for disobedience of its mandates, was shown in the federal court during this morning's session of the Black Hand trial. A book found in Salvatore Lima's safe at the time of his arrest, was introduced in evidence, and District Attorney William L. Day read there from what purported to be "The Laws and Regulations of the Society of the Banana." Punishments provided for disobedience or failure to carry out orders include being branded, stabbed, or killed outright if the society so judges.

All of the documentary evidence was read to the jury and the defense fought to have the evidence kept out, but Judge Tayler ruled that it may be admitted. This included Black Hand letters to prospective victims, receipts for money extorted, letters, telegrams, and other communications between the men. Many of the letters that passed between the defendants contained ambiguous references to objects, packages, shipments, medicine, and other phrases.[240]

The judge overruled all of the motions by the defense to dismiss the charges and said that evidence seemed to show that an organization existed between the defendants and that it might have been the Society of the Banana. The judge said that he believed there was an unlawful conspiracy and the mails were the backbone of the system for carrying out the schemes. After giving his opinion, he declared that who should be held accountable was then up for the jury to decide.[241]

The prosecution announced that it would not ask for a conviction on one count alleging that Tony Vicario had written a threatening letter to Joseph Gatto. The letter was written in print, and there was no basis to compare it to his normal handwriting.[242]

On January 29, 1910, after two weeks of listening to witnesses sharing their personal experiences with the Black Hand Society and reviewing an astounding amount of evidence, the jury quickly returned its verdict:

We, the Jury in this case, being duly impaneled and sworn, do find the Defendants guilty as charged in the indictment.

UNITED STATES OF AMERICA, DECEMBER Term, A. D. 1909.
Northern District of Ohio, WESTERN Division, ss.

THE UNITED STATES

vs. Plaintiff In the District Court of the United States.

Salvatore Lima, Sebastiano Lima, No. 1344.
Giuseppe Ignoffo, Saverio Ventola,
Salvatore Rizzo, Salvatore Demma,
alias Salvatore Demar, Agostino VERDICT.
Marfisi, Antonio Vicario, Cologero
Vicario, Orazio Runfola, Pippino
Galbo, Salvatore Arrigo, Francesco
Spadara and Vincenzo Arrigo,
Defendants.

We, the Jury in this case, being
duly impanelled and sworn, do find the Defendants

Salvatore Lima
Sebastiano Lima
Giuseppe Ignoffo
Saverio Ventola
Salvatore Rizzo
~~Salvatore Demma alias Salvatore Demar~~
Salvatore Demma alias Salvatore Demar
Agostino Marfisi
Antonio Vicario
Cologero Vicario
Orazio Runfola
Pippino Galbo
Salvatore Arrigo
Francesco Spadara
Vincenzo Arrigo
guilty as charged in the indictment

J. W. Riley Foreman.

The verdict. *National Archives.*

Whereas, at the December Term of the District Court of the United States for said Northern District of Ohio, begun, and held on the 7th day of December A.D. 1909, at the City of Toledo in said District, to-wit:

On the 29th day of January, A. D. 1910,

Antonio Vicario

indicted for Conspiracy under Section 5440 Revised Statutes of the United States

having been convicted was sentenced to be imprisoned in the State Reformatory, at Elmira, New York,

for the period of two years,

from the 29th day of January A.D. 1910.

You are therefore commanded to take the said

Antonio Vicario

and him convey as soon as possible to the said State Reformatory, Elmira, N. Y. there to be imprisoned in pursuance of the said sentence, and to deliver to the Superintendent of said State Reformatory a duly certified copy of said sentence, under the seal of said Court

And of your proceedings make due return, together with this writ.

Tony Vicario was sentenced to imprisonment in the State Reformatory, Elmira, New York. *National Archives.*

In the case of Salvatore Rizzo, Agostino Marfisi and Vincent Arrigo, new trials were granted, and the three were released. The rest of the men were brought before Judge Tayler for sentencing. After one count was dropped, they were found guilty on fourteen counts.

The members of the Society of the Banana stood in front of Judge Tayler and awaited their sentences. Tony Vicario, the youngest man convicted, received a sentence of two years at the Elmira, New York reformatory. The rest of the men were told that they would be going to Leavenworth Federal

𝕿𝖍𝖊 𝖀𝖓𝖎𝖙𝖊𝖉 𝕾𝖙𝖆𝖙𝖊𝖘 𝖔𝖋 𝕬𝖒𝖊𝖗𝖎𝖈𝖆,
NORTHERN DISTRICT OF OHIO, | *SS.*
WESTERN DIVISION.

THE PRESIDENT OF THE UNITED STATES OF AMERICA,
TO THE MARSHAL OF THE NORTHERN DISTRICT OF OHIO—GREETING:

𝖂𝖍𝖊𝖗𝖊𝖆𝖘, *at the* December, *Term of the District Court of the United States for the Western Division of the Northern District of Ohio, begun and held at the City of Toledo in the Division and District aforesaid on the* 7th, *day of* December, *A. D. 1* 909, *to wit:*

On the 29th, *day of* January, A.D. 1910, *in said year,* Salvatore Lima,

indicted for Conspiracy under Section 5440 Revised Statutes of United States,

having been convicted, was sentenced to be imprisoned in the United States Penitentiary *at* Leavenworth, Kansas, *for the period of* Sixteen years

Salvatore Lima, who was considered the moving spirit in the operations of the society, was sentenced to sixteen years in Leavenworth Federal Penitentiary. *National Archives.*

Penitentiary. Frank Spadara, Saverio Ventola, Charles Vicario and Sam DeMar all received a sentence of two years. Salvatore Arrigo and Pippino Galbo were given four years, Orazio Runfola, six years.

When it was time for Judge Tayler to sentence the Limas and Joe Ignoffo, he looked at Salvatore Lima and said:

> *You seem to have been the moving spirit in this nefarious business, Sebastian Lima seems to have borne a somewhat less part than his brother and Ignoffo has been part of the heart and center.*

He sentenced Sebastian Lima and Joe Ignoffo both to ten years' imprisonment. Salvatore Lima, leader of the Society of the Banana, was sentenced to sixteen years at the federal penitentiary, Leavenworth, Kansas.[243]

The conviction of the members of the Society of the Banana was the first conviction of an organized band of Black Hand criminals in the United

States. Inspector Oldfield believed that his work had effectually broken up Black Hand operations in the Midwest region. Government officials said that they had made the first successful move toward breaking up the American Mafia, and the case was regarded as the most important federal prosecution in recent years. Officials believed that the conviction and penalties imposed would break the backbone of the Black Hand.[244]

INMATE NUMBER 6892

overnment officials had expected to hear the guilty verdict and prepared for public demonstrations. Throughout the entire trial, they had received threats of violence. Guards had been placed at the tops of the stairways leading to the courtroom. They were armed and under strict instruction to not allow anyone who appeared to be Italian or Sicilian to enter the corridor. U.S. Marshal H. Davis was aware that there had been Sicilians in the building that were making signs in the direction of the prisoners as they entered the courtroom. There was also a conversation in the Sicilian language that was overheard, which led Davis to believe that there might be an attempt of an act of violence.[245]

After the verdict was given, the prisoners were quickly removed from the courtroom and hidden in a room in the federal building. They waited briefly before they were moved out and placed on a bus. Everyone expected that the prisoners would go to the Toledo jail before being transported to the federal prison. The bus drove a couple blocks in the direction of the jail and then made a turn toward Union train station. Davis had a private car waiting for them. He made arrangements with the Lake Shore Company to have the prisoners transported directly to Leavenworth.

Along with the U.S. marshal, eight deputies closely guarded the prisoners. They were on the lookout and prepared for any attempt in which friends of the convicted men might try to break them free. George Randall was the manager of Patterson Café and brought enough food for the prisoners' time on the train. He was also sworn in as a deputy and expected to do double duty.[246]

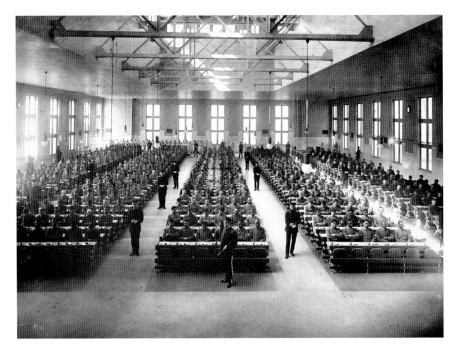

Leavenworth penitentiary mess hall. *Author's collection.*

Once all of the men were on the car and the train began its journey to Leavenworth, tensions calmed and the deputies relaxed. The prisoners seemed to enjoy themselves while Davis allowed them to smoke and play cards. The deputies handed out supplies of snuff, and the men did not cause any trouble. Out of everyone, Joe Ignoffo seemed to be the most disappointed. He had hoped to be going back to Marion after the trial and had even sent in new advertisements for his cobbler shop to be published in the newspaper because he was sure that he would be returning home.[247]

Meanwhile Tony Vicario was being transported to New York to serve his sentence at the Elmira Reformatory with a younger criminal population. He was the only one of all of the convicts not going to Leavenworth. At the federal penitentiary, the three Marion men would be together along with two Cincinnati men, two from Pennsylvania and two who lived in Columbus, but the Vicario brothers would have to serve their time separately.

The next afternoon, the men arrived at Leavenworth. They were met by Warden J.C. McClaughry, who had been waiting to receive them and accord them all the honors of the penitentiary. Since they arrived on a Sunday, which was a day of rest at the institution, they were put in cells until the next morning.

Early Monday morning, they were awakened and taken to the office of the record clerk. Salvatore Lima was the first to be signed in and was assigned inmate number 6892. They were photographed and sent to the laundry room. They were stripped of their civilian clothes, made to bathe and then put into prison uniforms. Next, they were lined up at the office of the prison physician and given physical examinations. After seeing the physicians, they were taken back to the record office, photographed again and had their Bertillon and fingerprint measurements taken.[248]

All of the new prisoners were eager to get their work assignments. They had been sitting idle for a long time since the trial began and were ready for some activity.[249] Warden McClaughry wanted to make sure that the men would be distributed throughout the different work gangs. Some would have physical jobs in the brick and stone yards while others would be assigned to less strenuous work in the commissary or shoe shop. The warden wanted to ensure that the men would not have the opportunity to consult with one another and plan other Black Hand schemes while under the charge of federal officers.[250]

Frank Spadara, Saverio Ventola, Charles Vicario and Sam DeMar stayed out of trouble during their two-year sentences. They did their work assignments, wrote letters, passed the time and paid their debts to society without issue. Salvatore Arrigo, Pippino Galbo and Orazio Runfola were there longer but still managed to get by without any problems. At Elmira, Tony Vicario spent his days exercising, practicing military drill and learning the trade of shoe repair.

The "directorate" of the Society of the Banana—Joe Ignoffo, Sebastian Lima and Salvatore Lima—were serving much longer sentences. All three had high hopes that they would be able to secure early releases. In late 1911, after a year in the prison, Joe Ignoffo was still in great distress and worried about the well-being of his family. His wife, Pietra, and the Lima women were constantly attempting to get their husbands released.

The Ignoffo and Lima families were living together in Marion. There were stories going around the city that they were suffering terribly and that they were without money and food. Credible sources denied that it was true. A well-known minister said, "The trustees of Marion township, the churches, and charitably inclined people generally have been imposed upon." He said that after the murder of Louis Giofritta, there was a similar circumstance. He claimed that when Mrs. Giofritta returned to Italy, she had nearly $5,000 in her possession.[251] Salvatore's wife, Maria, and Joe's wife, Pietra, eventually relocated to Portland, Oregon, to stay with family, and Sebastian's wife, Caterina, went to Johnstown, Pennsylvania.

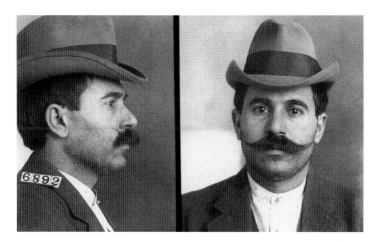

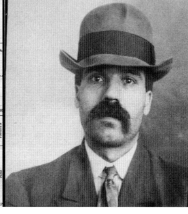

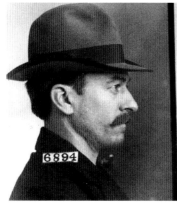
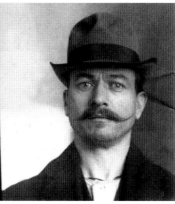

Top: Inmate #6892, Salvatore Lima. *National Archives.*

Middle: Inmate #6893, Joe Ignoffo. *National Archives.*

Bottom: Inmate #6894, Sebastian Lima. *National Archives.*

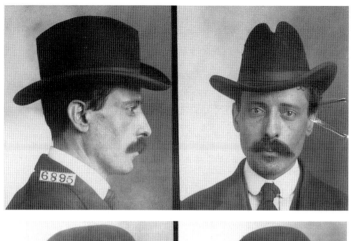

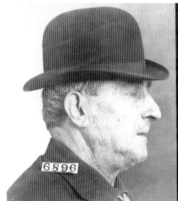

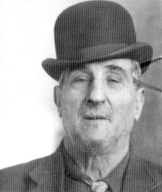

Top: Inmate #6895, Orazio Runfola. *National Archives.*

Bottom: Inmate #6896, Salvatore Arrigo. *National Archives.*

As the years went by, Joe Ignoffo established his routine in the prison but never quit trying to secure an early release. For Sebastian Lima, the time seemed more complicated. He was frequently in trouble for violating the rules of the prison. Guards wrote him up for disorderly conduct, disobedience to guards' orders, lying and neglecting his work. In 1911, he was diagnosed with diphtheria and spent many of his days visiting the penitentiary hospital. He eventually started having mental episodes.

Sebastian continually spoke of the sufferings of his wife and children and had hysterical attacks followed by hours of unconsciousness. It appeared that he was losing his sanity. His attendants said that he began showing signs of religious fanaticism.[252] Sebastian would tell the others around him that a higher power was directing him in his actions. In 1914, he was diagnosed with organic brain disease and put in isolation.[253]

Salvatore Lima, unsurprisingly, seemed to have no difficulties whatsoever. After a year working in the shoe shop, he managed to get moved to the

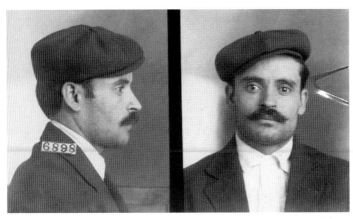

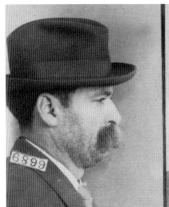 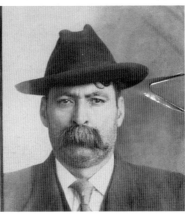

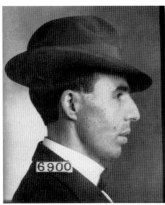 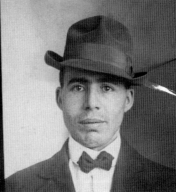

Top: Inmate #6898, Salvatore Demma, alias: Sam DeMar. *National Archives.*

Middle: Inmate #6899, Frank Spadara. *National Archives.*

Bottom: Inmate #6900, Charles Vicario. *National Archives.*

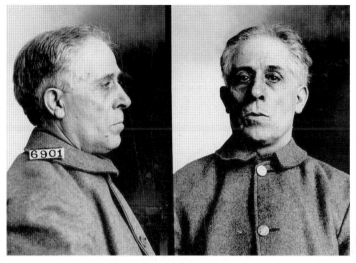

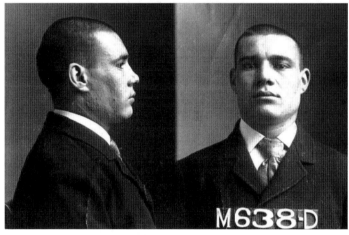

Top: Inmate #6901, Saverio Ventola. *National Archives.*

Bottom: Inmate M638-D, Tony Vicario. *New York State Archives.*

hospital, where he befriended the physicians. Salvatore had occasional mild asthma attacks, and once he got the job he wanted in the hospital, "to the doctors' surprise," the symptoms disappeared. Salvatore wrote a letter to the warden saying:

> *Honor,*
> *I am suffering from asthma a great deal and in order to preserve my health and future life for my family sake, I sincerely pray, dear Warden, to please consider my condition and grant me the privileges of a trustee, so that I may enjoy a large sleeping room, where I can have more air, and some exercise. I*

am now two years and two months in this institution and my conduct have
been such that I am sure that you will grant my request.
Most sincerely yours,
Salvatore Lima, #6892

Salvatore managed to live comfortably in the penitentiary. He made many connections and throughout the years he was in frequent contact with the Italian consulate to seek assistance in getting early parole. When his wife became sick and had to move to California to receive proper medical care, Dr. Benedetto Tripi-Rao, a Leavenworth doctor, went to visit her and wrote to the warden asking that he would take the matter up with the parole board. Even with his wife's serious illness, Salvatore continued to be denied parole.

11

BANANA KINGS

After the convicted members of the Society of the Banana were transported to Leavenworth, there was a sense of relief among the Sicilian and Italian communities. There may have been smaller groups still running extortion operations in other states and even in Ohio, but John Amicon and Agostino Iannarino were able to get back to business in Columbus and not have to worry about the threat of the Marion-based gang.

John and Charles Amicon both moved into bigger homes, and Amicon Brothers & Co. continued to grow. By 1917, the business was grossing around $2 million per year. They declared that they had the largest fruit company in the United States. John and his wife, Teresa, raised a large family of ten children. John was an active member of St. John the Baptist Parish and a proud member of the Holy Name Society.[254]

Ignazio Iannarino continued working in Columbus as a wholesale fruit dealer for many years. He and his wife, Cosma (Russo), had fourteen children. He was a charter member of the Holy Name Society at St. John the Baptist Church. Ignazio died in 1960 at eighty-nine years old. Cosima was ninety-five when she died in 1974.

Agostino Iannarino also had a large family in Columbus. He and his wife, Maria, had sixteen children. They were devout Catholics, and Agostino was a member of the Holy Name Society of Christ the King Church. He was financially well off by the early 1920s, owning three pieces of property. He invested much of his money into stocks, including Columbus Tire and Rubber Company, Penn Seaboard Steel, Island Oil and Transport Corporation, and he wrote the stocks in his children's names.[255]

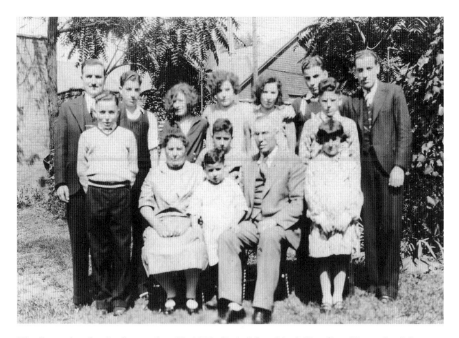

The Iannarino family, September 22, 1929. *Back, left to right*: Mike, Gus, Harry, Jay, Mary, Antoinette, Leonard, Joe and Bill. *Front, left to right*: Maria (Purpura) Iannarino, Francie, Charlie (in front of Francie), Agostino and Peggy. *Author's collection.*

Both the Amicon and Iannarino families did well through the 1920s, until the stock market crashed in 1929. The Great Depression followed, and both John Amicon and Agostino Iannarino lost everything. Agostino sold two of his properties and all of his stocks, and he resorted to illegally "writing numbers" to have a little bit of money to take care of his family. The John Amicon Brothers & Co. filed bankruptcy in 1935, and by 1936, all of their property was sold.[256] John Amicon died on March 9, 1937; his brother Charles died in 1938; and John's wife, Teresa, died in 1941.

Agostino Iannarino's family faced tremendous struggles during the Great Depression, but Agostino and his wife, Maria, were not unfamiliar with hard times. They lost baby daughters in 1908, 1915, 1920 and 1925; twenty-nine-year-old daughter Antoinette in 1935; and sixteen-year-old son Frank in 1936. In February 1943, Agostino's youngest son, Charlie, left for the army and was sent to fight in World War II. In June 1944, he landed in Normandy, France, during the D-Day invasion with the 307th Engineer Battalion, 82nd Airborne Division. He was declared missing in action, and his remains were never found. Agostino flew a gold star flag on the porch of his home until he passed away in 1951. His wife, Maria, died two years later in 1953.[257]

Left: John Amicon in Columbus, Ohio. *Courtesy of the Pardi family.*

Below: John Amicon Bro. & Co. produce trucks in Marion, Ohio. *Courtesy of the Pardi family.*

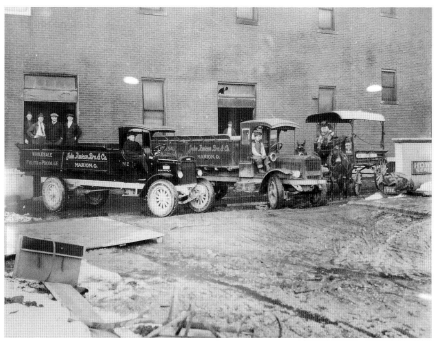

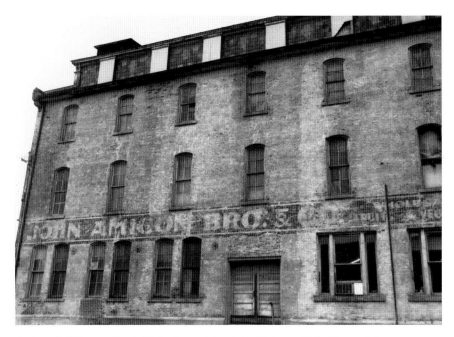

Amicon Building on North Main Street, Mansfield, Ohio, c. 1980. *Library of Congress.*

John and Agostino were both considered Banana Kings in Columbus and made many contributions to the city. The Amicon and Iannarino families, along with other witnesses in the trial, stood up against a society that was feared by every Italian in the country. They left great legacies behind them.

Shortly after the Black Hand trial was over, Inspector J.F. Oldfield left the postal service and began working as a private detective. He was successful in his investigations in areas across Pennsylvania. He passed away in 1916. The newspapers regarded him as one of the shrewdest Secret Service men in the service of the government and a terror to violators of the postal laws.[258] Judge R.W. Tayler died in late 1910 under mysterious circumstances after he was at a charity event with his wife and was stricken with paralysis. He was fifty-eight years old.[259]

Most of the DeMar/Demma family left Bellefontaine. Frank and Anna Demma Comella made their way to San Jose, California, and Tony DeMar returned to Sicily. It was unknown what happened to Charlie DeMar. He had sisters in Gloversville and Albany, New York, and a brother in Cleveland, but it was believed that he likely returned to Sicily. Antonino Demma stayed in Bellefontaine, where he died in 1920. Maria Demma Cira continued raising

Maria (Demma) Cira (1876–1964). *Author's collection.*

her children in Bellefontaine. She passed away in 1964 and was buried next to her husband, Salvatore Cira, at Calvary Cemetery. The potter's field section of the cemetery was blessed by Reverend Father Patrick Leo Sheridan (1945–2016), circa 2008.

The Ciras' family friend Dr. Giuseppe Romano became a prominent and recognized surgeon in Cleveland. He was a respected philanthropist, president of the Italian Red Cross and one of the few Italian Americans to be decorated by Italian dictator Benito Mussolini.[260] Romano was deeply involved with the Mafia and in the early 1930s was the boss of the Cleveland crime family. On June 11, 1936, Dr. Romano's car was found on a lonely road in a suburb, pushed into the woods. When roadworkers looked inside, they found Dr. Romano brutally murdered. He was killed in retaliation for his involvement in the murder of Mafia boss Joe Lonardo in 1927.[261]

12

LEGITIMATE BUSINESS

THE SOCIETY OF THE BANANA

There were two men who were not at the trial: Antonio Lima and Joe Nuzzo. Both were believed to have escaped to Italy. Antonio Lima's nephew Michael Angelo escaped from Portland and also returned to Italy.[262] The three men who were granted new trials and set free in 1910 all appeared to have connections to illegal liquor activities in the years following their release. Salvatore "Sammy" Rizzo of Marion married Marianna Battaglia in 1912. Ten years later, in the early 1920s, he was arrested with his brother-in-law after police raided their homes and found about six gallons of illegal corn liquor.[263] He died in 1961 at seventy-five years old. He had two daughters, two sons and four grandchildren.[264]

Vincent Arrigo returned to Cincinnati and continued working in the fruit business. He stayed out of trouble, but in 1931, his son Nicholas was captured after a car chase from Cincinnati to LeSourdesville. Police found 321 bottles of wines, whiskies, brandies, gin and cordials.[265] Vincent died in his home in 1947 at eighty-five years old.[266]

Agostino Marfisi returned to Dennison and in 1922 was renting out his building to a businessman who was running illegal liquor operations. Agostino died at eighty years old in 1946. He was a successful and prominent resident of Dennison.[267] He and his wife, Girolama, had five daughters: Laboria, Agata, Rose, Mary and Josephine. Sister (Agata) Augustina Marfisi was a seventy-five-year member of the Sisters of Charity of Nazareth.

Sitting: Sam Cira, son of Salvatore Cira. *Standing*: Antonio "Tony" Vicario. *Vicario Family Collection.*

Tony Vicario was paroled from Elmira Reformatory on March 31, 1911. He went to Bellefontaine, Ohio, and began working as a machinist helper and boilermaker apprentice. On February 19, 1912, he married Providence "Perry" Cira, daughter of the late Salvatore Cira. Tony was proud of his career as a boilermaker and rose to become the union chairman of the New York Central Railroad, Big Four District. He was secretary-treasurer of the International Association of Boilermakers and spent fifteen years as general chairman. Tony was an ardent baseball fan and served as manager of the Bellefontaine Merchants baseball team, leading them to three consecutive championships in 1938, 1939 and 1940.[268]

After his time at Elmira, Tony lived his life as an honest and hardworking American. Tony and Perry had four children: Angeline (married to John Lombardo), John (Maxine Wright), Joseph (Dorothy Lombardo) and Mary Virginia (William H. Miller, World War II veteran, USMC). Tony died in

Providence Cira and Tony Vicario were married by Reverend Father Sourd in St. Patrick Catholic Church, Bellefontaine, Ohio. *Vicario Family Collection.*

his home at 320 East Brown Street on February 23, 1958. Perry died in 1984. Both were active members of St. Patrick Catholic Church and are remembered as loving grandparents.

Tony and Perry's son John was a graduate of the Cincinnati Conservatory of Music. He was a talented singer and expert welder and served in the U.S. Army during World War II. Their son Joseph also served during World War II, as an aircraft welder with the 8th U.S. Army Air Force. In Bellefontaine, he was a boilermaker and active in local politics, serving on the city council for sixteen years. Joe was a teacher at Bellefontaine City Schools for twenty-seven years and is an inductee in the BHS Athletic Hall of Fame.[269]

Charles Vicario was released from Leavenworth on September 7, 1911. Two days after arriving in Bellefontaine, with Mary Cira, he went and applied for a marriage license. Then on September 24, they were married by Reverend Father Sourd. In 1912, Charles was in some brief trouble and arrested on a charge of illegally selling and furnishing whiskey. Police were told that in two weeks he sold nearly 150 quarts of liquor. On a Sunday morning, police hid in the weeds near his house, waited for a sale to be made and then placed him under arrest. He was fined one hundred dollars.[270] Three weeks later, he was in front of the judge again for holding up a local man with his revolver after he was said to have disturbed Charles's chickens.[271]

Charles had no interest in having troubles with the law and decided to start a legitimate business. He opened the Hat Hospital and Shine Parlor in Bellefontaine. He later opened the Home Restaurant and Oyster Bay. He became a reputable businessman in the community. Charles and Tony were naturalized as American citizens in 1916, and both were having great success in their careers until the Great Depression. Charles would work from six o'clock in the morning until midnight trying to make any little bit of money that he could. There was a night he was so down that after arriving home, he sat at the table and began to cry. Mary said, "Charlie, what's the matter?" He held out his hand, holding just one dime, and said, "That's how much I made today."[272] Tony also struggled to find work during the Depression, and one year at a quiet Thanksgiving dinner, he threw a plate of spaghetti against the wall in despair because he did not have enough money to provide his family with a turkey. Both men eventually recovered from the hard times and became successful in their careers.

In 1932, the Vicario brothers' mother, Angela Emanuele, who was seventy-six years old, moved from Galati Mamertino, Sicily, to Bellefontaine.

Charles Vicario (*right*) in front of his shoe and hat business in Bellefontaine, Ohio. *Vicario Family Collection.*

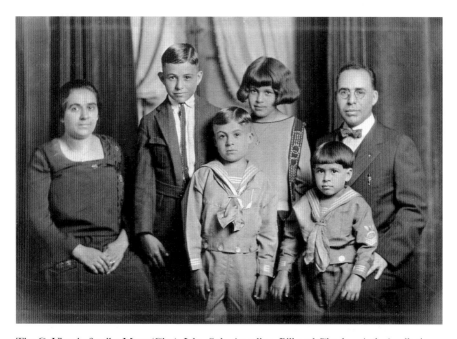

The C. Vicario family: Mary (Cira), Jake, Sab, Angeline, Bill and Charles. *Author's collection.*

Charles cared for not only her but also his cousin Pietro, a World War I veteran who suffered from shell shock. He was a good family man and always looked after his mother and mother-in-law.

In the 1940s, a man named Carmelo Fasano came from Cincinnati and taught the family how to repair shoes. Charles had a shop with his sons in the Powell Block, not far from where Salvatore Cira had been killed many years before. The family shined and repaired shoes, and Charles was well known for being a master hatmaker. Charles and Mary had five children: Jacob Abraham, Angeline Rose, Salvatore "Sab," Charles William "Bill" and Richard Joseph. Charles died in his home at 620 South Main on June 10, 1957, at seventy-one years old. Mary was heartbroken. She died just three months later.[273]

Tony Vicario with his mother, Angela Emanuele. *Vicario Family Collection.*

Richard Vicario expanded his father's shoe business and began new ventures of his own. He served four years as a city councilman; he was council president and from 1983 to 1996 served as mayor of Bellefontaine. He was extensively involved in the community and, with his wife, Jeanne, made many significant contributions to the city.[274]

Sam DeMar and Saverio Ventola returned to Columbus after their sentences. Both were released on September 7, 1911. Sam married Katie Lombardo on November 1, 1911. They had one daughter, Providence "Florence" Marie, born on December 14, 1912. Sam worked with Katie's father, Joseph Lombardo, at Central Market. Sam also spent many years working with his brother-in-law John Lombardo and Tony Pusateri. Sam's wife, Katie, was a clerk, and John's daughter Dorothy kept the books. Dorothy was a granddaughter of Agostino Iannarino and married Joseph Salvatore Vicario (son of Tony Vicario) on July 31, 1950. Sam DeMar was naturalized as a U.S. citizen in 1944 when he was sixty-two years old. He was in the fruit industry for most of his life and in his later years worked as a truckster. He died on August 20, 1959, at seventy-nine years old. Katie died on July 3, 1961.

Right: Sam DeMar holding Johnny Vicario (son of Tony). *Author's collection.*

Below: 119 East Town Street, Columbus, Ohio. *Left to right*: unidentified, Charlie Lombardo, Salvatore "Bill" Iannarino, John Lombardo, "Blacky" Joe Sansone, Tony Pusateri, Sam DeMar, Sam Mangia and Joe Lombardo. *Author's collection.*

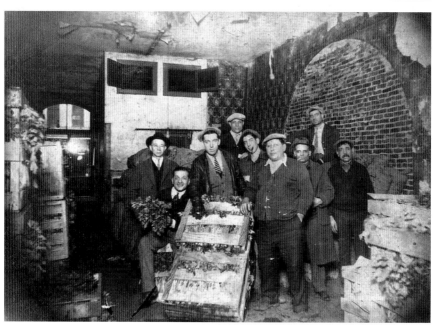

Saverio Ventola also went back to working in the fruits and vegetables industry. He lived with his wife, Mary, and their daughters, Sadie and Josephine. He retired from the fruit business by 1930. He was a secretary of the Holy Name Society of St. John the Baptist Church and a secretary for the Società Fratellanza Italiana.[275] He spent his later years with his family and died on March 22, 1949, at eighty-eight years old. Saverio had six children: Frank, Thomas, Michael, Jennie, Josephine and Sadie; nineteen grandchildren; and sixteen great-grandchildren.[276]

Frank Spadara was discharged on September 7, 1911. He returned to Cincinnati and moved into a West Fifth Street apartment and opened a fruit store. He was arrested in 1922 and charged with conspiracy to violate the national Prohibition laws, but the case was dismissed.[277] In 1927, his son Frank Jr. was also arrested on a charge involving illegal liquor.[278] In March 1948, when he was eighty-five years old, he was visiting the location of one of his old fruit stores. While surrounded by his friends, he collapsed in the store, dying of a heart attack. He had four sons—Leo, Joseph, John and Frank Jr.—and one daughter, Rosie.[279]

Salvatore Arrigo also went back to Cincinnati after he was discharged on February 27, 1913. While in prison, his five-year-old grandson was killed when hit by a car in front of the home of Vincent Arrigo. Salvatore spent time with his large family after his return to Cincinnati.[280] He was retired by 1920 and died on June 21, 1922, at seventy-nine years old. He was the father of Vincent, Peter, Charles, Teresa Bardi and Josie Deseiro and father-in-law of Vincent Sansone.[281]

Pippino Galbo was released in 1913 and returned to Meadville, Pennsylvania. In 1914, he built the Galbo Block, a large building where he planned to conduct one of the most exceptional wholesale fruit establishments in the state.[282] He appeared to be doing legitimate business until 1933, when Erie Police and federal authorities arrested him for passing counterfeit bills.[283] He was sentenced to five years at the federal penitentiary in Lewisburg, Pennsylvania.[284] After his release, he continued selling fruit and eventually started farming chickens. He died in 1966 at ninety-four years old. He had four kids: Joseph, Anthony, Rose and Marie.

When Orazio Runfola was released from prison, he went directly to New York, where he married Nunzia Runfola in 1914.[285] They moved to Northampton, Pennsylvania, before eventually returning to New York, where they had relatives. Orazio worked as a salesman and a broker. He naturalized in 1926. He kept a clean record and lived an honest life. He died in 1954 when he was eighty-one years old.

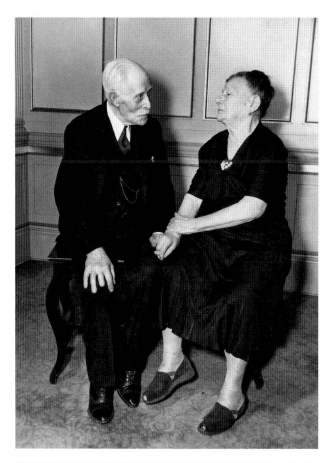

Left: Saverio Ventola with his wife, Maria (Palmisano). *Courtesy of Cheryl Bliss Ellinger.*

Below: Pippino Galbo was sentenced to five years at U.S. Northeastern Penitentiary, Lewisburg, Pennsylvania. *National Archives.*

Opposite: Salvatore Arrigo pictured in *McClure's Magazine*, May 1912. *Author's collection.*

No. E- 2667 Crim.

District Court of the United States of America

WESTERN DISTRICT OF PENNSYLVANIA

THE PRESIDENT OF THE UNITED STATES OF AMERICA

To the Marshal of the Western District of Pennsylvania, and the Warden or Keeper of the Common

Jail of _____Allegheny_____ *County, Pennsylvania,* GREETING:

YOU, the said Marshal, are hereby commanded to deliver to the said Warden or Keeper of said Common

Jail the body of _____Pippino Galbo_____ who has been

charged with counterfeiting and sentenced to a penitentiary for

a term of five years

IMPORTED CRIME

The Story of the Camorra in America

ILLUSTRATED WITH PHOTOGRAPHS

BY ARTHUR TRAIN

For a full century the menace of the Mafia and the Camorra has hung like a blight over southern Italy. Originating as patriotic clubs, these secret societies have slowly degenerated until now they are the most powerful and highly organized bands of depraved criminals in Europe. Throttling the Italian government on the one side, with the other hand they are industriously occupied in collecting bloody tribute from the people.

The Camorra and the Mafia have laid their predatory hands upon this country. Their agents have come here with the tremendous influx of immigration from Italy, and are busy with their criminal work.

Mr. Arthur Train, as former Assistant District Attorney of New York City, has had an exceptional chance to get expert knowledge of the New York operations of the Italian desperado.

Over a year ago Mc-Clure's Magazine selected Mr. Train as the man best fitted to study the Camorra in its native soil, and commissioned him to spend six months in Italy in close observation of the many-sided Camorra. Mr. Train tells here the story of this sinister criminal association.

THERE are a million and a half Italians in the United States, of whom nearly six hundred thousand reside in New York City — more than in Rome itself. Naples alone of all the cities of Italy has so large an Italian population; while Boston has one hundred thousand, Philadelphia one hundred thousand, San Francisco seventy thousand, New Orleans seventy thousand, Chicago sixty thousand, Denver twenty-five thousand, Pittsburgh twenty-five thousand, Baltimore twenty thousand, and there are extensive colonies, often numbering as many as ten thousand, in several other cities. So vast a foreign-born population is bound to

SALVATORE ARRIGO, A DEPOSED LEADER OF THE CAMORRISTS

contain elements of both strength and weakness. The North Italians are *molto-simpatici* to the American character, and many of their national traits are singularly like our own, for they are honest, thrifty, industrious, law-abiding, and good-natured. The Italians from the extreme south of the peninsula have fewer of these qualities, and are apt to be ignorant, lazy, destitute, and superstitious. A considerable percentage, especially of those from the cities, are criminal. Even for a long time after landing in America, the Calabrians and Sicilians often exhibit a lack of enlightenment more character-

83

When Sebastian was released in October 1916, he was still suffering from physical and mental illnesses. He was happy to finally return to his wife, Caterina; daughters Anne and Millie; and son Tony; but he lost one son, Antonio, who was only four years old, while he was in prison.[286] The family lived in Johnstown, Pennsylvania, and Sebastian worked as a laborer for the Cambria Steel Company for a short time until he opened a fruit store. Sebastian and Caterina had three more children: Mary, Joseph and Sebastian "Sammy."

By 1920, Sebastian's family was living with his son-in-law Sam Butera near Pittsburgh. The following year, Sebastian's son Tony died tragically when he drowned in a swimming pool. He was only eleven years old.[287] Sebastian worked an honest career after his release from Leavenworth. He died in his home in 1927 at the young age of forty-nine. Caterina died two years later in 1929. When they passed, they had three children who were not yet teenagers. Millie took care of Mary, and Anne raised the two youngest, Joe and Sammy.

Sammy later served in the U.S. Army during World War II and often worked as an interpreter and translator while his unit was in Italy. He became an opera conductor and was an operatic tenor, performing in the Boston New England Opera.[288] In 1933, Joseph entered the Missionaries of the Precious Blood, and the following year he was ordained as a Catholic priest: Reverend Father Joseph Lima.[289] Anne Lima always proclaimed her father's innocence and had memories of him being a well-educated man, saying that he was never the same after prison. All of Sebastian and Caterina's children got away from the "family business" and lived honest lives.[290]

Joe Ignoffo's sentence was commuted by President Wilson on February 24, 1916.[291] He went to live in Portland, Oregon, for a short time until he moved his family to San Francisco, California. He kept with his old trade as a cobbler and opened Sunset Shoe Repair. His son Anthony, who was born in 1909, just a few months before Joe was sent to Leavenworth, passed away in 1922 when he was only twelve years old. Pietra Lima died in 1942, and Joe died in 1964, at eighty-four years old. He was a devoted grandfather of eight grandchildren and ten great-grandchildren.[292]

Salvatore Lima, the convicted leader of the Society of the Banana, was granted early release from Leavenworth on February 2, 1918. He went directly to be with his wife, who had been extremely ill. Salvatore and his wife, Maria, had four children: Marina (1894–1931), Nunzia (1899–1900), Antonio (1902–1904) and Nancy (1905–1997). Once Maria regained her

Salvatore Lima declared that he would "make good and do honest work" after his release from prison. *National Archives.*

health, Salvatore went back into business. He worked briefly in Portland, Oregon, and then opened a fruit business in California. In 1921, Salvatore became a naturalized U.S. citizen. By the 1930s, he had entered the olive industry, managing a vineyard, and by 1939, he was overseeing the Palermo Olive Co. and Oroville Distribution. He farmed and had many business ventures but also ran into small troubles with the law from time to time.

Salvatore's cousin Sam "Totò" Lima was in the olive business with him. In 1943, they were both charged and found guilty of receiving stolen property. Totò was said to have bought over 800 pounds of stolen olives from local teenagers. Salvatore denied that his company made any of the purchases,

but he had allegedly bought 120 pounds from the boys. Salvatore received three months of probation and paid a $500 fine.[293]

Totò had three charges against him and was facing a minimum of three years at San Quentin Prison. He appealed to the Supreme Court, and they reversed his conviction.[294] In October 1943, Salvatore went into semiretirement and turned the Palermo Olive Oil Co. over to his nephew Tony Lima.[295] Salvatore died on September 9, 1965, at the age of eighty-seven.

Two years later, an FBI report circulated regarding the American Mafia, also known as La Cosa Nostra. Under the headline "Deceased Members of the San Francisco Family" was the name "Salvatore 'Sam' Lima, Sep. 9, 1965."[296]

APPENDIX A
BLACK HAND LETTERS

The Grand Jury declared that the Society of the Banana confederates were members of an organization, sect and society known as "The Black Hand." The Society members were bound together and had an arrangement between themselves to destroy property of, do bodily injury to or assassinate any person who refused to respond to their demands. Extortion letters that were sent in the U.S. mails violated Section 5480 of the Revised Statutes of the United States.

What follows are twenty-four extortion letters written and sent by members of the Society of the Banana.

All images are courtesy of the U.S. National Archives unless otherwise noted.

And the Grand Jurors say that a translation of the words of said letter and communication into English is as follows:-

Dearest friend:
 Ciali Amicone:

 Last week our band at Pittsburg, Pa. sent two of us to Columbus, Ohio, and put dynamite behind your door, and one behind the door of your brother John, accompanied by two letters in which you were notified by our band to pay $10,000.00, which for your firm are only a hair of your head. If you refuse it is under the penalty of death for you and your children, and all the family. Now we will show you the way. If you search for honorable persons, Most Honorable, giving them the money, who will leave Columbus for Pittsburg. This person arrives in Pittsburg, Pa. and goes searching for persons, and while he is searching he will be found by us. There must not be more than two persons, and this must between the first and tenth of February, and if no one presents himself the eleventh he will return to Columbus and pay attention to our orders. Then in case you favor us, you can continue your affairs. You will be peaceful, you can go out night and day, and no one will molest you for by us you will be protected. In case you refuse, we will give you a taste of our daggers, and our trusty carbines, which have never failed, and which cannot fail. We will kill you like a dog. We have decided by lot, and the two chosen must kill you even in the midst of a thousand police. We have killed Kings, Emperors, and Presidents. Consider this was in the midst of thousands and thousands of police. Consider yourself, worm of the earth. The two who will come are obliged to kill even though they themselves must pay the death penalty. Woe unto you if you turn to the police. We are brigands escaped from Italy, and the police look like flies to us. Take account and discuss it in your family because no one under our hands can free himself. Read the newspapers and see what we have done in New York, Chicago, New Orleans, and Pittsburgh. We advise you that we have dynamite, a double load, that will send your house up in the air and kill all who are within, and we will do the same to your brother. Understand that our band is in the whole world, and we hold all under our feet, especially the police. Woe, if you refuse. We have you registered in our register that you must pay the money or your head must be brought to Pittsburgh, Pa. to our chief. For the person who joins our band shall have killed ten men before. Don't get a crazy notion in your head for you have to deal with men who will eat you raw. Either money or your life.

 The Human Butchers.

Your place or be peaceful. 12

Opposite: Count 1.

Above: Count 1. Date: January 27, 1909. Addressed to: Charles Amicone, Columbus, Ohio. Mailed from: Pittsburgh, Pennsylvania. Written by: Salvatore Lima.

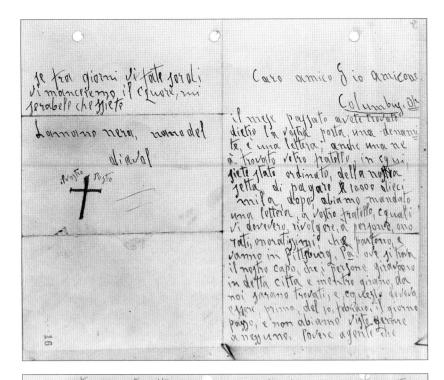

And the Grand Jurors say that a translation of the words
of said letter and communication into English is as follows:-

Dear friend John Amicon, Columbus, Ohio:

 The last month you found dynamite and a letter back
of your door, and also your brother found one, and you are or-
dered by our Band to pay $10,000.00. Afterwards we sent a
letter to your brother where he was to look for some honora-
ble persons that were to bring the money to Pittsburgh, Pa.,
where our leader lives; that the prsons were to walk around
in said city. In the meantime while they were walking a-
round, they would be found by us. This was to be before the
10th of February. This day passed, and we saw nobody walking
around. Poor people, that you have made your calculations
wrong. We have already selected two young men that are obli-
gated to butcher you at the cost of our lives. Read the news-
paprswell, and see what we have done in New York, New Or-
leans, and Chicago, and other cities. You will understand that
under our hand that nobody has escaped. Neither will you.
It will be awful for you if you turn to the police. You un-
derstand that the police cannot watch you all the time, even
if you were in the midst of 1,000 police, the first rifle shot
would be for you, and afterwards all the police would die who
were watching you. We are a multitude, brave shots, that one
time in a mountain of Saint Mauro met lots of police and kill-
ed twenty and the rest ran, and we were only four. So you
see, we kill all who do not obey our commands, and we do not
fear the police. We have rifles that will make you shiver,
We don't want to do much taking. Make your calculations good.
You are compelled to leave your business if you come to your
duty we will make you be respected by the whole world. We ex-
ist everywhere, and all are under our feet. See what you have
resolved as soon as you get this. Hunt honorable persons,
give them the money, and they will come to Pittsburgh, and
while they will be hunting, they will be found by us, and
there cannot be over two. Do your calculations, and don't
think of it because you can see yourself in the hands of the
lion. Come to your duty. Come with your money or your life.
Money to you is nothing. If you are deaf, in a few days we
will eat your heart, miserable that you are.

 The Black Hand.

 Hand of the Devil.

Your Place.

 2 18

Opposite: Count 1-2.

Above: Count 1-2. Date: February 16, 1909. Addressed to: John Amicon, Columbus, Ohio.
Mailed from: Pittsburgh, Pennsylvania. Written by: Salvatore Lima.

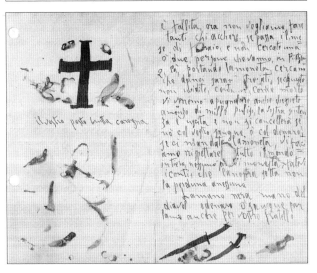

And the Grand Jurors say that a translation of the words
of said letter and communication into English is as follows:-

Finally you play deaf, but if you think we are fooling.
No! Ugly carrion that you are. You will believe it when you
see two or more with daggers in their hands which we will
plunge into your heart. In that moment you will call for
help, but there will be no remedy, it will be useless. We
have put you down in the register of the dead, nasty brute,
that for money you are content to be killed, do not think you
can free yourself. No! No! no one escapes from under our
hands. We have stabbed many in Italy, and consider that I,
whowrite this, had a price of 14,000 lire on my head for
eight years, was followed by the police, and know not how many
I have killed with my trusty carbine, which has never failed
me.

Now we do not wish to have too much idle talk. If the
month of February passes and you do not search for one or two
persons to come to Pittsburgh, Pa., bringing the money and
searching and who will be found by us, if you do not obey
this, count yourself as dead. We will come and stab you even
if you are in the midst of a thousand police. Your sentence
is passed, and it cannot be cancelled. Either your blood or
your money. If yousend the money, you will be well respected,
and we will have you respected over all the world; no one
will molest you. Consider well that our band pardons no one.

 The Black Hand.
 Hand of the Devil.
 Either your money or blood.
 We speak also to your brother.

Your place, Ugly Wretch.

3. 24

Opposite: Count 1-3.

Above: Count 1-3. Date: March 16, 1909. Addressed to: John Amicon, Columbus, Ohio.
Mailed from: Pittsburgh, Pennsylvania. Written by: Salvatore Lima.

Egreggio Amico

Gia siamo arrivato nellultimi e
strette punti Dietro 4. lettere che
viamo inviato, e ni date a sospettare
che non volete venire al dovere.
Arrivato a questo punto la nostra
setta si è determinata al tocco
e siete condannato a morte, e taluni
di noi arriguardo dei vostri figli,
noinnocente, obbiamo avuto conzide
razzione, altrimente a quistora,
avrebbe passato la vostra puzza
di voi e della vostra famiglia, e se
il sanguinoso disastro si avverrà
è causato di voi, contro la vostra
generazzione, Sonomo ancora a dirvi
che giorni addietro sono stati
venuti tre di noi giusto il sorteggio
fatto, per compire il mortale

disastro, e ci siamo accorti, che voi
tenete i sbirri Dentro, ai ai
misero non uomo sfortunato, mentre
dovete penzare, che sotto della
nostra setta, nessuno selafatto
franca. e nemmeno se la potuto
farsela franca, favvi il signor
petrosino che intendeva d'essere
affiancato Di tutta l'utorità, è vero
era, epure essendo condannato a
morire in menzo a mille persone,
anche ci sono stati Re, come voi
sapete, e conziderate voi misero
uomo di Bissinisi, Statu pur sicuro
che se voi non venite di urgenza al
dovere, sarete pugnalato anche in
menzo a cento sbirri. Il vostro
sanguinoso disastro deve arrestare
per memoria al mondo, mentre
se voi veruissive al Dovere, foste

garentito della nostra setta, pas
sandovi la vita tranquilla e felice.
Perciò caro amico, il grande pro
blema lascio voi nelle vostre mani
e sta avoi risolverlo avanti il
sanguinoso disastro.
preparato al vostro petto.

And the Grand Jurors say that a translation of the words of said letter and communication into English is as follows:-

Eminent Friend:-

Already we have arrived at the last and pressing moments after four letters which we have sent you, and you lead us to suspect that you do not wish to come to your duty. Arrived at this point our sect has cast lots and you are condemned to death, and some of us with regard to your innocent children have had consideration, otherwise by this time the stench of you and your family would have been past, and if the bloody disaster (comes to pass) it will be on your own account against your generation. We have yet to tell you that some days ago three of us have come according to the choosing already made to perform the mortal disaster and we perceive that you have policemen within. Ha! Ha! miserable man, unfortunate, while you must think that under our Society no one can go free not even Mr. Petrosino who believed himself to be affiliated with all the authorities and it was true, could escape and also being condemned to die in the midst of thousands of persons. And also there have been Kings as you know and consider miserable man of business, yourself. Rest assured that if you do not come at once to your duty you will be stabbed even in the midst of hundreds of policemen. Your bloody disaster must remain for the memory of the world while if you would come to your duty you would be guaranteed by our sect living your life tranquil and happy, therefore dear friend you have the great problem in your hands and it is up to you to decide ahead of this bloody disaster. Prepare your chest.

4

30

Opposite: Count 1-4.

Above: Count 1-4. Date: March 23, 1909. Addressed to: John Amicon, Columbus, Ohio. Mailed from: Cincinnati, Ohio. Written by: Salvatore Lima.

Caro Gian Amicone
vi abiamo mandato diversi lettere
vi abiamo mezo lo denomite dietro
la vostra porta e fote il sordo, brutta
carogna non vi dovete l'amentare se men
tre non vi la spettate vi costerà la vita già
la nostra setta vi a calato nel registro dei
morti abiamo toccato al tocco, e già due
di noi vi dobiamo ammazzare, anche
che vi fate guardare di mille pulizi
fate la strada che affatto il vostro amico
tenente pelegrino brutta carogna che
siete che vi contentate tardi sarà morse

Simo uscire la moneta ma
sangue di dio siamo sieno di voi vi
abiamo imparato il vostro fare, seni acorgete
quando, all'improviso vi viene dare due
buoni pugnalate, e così dormite per sempre
vi dico che nessuno può appartenere
alla nostra setta se non ammazzato il primi
una dieci persona, doiamo mezzo visca
in peratura considerato una mosca come
voi, ho nò non vi la campate, noi abia
mo saputo, appunto che siete ricca, e dovete
scarcare sangue sceleste scarpa parci la
morte cercati persona onorata dicela
in Pitsburg, Pa, mentre lui carca di noi
sara trovato vi avvisiamo che se si rivolgete
con ibissi contattavi come vuoto cioè
morite prima

carogna venite al dovere vostri
ibissi esistibene adenaro a vita
in breve sredete che sappiamo fare
l'anomo nera

morite carogna

il voglio poto

in breve portate la croce

And the Grand Jurors say that a translation of the words
of said letter and communication into English is as follows:-

Dear John Amicone:-

 We have sent you several letters, we have put
dynamite behind your door and you play the deaf. Ugly carrion,
you need not lament if when you do not expect it, it will cost
you your life, already our sect has you down in the register
of dead we have cast lots, and already two of us must kill you
even if you get one thousand policemen to watch you. Take
the samestreet that you friend lieutenant Petrosino has
taken ugly carrion that you are that you content yourself to
be murdered rather than set out the money but by the blood of
God we are after you we have learnt your store and you will
be accorded when you do not expect it and the site two good
dagger thrusts and thus you sleep forever. One thing I tell
you, no one can belong to our sect who has not killed ten per-
sons at least. We have killed Kings and Emperors - - consider
a fly like you, No-No you will not escape, we have known that
you are rich, and you must spit out blood if you wish to avert
your death, search for an honorable person who goes to Pitts-
burgh, Pa. and while he is searching for us he will be found.
We warn you that if you go to the police you can count your-
self dead, that is you die first. Carrion come to your duty
without the police and it will be well. Either money or life.
In a short time you will see what we are able to do.

 The Black Hand.

Die carrion. Your place.

 Soon you will bear the cross.

36

Opposite: Count 1-5/6.

Above: Count 1-5/6. Date: June 2, 1909. Addressed to: John Amicon, Columbus, Ohio. The letter was sent first to Agostino Marfisi in Dennison, Ohio. Mailed from: Marion, Ohio. Written by: Salvatore Lima.

Signori Americani
abiamo visto quanto
siete brava gente e
l'ultima lettera che vi man
diamo avete sbagliato la
strada nel rivolgervi con la
giustizia più vi avvisiamo
per l'ultima volta di tutti
quelli che avete fatto arrestar
sono tutti innocenti, la nostra
setta non da confidenza a
quelli genere di persone lo
scrivente sono io che mi giro
sempre nei pressi di Colonna
(bus) e non lascio di piare
i vostri passi se il mio pugnale
non accarezza il vostro cuore
la vostra testa la debbo portare
al mio capo

se volete avanzare la vita
rivolgetevi a qualche persona
onorata, siam genti cinque
mila che cerca che mentre
più cerca da noi sarà
trovato, se fate così povere
che non avete mostra volta
capirete che sempre noi sbirri
non di potete fare guardare
caragna avete sbagliato
la strada
vi avete fatto male i
Conti

la mano nera
† vi porterà al fosso

And the Grand Jurors say that a translation of the words and language of said letter and communication into English is as follows:

John Amicone:

 We have seen what a dog you are and this is the last letter we will send you.

 You have made a mistake in the road, in conferring with the courts, furthermore we will advise you for the last time that all those whom you have had arrested are innocent, our band does not give confidence to that class of persons. I am the writer. I move around always in the vicinity of Columbus, and I do not fail to watch your movements, if my dagger does not caress your heart, I must carry your head to my leader. If you wish to save your life, go to some honored person with $5000.00, who will search, and while he is searching, he will be found by us. If you think to hide again, you will understand that you cannot always be watched by the police.

 Carrion! you have made a mistake in the road. You have made bad calculations. The black hand will bring you to the grave.

43

Opposite: Count 1-7.

Above: Count 1-7. Date: November 23, 1909. Addressed to: John Amicon, Columbus, Ohio. Mailed from: Akron, Ohio. Written by: Joe Ignoffo.

Dopo tanto ritardo vi scriviamo la terza
lettera la quale abbiamo aspettato a voi che
girate oppure mettete una persona in giro
per accomodare questa faccenda. Voi
di questo non ne avete fatto niente e
perciò si avvicina il punto di lavorare
sopra di voi perchè dovete penzare che
la nostra sogietà a il piede di piombo ed
aggiunge a tutto. Dunque noi vi rebblichia
mo di andare voi stesso in Springhfild
Ohio ed andate a trovare amici vostri
stessi ed anche paesani vostri la quale
~~[cancellato]~~ vi possono
conzigliare come dovete fare vi dovete
presentare ad amici di onore e non giam
mai a gente infame perciò fate presto
ad eseguire i nostri ordini se no se tarde
rete si andrà nel menzo la vostra vita
vi saluta la mano nera

† questo e la croce del vostre carne.

Vi raccomandiamo di più di non andare
per giustizia perchè voi lo sapete bene
che a noi il minimo che penzamo
la giustizia ~~ed anche~~

And the Grand Jurors further say, present and find
that a translation of the words of said letter and communi-
cation into English is as follows:

After so much delay we wrote you. We waited that
you might come around or send some one to complete this af-
fair. Of this you have done nothing, and therefore the
time is at hand to begin work on you, because you must
think our society has a leaden foot (a secure footing)
and reaches every one.

Then we ask you again to go yourself to Springfield,
Ohio, and go to find friends and also countrymen with
whom you can hold counsel as to what to do. You must
present yourselves to friends of honor and never to de-
framed persons; therefore hurry up and follow our orders,
for if you delay it will cost you your life.

The Black Hand salutes you.

This is the cross of your flesh.

We recommend to you again to not seek justice (law)
for well know we think the least of justice(the least of
our thoughts .)

56

Opposite: Count 2.

Above: Count 2. Date: December 9, 1908. Addressed to: Michele Amato, Greenville, Ohio.
Mailed from: Cleveland, Ohio. Written by: Joe Nuzzo.

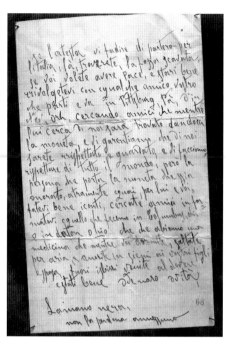

And the Grand Jurors say that a translation of the words of said letter and communication into English is as follows:-

Dearest Friend:-
 Geo. Pash.

 The Black Hand makes you a visit, and you are ordered by our band to pay $5500. under penalty of your life if you refuse. If you have read in the papers what we have done in New York, in Pittsburgh, Pa. and in Chicago; that we have killed those who refused to comply with our orders; also inform yourself as to what we have done in Columbus, Ohio; that we have blown up a house. Woe to him that refuses! We advise you that if you go to the police--- Woe to you! You are dead! We are brigands escaped from Italy, and the police seem like hogs to us. If you get it in your head to depart for Italy, there you will find your grave dug. If you want to have peace and do well, go to some friend of yours, who will depart and go to Pittsburgh or New York, searching for friends, and while he is searching he will be found by us, giving him the money, and we will guarantee that you will be respected and watched by us, and we will make you to be respected in all the world. However, the person who brings the money must be honorable, otherwise woe unto him and you! Think over it well, search for friends, inform yourself as to what we did in Columbus, O., and in Dayton, O., for we have a medicine, that while you sleep you go up in the air and die together with your children and your wife. Without the police! Do your duty and it will be well. Either money or life.

 The Black Hand
 pardons no one

Above: Count 3.

Left: Count 3. Date: December 29, 1908. Addressed to: George Pash, Coshocton, Ohio. Mailed from: Unknown. Written by: Salvatore Lima.

And the Grand Jurors say that a translation of the words of said letter and communication into English is as follows:-

Dearest friend:-

You think that I have forgotten, but that is not true. This will be the last and then things you saw will go ahead. You think you did well to go to the Post Office and stop this but it will be worse. It will be better for you to do what is expected of you, if not it will cost me $4.75 and you will get a good dose of medicine which will relieve you of all pains, as you know.

Govern yourself accordingly.

Top: Count 4.

Bottom: Count 4. Date: January 13, 1909. Addressed to: Ignazio Fazone, Columbus, Ohio. Mailed from: Pittsburgh, Pennsylvania. Written by: Pippino Galbo.

ni fermiamo

La società banditi

Mano Nera

vi avvertiamo dipiù che la
detta somma la dovete uscire
tutti in compagnia vuol dire
Gentile Catalano e compagnia

Dunque la nostra società viene
a farvi una visita acciò ar
fa sentire che siamo venuti
dal litalia scappati per le
nostre circostanze che abbiamo
avute ed avendo di bisogno
di moneta ..to siamo ricorse
e che noi facendo parte alla
nostra società cioè la mano
nera vi nostri amici ni
anno indirizzato che voi
siete un ricco possidente e
crediamo che ...

tanto gentile che anzi voi vi
piamate di non rifiutarvi di
sborgare la somma li dodici
mila venti 12000 e se questo
voi farete sarete rispettato da
noi tutti però se farete il ...
bo sarete castigato alla più severa
punizione cioè la morte
Volete sapere come dovete
fare certiote amici di onoré
e che non siamo infime
la nostra sede si trova in
Chicago Illi in Pizzzburgo Pa
in Colombo O però dove
vi viene più comodo andate
e cercherete e se non troverete
in una queste città andate

nelle altre e così sereno sicuri
che voi troverete qualche buono
amico che avrà pietà di voi
e così vi potrà levare questo
male che vi contrista
vi avvertiamo positivamente
di non allargarvi a parlare
molto sopra di noi che noi
sappiamo tutto e dippiù di
non andare per giustizia
che se farete questo per voi
non c'è nessuna speranza
di campare saperlo bene
regolare sezeate di non dormire
tre più il nostro mestiere e
questa vi facciamo risveglia
...

And the Grand Jurors say that a translation of the words
of said letter and communication into English is as follows:-

Well our Society comes to make you a visit and to let
you know that we came from Italy, escaped on account of cer-
tain circumstances which we had and having need of money,
as we are broke and as we are in the Society of the Black
Hand, our friends have directed us to you as you are a rich
man, and we believe that you are a kind man and that you
will not refuse to disgorge the sum of $12,000. and if you
do this you will be respected by us all, however, if you are
deaf, you will be punished with the worst punishment which
is Death. You will know that you are to do. Search for
honorable friends who are not infamous. Our seat you will
find in Chicago, Ill. in Pittsburgh, Pa. and in Columbus, Ohio
therefore you will go where it suits best.

Go and search and if you do not find us in one city you
will go to another, and thus you will find some good friends
who will have pity on you, and help you to settle this
trouble.

We warn you not to talk too much against us, as we know
it all, and at the most do not go to the justice for if you
do this there will be no hope for you to live. Obey the
rules, do not sleep, for our train is this, and we will wake you
up quicker than possible.

We sign,

The bandit Society,

Black Hand.

We warn you further that the above sum must be paid
by the entire company that is, Gentile, Gatalano & Company.

94

Opposite: Count 5.

Above: Count 5. Date: January 19, 1909. Addressed to: Ignazio Gentile, Dayton, Ohio.
Mailed from: Delaware, Ohio. Written by: Joe Nuzzo.

Siamo alla terza lettera e noi
crediamo bene che voialtri
siete tutti tranquilli e contenti che
non avete messo una persona
in giro per potere accomodare
questa faccenda ma noi ve
lo giudiamo che queste lettore
che vi facciamo sarà la vostra
condanna di andare qualcuno
di voialtri chi capita il primo
di morire per sé appunto noi
siamo bene informati che
voialtri siete ricchi possidente
e la detta somma che vi
abbiamo ordinito di mettere
la potete sborzare senza

indugiare a perdere tempo op-
pure noi capiamo che volete
fare li spiritosi e li sostenuti verso
di noi ma ve lo ripetiamo che
vi troverete troppo in isbaglio
che chi troppo si fida si trova
ingannato appunto vi diciamo
questo che voialtri cercate tempo
e quando avrete tempo non vi
troverete la disposizione da fare
qualunque delitto
 pensatela
 ora vediamo
se amate la moneta
oppure pensate
 la vostra vita

la mano nera
 con tutti
 i suoi
 membri

La nostra sede è
in Colombus O
in Pizzoburg Pa
in New York

And the Grand Jurors say that a translation of the words
of said letter and communication into English is as follows:-

Well we have arrived at the fourth letter and you are
so infamous as to make us believe that you do not understand
anything, but by Madonna's blood we swear that we will not
leave you one hour in peace, if you do not pay the money or
we will take the life of one of your family. You know very
well that you must go to Pittsburgh or to Buffalo or to New
York in which cities exist our heads and our companions,
therefore there is no need to repeat these things to you
again. You know what to do and must do it. Beware! Do
not go to the justice for if you do this it will be worse
for you. We repeat again the money must come, either by
force or by good-will, and we are tired of writing and do
not wish to write so much, because you rogues wish to uphold
yourselves,- we will shorten the time and we repeat, we will
not write any more, but you must not think that this time it
will be smoothed over, for thus far we have worked with the
pen, but hereafter we will apply the remedies. Either with
powder and ball, or with dynamite, whichever pleases most.

We sign, the Black Hand of the United States.

/ 2 100

Opposite: Count 5-2.

Above: Count 5-2. Date: February 16, 1909. Addressed to: Ignazio Gentile, Dayton, Ohio.
Mailed from: Pittsburgh, Pennsylvania. Written by: Joe Nuzzo.

Dunque siamo alla 2ª lettera
e voialtri siete tanti infame che
facete copire se non capite
niente ma sangue della
Madonna ve lo giudiamo
che non vi lascremo ancora
in pace se non uscite la
moneta oppuramente la
finiremo con levarvi la
vita a qualcuno di voialtri
voialtri ben sapete ciò che
dovete fare di rivolgervi in
Piazzoburgo o in Busto o in
Nev Jorico la quale esistono
i nostri copi e nostri compagni
perciò non vi è di bisogno

di ripeterui ancora un discorso ti
voialtri sapete come dovete fare
Badate di non andar per più
stiga che se questi facete peggio
ancora per voialtri di più vi
ripetemo che la moneta deve
venire o per forza o per buona
voglia dunque siamo stretti
di ricevere e non vogliamo
tanto scrivere perciò con
voialtri gente canaglie che
volete fare li sostenuti noi
acarezeremo le parole perciò
vi ripetemo che non vi scriverò
più mo no non lo voleti credere
che vi lo proverete liciam

de per ora abbiamo lavorato
son lo penna ceco di oggi in
poi penseremo i nostri rimedio o
con la polvere e le palle o con
la tarantula e ciò che vi vie
più comodo

Ni firmiamo la mano
La Nera dei stati
agonti

And the Grand Jurors say that a translation of the words of said letter and communication into English is as follows:

We have come with the 3rd. letter and we believe that you are all peaceful and contented as you have not sent any one to accommodate us in this affair, but we swear that this letter, which we write will be your condemnation, and the first one of your firm we meet will be killed, for we know that you are possessed of riches and the above sum which we have ordered you to pay, you can disgorge without delay or loss of time, and we understand that you wish to be strong and defend yourself against us, but we repeat that you are badly mistaken, and if you have too much faith you will be deceived. We don't allow you time to think over the matter, for the desperation makes commit any crime. Think of it! now we will see if you love your money or if you think of your life.

The Black Hand.

With all their members.

Our seat is in Columbus, Ohio in Pittsburgh, Pa. and in New York.

106

Opposite: Count 5-3.

Above: Count 5-3. Date: March 16, 1909. Addressed to: Ignazio Gentile, Dayton, Ohio. Mailed from: Pittsburgh, Pennsylvania. Written by: Joe Nuzzo.

Caro amico
Vi abiamo mandato due lettere
e non abiamo visto comparire a
nessuno, e ora invece di caminare
voi con i vostri amici, veniamo noi
a Cincinnati, e vennimo con l'intenzio
ne, o di uccidervi o di farvi salta
re in aria come abiamo fatto col
palarmitano, a taluna di voi altri
vi pare che noi siamo gente di poco
conto, e vi facete sordi, ma noi siamo
buoni farvi venire la tisa. opure di
commettere qualunque delitto per
denari, perciò se volete evitare ogni
pericolo cercate amici e mandateni
2000 - due mila scuti a Cleveland
entro questo mese, arrivato che man
date la persona e penziero nostro
trovare chi porta la moneta

anche voi potete venire assieme con
l'amico che voi sceglierete, noi siamo
gente che damo tutti le medicine
avanti che mettimo mano all'armi.
ma se vedemo che le nostre medicine
non vi fanno profitto, daremo l'ultime
a coloro che si rifiutano, e chi resta
vivo della vostra famiglia sempre
il denaro deve uscire, come anno
fatto gli altri che sono caduti sotto
la nostra potente mano, vi dovete
mettere in testa che fanno ni cattamo
quannu prima uscite il denaro
o si ni faciti fari ancora spese, per
duemila scuti non ni contentamo più.
vi salutiamo, e alcuni di noi aspet
tano i vostri denari a Cleveland e
nátra poca siamo a Cincinnati per
sapere l'esito risultato e siamo

di giorno e faremo quello che sen
piamo fare, non vi la prendete con
indifferenza, perche dovete uscire
la moneta e nemmeno ci può dio.

And the Grand Jurors say that a translation of the words of said letter and communication into English is as follows:-

Dear Friend:-

We have sent you two letters and have seen no one appear and now instead of you walking with your friends, we come to Cincinnati and come with the intention of either killing you or making you to raise in the air as we did with the Palarmitano. To such as you are it appears that we are people of little account and you make yourself deaf, but we are able to turn the trick or to commit whatever we please for money; therefore if you wish to avoid every danger, hunt up friends and send us $2000 to Cleveland within this month. Announce that the person is sent and we will find who carries the money; also you may come along with the friend whom you choose. We are people who give all the medicine before we put on the hand of alarm, but if we see that our medicines do not help you, we will give the last to those who refuse us, and from whom remains alive of your family the money must always come, as we have done to the others who have fallen under our powerful hand. You must get it into your head that we have cautioned you when to send the money and you wish to make more expense. For the $2000, we will not contend any more. We salute you and some of us await your money at Cleveland, and a few of us are in Cincinnati to see your results, and we are able and within your house we will enter by day and will do that which we know how to do. Do not take this with indifference for you must come up with the money and not even God can prevent.

119

Opposite: Count 6.

Above: Count 6. Date: January 19, 1909. Addressed to: Salvatore and Antonio Rizzo, Cincinnati, Ohio. Mailed from: Cincinnati, Ohio. Written by: Salvatore Lima.

Caro amico

Noi accettiamo il vostro an
damento: ma non vediamo spun
tare nessuno, forse vi chrecete
che scherzamo. oppure vi sembra
che ne lo dimentichiamo, noi
finiamo quanto prima ni date la
moneta. o altrimenti qualche volta
finiranno i vostri giorni. quando non
ve laspettate. perciò sceglete qualche
amico vostro onorato di Cincinnati
e assieme a voi portatene 2000 $.
Duemila scuti in Clevelad. Ohio.
che là mentre voialtri cercate
da noi sarete trovate, e le perso
ne che vi si presentano vi chiede
ranno il passaporto, e voialtri gli
darete la moneta, badate a non
rifiutarci altrimente vi ammazzeremo

vi damo tempo altri 15 giorni per
riflettere. e poi quando ni cercherete non
ni troverete. con noi e difficile chi
se la scampa. e chi è cascato sotto
le nostre mani. o denari o la
sterminazzione. se l'altra volta
vi scattò la pippa dell'agua. un'al
tra volta vi faremo scattare la
testa. se vi rifliutate a mandarni
a portarni la moneta

And the Grand Jurors say that a translation of the words of said letter and communication into English is as follows:-

Dear Friend:-

We accept your way of acting, but we don't see anybody come up. Perhaps you think we are joking or that we may forget. We will stop only when you will give us the money, or otherwise some day your days will end when you don't expect it. Therefore, get some friends of yours of Cincinnati that you have confidence in, and with him bring $2000. in Cleveland, Ohio. That while you will be looking for us there, we will find you, and the people that will present themselves will ask you for your passport, and you will give him the money. Be sure not to refuse otherwise we will kill you. We will give you 15 days time to reflect, and after that if look for us you will not find us. It is hard to escape us, and for him who has fallen in our hands there is nothing but money or extermination. If the other time the water pipe bursted the next time we will make your head burst, if you refuse to send or bring us the money.

132

Opposite: Count 7.

Above: Count 7. Date: February 2, 1909. Addressed to: Battista Terzo, Cincinnati, Ohio. Mailed from: Delaware, Ohio. Written by: Salvatore Lima.

amico,

gli amici vogliono 1500 $ se non
peggio per te'.
se acconsenti metterai 3 loxs vuoti di
arangi fuori
non ti fidare con pulizia cha peggio
per te.
 Ti saluta
 L. m. n.

And the Grand Jurors say that a translation of the
words of said letter and communication into English is as
follows:-

Friend.

The friends wants $1500.00 from you. Otherwise it
will be bad for you.

If you will give the money, put three empty boxes of
oranges outside of your store.

Do not trust the Police, otherwise it will be bad
for you.

With best regards.

The Black Hand.

Top: Count 8.

Bottom: Count 8. Date: February 20, 1909. Addressed to: Ignazio Camella,
Cleveland, Ohio. Mailed from: Cleveland, Ohio. Written by: Salvatore Lima.

And the Grand Jurors say that a translation of the words
of said letter and communication into English is as follows:-

Mr. Purpura:-

We need help and we have no one that can ask
you for it, we know that you are in a good position and
have plenty of money and we ask you to give us a very small
amount $5000. We know very well that you can afford to give
us this amount and that you would never miss it.

We want to warn you about going to the au-
thorities about this matter for it will go hard with you if
you do, we will now tell you where you can find us, our men
are in Chicago,Ill., Buffalo, N.Y. and you can find some
good friend of yours and he can give you instructions, select
a good man who will not tell the authorities, be very careful
of this friend you are to find, for if he does not suit us
we will first kill him and then you.

The Black Hand.

Top: Count 9.

Bottom: Count 9. Date: March 16, 1909. Addressed to: Vincenzo Purpura, Dayton, Ohio.
Mailed from: Pittsburgh, Pennsylvania. Written by: Charles Vicario.

155

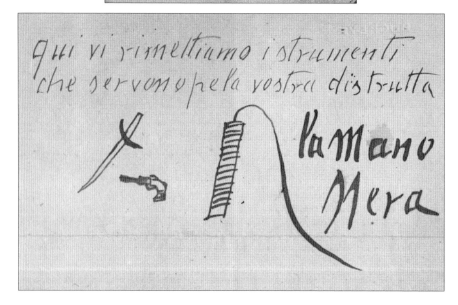

La † Mano Nera

dopo due lettere e questa
tre ed ancora non avemo visto a
nessuno. voi forse vi pare che è
una buffonata ma badate corpo
di dio che avete da fare con per-
sone che poco sicurano della vita
se voi questa volta non venite
al dovere sarete più che sicuro
che vi facciamo saltare per aria
pe via di dinamite. in contrario
corpo della Madonna vi facemo
fare la fine che fece il vostro
amico e infame sbirro col nome
di giuseppe Petrosino. a Palermo
in Piazza Marina. non dubitate
che fra poco tempo vi facemo cono-
scere quello che noi sapemo fare-
pezzo di carognone e infame che
sete.

qui vi rimettiamo istrumenti
che servono pe la vostra distrutta

la Mano Nera

And the Grand Jurors say that a translation of the words of said letter and communication into English is as follows:

The Black Hand.

After two letters, and this is the third, and we have not yet seen any one, you possibly think that this is foolishness, but beware, by God's body you are dealing with persons who care not for life. If you do not do your duty this time, you can be sure that we will blow you up with dynamite, or by Madonna's body we will finish you, as we did your friend and infamous police Petrosino at Palermo, in Piazza Mariana. Do not doubt that soon we show you what we can do, you big piece of carrion and infamous that you are.

Here we sent you the instruments which will serve to destroy you.

The Black Hand.

163

Opposite: Count 9-2.

Above: Count 9-2. Date: March 31, 1909. Addressed to: Vincenzo Purpura, Dayton, Ohio. Mailed from: Pittsburgh, Pennsylvania. Written by: Charles Vicario.

Caro Amici Cosintino lanostra
setta lichinata mano hera viene
offare una visita gia siete stato
ordinato della nostra setta ordine
delnostro capo di pittsburg pa,
di uscire scuti 2000, rivolgen-
doui appersone onorate, onorati-
ssimi, he parti, siporta in pittsburg
pa.—va cercando che mentre—
lue cerca danoi sara trouato.
Questo deve cominciari acirari del
girno 5. giugno sino il 10. ...
tutti igiorni sideue trattinere delle—
ore.10. di mattina alle ore 3. he
ll'union dipo dipittsburg, pa etrapa-
ssare il ponte alle 6. strade nuá
da pittsburg, per allegheecci pertutte
le sere, di questi girni dalle dalle—

10. di sera allamenzannotte. deue
passigiare sulponte. lapersona de-
ue auere un capello binco e 2 fiu-
re dipetto unfiure bianco edi
uno rosso mentre lue cerca da-
noi sara trouato. anzi se laper-
sona annoe honnipiace honsaua
auicinato voibensapete he se
virrivogete alle sbirre lanostra-
ta sara finta: uiscannirchio como
uno animale; come pure voisape
te he noi abiamo una medicina
he mentre dormite conloro famig-
lia lanostra casa saltera peraria.
Quindi scuoleti e iuetare lamorte
voc stará avuoi auuoi: circate
persone onrate he parte subito.
Badate di honsbagliate—

nessuno sotto lenostre mane
selaputrá fare franca: hi danoe
viene rigestrato nello rigistro—
ho. il dinaro. holauita. scuoi-
cifaorik sareti rippettato e ufa-
uiamo rippettare; di tutto il
mondo perche lanostra setta
ttene tutto il mondo. sotto ipiedi.
fatiue il conto discorrete
infamiglia ubidite e cosi starete
beni esireno. sono due punte
strene ho. dinaro. ouita
fuori isbirre.
uisalutiamo lamano mera-

And the Grand Jurors say that a translation of the words of said letter and communication into English is as follows:-

Our band called "black hand" have come to make a visit. Already you have been ordered by our head at Pittsburgh, Pa. to come out with $2000. address yourself to some honorable person, MOST HONORABLE, who will bring it to Pittsburgh, Pa. searching around and while he is searching he will be found by us. This search must begin on the 5th of June, until the 10th every day he must go up and down the street from 10 o'clock A. M. to 3 P.M. in the Union depot at Pittsburgh, Pa. pass over the bridge at 6th street which goes from Pittsburgh, Pa. to Allegheny every evening of these days from 10 o'clock P.M. to midnight. The person must wear a white hat and two flowers on his coat--one white and one red, while he searches he will be found. If we do not like the person we will not approach him. You know well that if you seek aid from the police your life will be ended. We will slaughter you like an animal, as you also know that we have some medicine that while you sleep with your family your house will be blown up. Then if you wish to avoid this death----- be yourself, search for an honorable person, who will leave at once. Beware! make no mistake. None under our bands can go free, and he who is registered by us in our register, either the money or the life. If you favor us you will be respected and we will respect you, for our band holds the whole world under their feet. Take account of it and discuss it with your family, obey and be well and happy. There are two extreme points, the money or your life, without the police.

We salute you.

The Black Hand.

175

Opposite: Count 10.

Above: Count 10. Date: March 26, 1909. Addressed to: Giuseppe Cosentino, Cleveland, Ohio. Mailed from: Columbus, Ohio. Written by: Salvatore Lima.

La Mano Nera

distrutta ✝ in Famiglia

Signor giovanni tralia

noi siamo li stessi perseguitori di

Biagio Bonanno e dei Romanelli

e ora siamo i vostri perseguitori motivo

che la somma che dovevano pagare essi la

dovete pagare voi che sarebbe #2000.00

Badate che se non uscite la detta somma

venite ucciso come il vostro amico Bonanno

e dove andate vi inseguiamo, perchè il

nostro Braccio si stende per tutto il

mondo. Noi siamo quelli che ne la prendemo

pure con la Polezia e se voi

non consegnate la detta moneta

fate la stessa sorte che fece

Petrosino a Palermo brutto

vigliacco e cretino che siete

badate corpo della Madonna

che avete da fare con persone
che poco se ne curano della
propria vita non passerà tanto
tempo che se voi non venite al
dovere morite sicuro vi uccidiamo
quando voi non ve la spettate
La moneta portatela in
eleveranti nel dipò di Lingal
Plei, si presentano cinque per-
sone e vi domandano da fumare
allora voi consegnate la moneta
dovete avere per segnale un
fazzoletto rosso alla gola - vi da
mo tempo dal 5 di Aprile fino
alle 25 di Aprile
Non andate per la polizia
che è peggio per voi, se mandate
la somma sarete protetto
durante il tempo della vostra vita
ma se non la mandate passera
temporaneo morirete sotto le nostri
mano

La presente la firmamo
con il sangue per farvi
conoscere che siamo proprio la
mano nera e quello che diciamo
lo faremo

La Mano Nera

And the Grand Jurors say that a translation of the words of said letter and communication into English is as follows:-

The Black Hand, destruction in the family.

Mr. John Trolio.

We are the same persecutors of Biagio Bonanno and of the Romanelli's and now we are your persecutors for the reason that the sum which they had to pay, you must pay, which is $2000.

Beware! That if this sum is not forthcoming you will be killed like your friend Bonanno, and wherever you go, we will follow, because our arm extends over the whole world. We are they who care not for the police and if you do not consign the aforesaid money you will meet the same fate as Petrosino at Palermo, ugly coward and heretic that you are, beware by Madonna's body. You act like a person who cares little for his life, not much time will pass if you do not come to your duty you will surely die. We will kill you when you do not expect it. Bring the money to Cleveland, to the depot in Lingal Place, there will be five persons present and they will ask you for something to smoke, then you give them the money. You must have for a signal a red handkerchief around your neck. We give you from the 5th of April to the 25th of April. Do not seek the police for that is bad for you, if you send the sum you will be protected during the time of your life, but if you do not send it, time will pass but you will die under our hands. This letter we sign with blood to let you know that we are really the black hand and that that which we said we will do.

The Black Hand.

187

Opposite: Count 11.

Above: Count 11. Date: March 27, 1909. Addressed to: John Trolio, Dennison, Ohio. Mailed from: Cleveland, Ohio. Written by: Charles Vicario.

poche parole. non più tardi del
giorno 25 del mese entrante la
moneta deve essere a pizziburgo
portatela o voi o qualche persona
fidata. la persona che porterà il
denaro dev avere un fazoletto bianco
al collo e una umbrella nei mani
e quando scende dal dipò deve
prendere la strada lungua del
dipò e caminare e chi ci dirà
amico datemi un bacio ci potrà
consegnare il danaro. Se mancate
o pure vi dirigete con la legge
quando non ve laspettete vi
faremo vedere una bella
festa
 la mano nera

La MONETa dive
ESSERE PORTATa NElle
MESE CORRENTE ultiM
YORNO SaRa giorNo 25
CORRENTE
La MaNO NERa

And the Grand Jurors say that a translation of the words of said letter and communication into English is as follows:-

A few words, not later than the 25th day of next month that is April the money must be in Pittsburgh, bring it either yourself or have some trustworthy person bring it, the person who will bring the money must have a white handkerchief around his neck nd an umbrella in his hand and when he gets off at the Depot must take the street along the Depot and walk, and to whoever says friend give me a kiss he will to him give the money. If you fail or seek said from the law when you do not expect it we will make you see a beautiful feast.

The Black Hand.

The money must be brought in the current month- the last day will be the 25th of the current month.

The Black Hand.

200

Opposite: Count 12.

Above: Count 12. Date: April 8, 1909. Addressed to: Matteo Rini, Cleveland, Ohio. Mailed from: Railway Post Office, Pittsburgh, Pennsylvania. Written by: Salvatore Rizzo.

Caro Amico

È trascorso molto tempo per darvi largo per decidere il vostro penzare e non volendo più aspettare, vi scriviamo per farvi ricordare che è passata l'ora, e che noi volemo la moneta che vi abiamo domandata, Non vi fate più lusingare di qualche amico vostro che vi a detto di non uscire denaro, perche sotto il nostro braccio non se la fa tò franca nessuno, e che noi usiamo, o denari o sterminazzione, e ne avete visto la prova, sopra quel sdisonorato di morello, e se non era per riguardo degli innocenti figli a questora fosse già morto sallando in aria con la bomba che ciabiamo sparato, mettendocila

e alla vita della vostra famiglia, vi dovete mettere in testo che noi conosciamo a tutti i taliani, e di penziero nostro venirvi a trovare in Cleveland quando mandate la moneta, la persono che porta la moneta gira per la città e da noi sarà trovata, non perdete più tempo perche se noi mettemo mano a fuoco la colpa e vostra

sotto dove lui dormiva, e se non si mura la bocca per sempre gli faremo vedere la differenza che passa tra i scassa paghiara e lui perciò se voi aspettate che noi agiamo verso di voi in modo come solemo usare, facetevi ancora sotto e vedrete come vi finirà, dovete uscire il denaro come cosa certa perciò cercate amici che vi potranno mettere nella via giusta e non tardate, e quando più presto sarete venuto al dovere, tanto più presto vi rasserenati, e da noi sarete protetto, noi aspettiamo a Cleveland o avoi con un amico vostro onorato, eppure se non volete venire voi la persona che deve portare la moneta deve essere onoratissima altrimenti l'ammazzeremo.

dovete mandare o portare due mila scudi, e se state ancora a cercare tempo aumentamo la somma e vi finirà come a finito agli altri, e unaltra cosa che chi resta vivo della vostra famiglia dovrà sempre uscire la moneta. Caro amico noi abiamo avuto per voi troppa pazienza, e non viabiamo fatto del male, perché abiam saputo che ci sono stati amici vostri cascittuna che vi anno sconzigliato a uscire la moneta e voi siete stato tanto miserabe che vi avete fatto connuscere di essi, ma ora arrivò il punto che se mancate, mancate voi e se noi vi faremo saltare la testa e perché voi tenete passione al denaro e non alla vostra vita

And the Grand Jurors say that a translation of the words of said letter and communication into English is as follows:-

Dear Friend:-

Much time has passed to give you time to decide what to do and not wishing to wait longer we write to let you know that the hour is past and that we want the money which we have demanded of you. Do not be flattered any more by your friends who advised you to not pay the money, for under our arm no one can go free, and we use either the money or extermination, and of this you have seen the proof in the dishonored Morello and if it were not for the regard of the innocent children he would be dead by this time, blown into the air by the bomb which we shot under where he was sleeping, and if he does not shut his mouth forever, we will show him the difference between a worthless man and himself.

If you are waiting to see what we are going to do with you, just remain deaf and you will see how it will end. You will certainly have to pay the money; therefore search for friends who can put you on the right road and do not delay, and the sooner you do your duty the sooner you will be released and by us you will be protected. We await either you or an honored friend at Cleveland; or if you do not wish to come yourself, the person who carries the money must be a most honorable person, otherwise we will kill him. You must send or bring $2000. and if you still put it off we will increase the sum, and you will end the same as the others, and he who remains alive in your family must always pay the money. Dear friend, we have had too much patience with you, and we have donw you no wrong, because we have known that some of your hog friends have advised you not to pay the money and you have been very miserable because you have listened to them, but now the time has arrived, if you fail, and we blow your head up in the air, it will be on account of your passion for money and not for your life and the lives of your family. You must get it in your head that we know all the Italians, and think of our coming to Cleveland to find you. When you send the money, the person who brings it must walk around the city and he will be found by us. Do not lose any more time, for if we extend the hand of fire the fault will be yours.

213

Opposite: Count 13.

Above: Count 13. Date: March 31, 1909. Addressed to: Tavillo Giardina, Indianapolis, Indiana. Mailed from: Chicago Heights, Illinois. Written by: Salvatore Lima.

Misseri e sillella sgangata
e arrivato il tempo di esigere. il
vostro billo che dovete pagare da
lunga data, perciò, gia che non
avete cercato ne parenti, ne amici,
mettetevi due mila scuti addosso,
e li dovete portare sempre con voi
notte e giorno, che quando siamo
accomodo noi vi veniamo a cerca
re, e ni li darete. se per caso non
ve li trovate di sopra, quando noi
ni presentiamo. come ni dice la testa
faremo. non vi abiamo voluto fare
del male, per i vostri figli, e voi
ve ne siete approfittato. ora finiz

And the Grand Jurors say that a translation of the words of said letter and communication into English is as follows:-

Missero e siletta sgangata (an epithet.)

The time has arrived to pay your bill, which you whould have paid long ago, therefore as you have not searched for either relatives or friends, you will put $2000. in your pocket and must carry it with you always - night and day, and when it is convenient we will come and search for you and you will give it to us; if in case you do not have this money when we meet you, whatever comes into our head we will do. We have not wished to do any harm to your children and you must profit by that. Thats all.

225

Opposite: Count 14.

Above: Count 14. Date: May 25, 1909. Addressed to: Giovanni Annarino, Cincinnati, Ohio. Mailed from: Chicago Heights, Illinois. Written by: Salvatore Lima.

SIGNORE GATTO
NOI IN SECOLO VI INVIAMO
LA PRESENTE dunque A QUESTA
ORA FORSE CHE A VOI
VI SEMBRA CHE NOI BUFFONAMO
MA BADATE CHE NOI PAREMO
SU SERIO, Quindi SARA
MEGLIO PER VOI SE VENITE
ALLO dovere PER CHE SE VOI
VI PATE GLI ORICCHE di MERCANTI
PORCA MADONNA NON PASSERA
ASSAI tempo CHE P PAREMO LAVO-
STRA FESTA FORSE VOI CREDITE
CHE AVETE dA FARE CON PERSONE
CHE TENGONO timore dA VOI
O PURE dELLA polizia. BAdATE
CHE VOI VI SETE SBAGLIATO

NOI SIAMO PERSONE CHE
NON tiMEMO di NESSONO NOI
NON tiNEMO NULLA dA PERdiRE
Quindi EA CORPO di dio
SARA MEGLIO PER VOI d'CERCARE
AMICE ONORATI PER dARVI
Auito E CONSIGLIO PER CHE
A NOI POCHI CI IMPORTA dELLA
VOSTRA MARIA SPATLA
E SE VOI VI PATE GLI ORICCHI
dA MERCANTE PORCO ddio
VI UCCIdiAMO COME UN CANE
O PURE VI PAREMO SALTARE
PER ARIA PE PER VIA di diNAMITE
PORCO di dio BAdATE CHE
AVETE dA FARE CON PERSONE
CHE NON VILASCIREMO O SE NON
CONSIGNATE LA MONETA
O LA VITA Quindi ESEMINATI
BENE Questi PAROLI
GRAN PEZZO di INFAME.
E VI AVERTIAMO

NON APPENA RECIVETE
LA PE LA PRESENTE SUBITO
dOVETE CERCARE AMICE
PERCHE NOI NON SIAMO
A MANI di COSI LUNGUE
E GUANTE N NOI SCRIVIAMO
UNA LETTERA VOGLIAM E ESSERE
SUBITO indi si, Quindi CIRCATE
AMICE. NOI SAPEMO CHE SE
VOI VOLETE CERCARE
AMICE ANCHE LE TROVERITE
IN PITTSBURGH PA.
VI AVERTIAMO CHE IL
NOSTRO CAPO SI TROVO
A BUFFOLO, BAdATE di NON
ANdARE PER LA polizia
PER CHE SARA PEGGIO PER VOI
dOVETE FARE LE COSI
CON VERO SICRETO,

LA MANO NERA

168

And the Grand Jurors say that a translation of the words

of said letter and communication into English is as follows:-

Mister Gatto.

 With this wesend you the second letter, for at this
time it possibly appears to you that we are fooling, but
beware: we are serious. So it will be better for you to
come to your duty, for if you turn a deaf, "Hog Madonna"!
it will not be long until we will make your feast. Possibly
you believe that you are dealing with persons who have fear
of you or the police. Beware! you are mistaken. We are
persons who fear no one - we have nothing to lose.

 Then "Body of God", it will be better for you to search
for honorable friends to give you aid and counsel, because
your broken-down Mafia is of little importance to us and if
you turn a deaf ear, "Hog God" wewill kill you like a dog
or send you up in the air by the dynamite route. "Hog of
God" beware! you have to deal with persons who will not
leave you - If you do not pay the money, you pay your life.

 Then examine well these words,"great piece of infamy",
and we advise you that as soon as you receive this, you must
search forfriends at once, for we do not send these things
long, and when we write a letter we wish to be understood
at once. So search forfriends, we know that if you wish
to search forfriends, you will find them in Pittsburg, Pa.

 We advise you that our head is at Buffalo. Beware!
do not go to the police, for that will be worse for you.
You must do the things in true secrecy.

 The Black Hand.

237

Opposite: Count 15.

Above: Count 15. Date: April 7, 1909. Addressed to: Joseph Gatto, Blairsville, Ohio. Mailed from: Cleveland, Ohio. Written by: Tony Vicario (alleged). COUNT DROPPED.

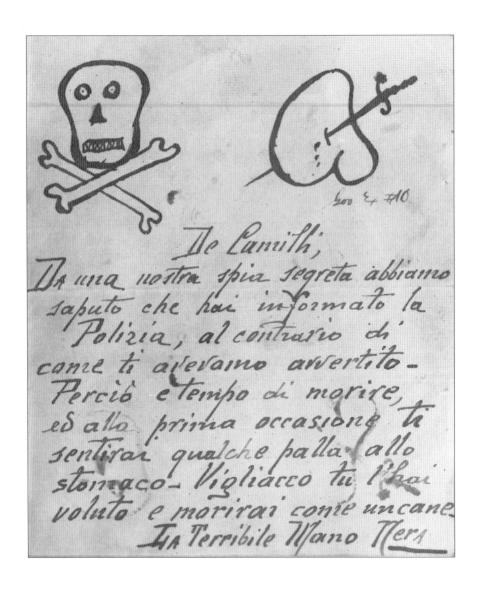

And the Grand Jurors say that a translation of the words of said letter and communication into English is as follows:-

De Camillo:-

From one of our secret spies we have learned that you have informed the police, contrary to our warning. Therefore it is time to die, and on the first occasion you will feel a bullet in your stomach. Coward. You have willed it and you will die like a dog.

The Terrible Black Hand.

Contrary to the form of the statute of the United States in such case made and provided, and against the peace and dignity of the United States.

...

United States Attorney.

A TRUE BILL.

...

Foreman of the Grand Jury.

95

Opposite: Quashed Count.

Above: Quashed Count. Date: June 8, 1909. Addressed to: Gaetano De Camilli. Mailed from: Unknown. Written by: Salvatore Lima (alleged).

PRISON RECORDS

Inmate files were kept for prisoners at Leavenworth federal penitentiary. The records included copies of the inmates' conviction information, personal data sheets, medical records, Bertillon measurements and fingerprint cards. Daily work records were filed and trusty prisoner's agreements were signed when an inmate earned the trust of the guards, allowing them to lead work crews. Correspondence logs were kept for incoming and outgoing letters, and important letters were recorded in the inmates' files.

The following records include letters written to the warden by the daughters of Sebastian Lima and Joe Ignoffo and a statement made by Salvatore Lima about his life leading up to his arrest and conviction.

All images are courtesy of the U.S. National Archives unless otherwise noted.

Above: Tony Vicario intake record. *New York State Archives.*

Opposite: Fingerprint card of Charles Vicario.

THIS FORM IS NOT TO BE PINNED.

Name _Colegero Vicario_ MALE
Aliases_____

Classification No. 5 — L/r — 9 / 1 — L/r — 7

9455

Prison Register No. 6900 RIGHT HAND.

1.—Right Thumb.	2.—R. Fore Finger.	3.—R. Middle Finger.	4.—R. Ring Finger.	5.—R. Little Finger.

LEFT HAND.

6.—L. Thumb	7.—L. Fore Finger.	8.—L. Middle Finger.	9.—L. Ring Finger.	10.—L. Little Finger.

9455

LEFT HAND. (9455) RIGHT HAND.

I, _Charles Vicario_ , a prisoner in the United States Penitentiary at Leavenworth, Kansas, do hereby authorize the Warden of said Penitentiary by himself or his authorized representative to open and examine all lettes, papers and other mail matters and all express packages which may be directed to my address so long as I am a prisoner in said Penitentiary.

Dated at the United States Penitentiary, Leavenworth, Kansas, this 31st day of Jany, 1910

Charles Vicario _Salvatore Arrago_

Top: Charles Vicario "Letters Received."

Bottom: Frank Spadara was assigned to work in the female prison yard.

Opposite: Fingerprint card of Saverio Ventola, the carpenter.

THIS FORM IS NOT TO BE PINNED.

Name _Saverio Ventola_

Aliases _____

MALE

Classification No. _10 11_
6 77

36874

Prison Register No. 6901

RIGHT HAND.

1.—Right Thumb.	2.—R. Fore Finger.	3.—R. Middle Finger.	4.—R. Ring Finger.	5.—R. Little Finger.
21	9	AMP. 18		
			W	W

LEFT HAND.

6.—L. Thumb	7.—L. Fore Finger.	8.—L. Middle Finger.	9.—L. Ring Finger.	10.—L. Little Finger.
12		18		
	T		W	W

LEFT HAND. 36874 RIGHT HAND.

I, _A Ventola_ , a prisoner in the United States Penitentiary at Leavenworth, Kansas, do hereby authorize the Warden of said Penitentiary by himself or his authorized representative to open and examine all lettes, papers and other mail matters and all express packages which may be directed to my address so long as I am a prisoner in said Penitentiary.

Dated at the United States Penitentiary, Leavenworth, Kansas, this _31st_ day of _Jan_ 19 _10_

A. Ventola

TRUSTY PRISONER'S AGREEMENT.

Name **Saverio Ventola** , No. **6901** , Color **White**

Crime **Conspiracy**

Sentence **—2—** , years **—** , months **—** , days **—**

Date of Sentence **January 30th 1910** , Sent from **Toledo, Ohio**

Full term expires **January 29th 1912** . Short term expires **September 7 1911**

Received at Penitentiary **January 30th 1910** Occupation **Carpenter** Age **60**

Reasons for being made a Trusty Prisoner

Is the above stated name your right name? **Yes**

If not, what is your right name?

Give a full history of the crime for which you were sent here: **I had a Commission House in Columbus,** (State fully the nature of the crime. Persons injured physically, financially, **Ohio handling fruit and Salvator Lima, 6892 wrote me a letter that he was** or otherwise. State when and where crime was committed. Names of persons with you when crime was committed and what was done with him or them. State the **going to ship me some fruit. I immediately wrote him not to send me any fruit** reason why the crime was committed and whether or not you plead guilty at the trial.) **as the weather was warm and the fruit would not keep When Lima was arrested my letter to him was found on his person which caused the authorities to believe I was implicated with him in the Black Hand Business**

With whom do you correspond? **Mary Ventola, Wife 324 East Spring St. Columbus, Ohio.**
Mary Capuano, Sister, 323 Spring St. Columbus, Ohio.

Where and by whom were you arrested? **Columbus, Ohio. Deputy Marshal do not know his name**

Are you married? **Yes** Number of Children? **Three**

Name and P. O. address of parents, **Both dead**

Name and address of wife, **Mary Ventola.**

Have you ever served sentence in Penitentiary, Reformatory, Work House or Jail before? **Yes about 22** (State under what name, when and **years ago. Was arrested at Cincinnati, O. and sent to Columbus, O. for 18 mos.** where.) **for short changing**

Do you own any real estate? **None** (State where located and the value of it.)

In consideration of being made a Trusty Prisoner, I **Saverio Ventola** , No. **6901** , a prisoner in the United States Penitentiary, Leavenworth, Kansas, do hereby pledge my word that I will not attempt to escape from said Penitentiary or Penitentiary Reservation, and will serve faithfully the unexpired part of my sentence.

(Signature) *Saverio Ventola*

Register No. **6901**

Remarks: **Mary Capunus, Sister, 323 Spring Street Columbus, O. Have no Brothers**

Trusty prisoner's agreement for Saverio Ventola.

Columbus. O. Sept 1st 1912

Chief Clerk
U.S. Penitentiary. Leavenworth Kan

Sir

I beg your pardon if I take the liberty
to address this letter—
I was in the U.S. penitentiary at Leavenworth Kas
for 19 month. and I went out from there
on last Sept. 7—
Now Kindly I request you if you will
be kind enough to send me one of
your papers which they contain the
rules have to apply the petition to
get my citizenship bak again—
as I did forghet to ask for one there
when I went out—
Hoping that you will grant my request
I remain your respectfully
Saverio Ventola
My address is—— 167. North Grant. Ave
Columbus Ohio

A letter to the warden from Saverio Ventola.

179

UNITED STATES PENITENTIARY
LEAVENWORTH, KANSAS.

Name *Salvaton Demma* No. 6898 Color *White*

Alias *Salvaton Demar*

Received	*Jany 30 1910*
Military or Civil Prisoner	*Civil*
From	*K.D.O. Toledo*
Crime	*Conspiracy*
Sentence	*2* Years — Months — Days
Date of Sentence	*Jany 29 1910*
Sentence Begins	*Jany 30 1910*
Full Sentence Expires	*Jany 29 1912*
Good-Time Sentence Expires	*Sept 7 1911*
Trade	*Fruit Dealer*
Education	*No english*
Religion	*Catholic*
Where Born	*Italy*
Nationality	*Italian*
Habits	*Smokes*
Parents Living	*Mother*
Left Home at what Age	*?*
Married	*No* Children
Father Born Where	*Italy*
Mother Born Where	*Italy*
Residence	*Columbus O.*

Sister Mary Cera
Bellefontaine O.

Age *76* Apparent Age

Height *5, 7 3/4* Weight *118*

Color of Hair *ch dp grey* Beard *ch dp (grey)*

Color of Eyes *Mar dp gr slat m - 6*

Complexion *dark* Chin *mc)*

Teeth *good*

Build *M*

BERTILLON MEASUREMENTS

Height	59.5	Inclin	*i*
Outs A.	64	Height	*M*
Trunk	85	Widht	*M*
Head Lenght	18.7	Ridge	*Rich*
Head Width	14.5	Bass	*Ker*
Cheek Width	13.8	Root	*M Shallow*
R. Ear	5.9	Length	*M*
L. Foot	25.3	Project	*M*
L. Mid. F.	11.1	Width	*M*
L. Lit. F.	8.2	Pecul	
L. Fore A.	44.4		

Remarks concerning measurements

MARKS, SCARS AND MOLES.

I Small sc at 3" ph left middle front
II Light fresh sc of 1/2 dia at 3" above right wrist rear
III Small sc of 1/2", at 1" above center of right brow
Sc of 1/4 x 1/2" 2" to left of AA
Small flesh mole at 3" to right of AA

Remarks

Prisoner's signature witnessed, Finger Prints and Measurements taken by *AJ Kenos*
at the United States Penitentiary, Leavenworth, Kansas, on *Jany 31 1910*

Opposite: Sam DeMar's Bertillon measurements.

Above: Sam DeMar "Letters Received."

UNITED STATES PENITENTIARY
LEAVENWORTH, KANSAS.

Name *Pipino Galbo* No. 6897 Color *White*

Alias

Received *Jany 30 1910*	Age *38* Apparent Age
Military or Civil Prisoner *Civil*	Height *5, 8'¼* Weight *158*
From *N. D. O. Toledo*	Color of Hair *ch blk grey mix* Beard *ch blk grey mix*
Crime *Conspiracy*	Color of Eyes *Ches M gr az m° 4*
Sentence *5* Years — Months — Days	Complexion *M Dark* Chin *(rec)*
Date of Sentence *Jany 29 1910*	Teeth *good*
Sentence Begins *Jany 30 1910*	Build *M*
Full Sentence Expires *Jany 29 1914*	
Good-Time Sentence Expires *Feby 27 1913*	

BERTILLON MEASUREMENTS

Height	72.5	Inclin	*i*
Outs A.	77	Height	*M*
Trunk	8.7	Width	*M*
Head Lenght	19.7	Ridge	*Rect cave*
Head Width	15,0	Bass	*Hor*
Cheek Width	14,1	Root	*M Shallow*
R. Ear	6,3	Length	*M*
L. Foot	25,6	Project	*M*
L. Mid. F.	11,6	Width	*M*
L. Lit. F.	9,4	Pecul	
L. Fore A.	46,9		

Trade *Fruit Dealer*

Education *No english*

Religion *Catholic*

Where Born *Italy*

Nationality *Italian*

Habits *Smokes, drinks*

Parents Living *Father*

Left Home at what Age *25*

Married *Yes* Children *4*

Father Born Where *Italy*

Mother Born Where *Italy*

Residence *Meadville Pa*

Wife *Angelina Galbo*

248 Pine St Meadville Pa

Remarks concerning measurements

MARKS, SCARS AND MOLES.

III *Small oblique cut at ¼" to right of root of nose on brow*

Sc. hor. of ¾". outer half right brow

Remarks

Prisoner's signature witnessed, Finger Prints and Measurements taken by *A J Renoe*

at the United States Penitentiary, Leavenworth, Kansas, on *Jany 31 1910*

Opposite: Pippino Galbo's Bertillon measurements.

This page, top: Orazio Runfola's "Letters Received."

This page, bottom: Sebastian Lima sent letters to his wife, members of his family, lawyers and the Cira family.

November 11, 1911

The Chief of Police,

 Johnstown,

 Pa.

Dear Sir:-

 I have a prisoner in this institution, an Italian named Sebastino Lima, No. 6894, who claims that he has a wife and three children living at 773 Hulber St. (this is as near as I can get the name from his talk) and he thinks they are in destitute circumstances. He has not heard from them for two or three months and he is getting very uneasy about them, as he does not understand why he receives no word from them. and fears that they have been taken sick and placed in some hospital or poor house, from which they cannot communicate with him.

 He is a very well behaved prisoner and seems to be quite intelligent, therefore I am anxious to help him, if possible, as he appears to be in such distress of mind about his family. If I can trouble you to look the matter up and advise me, sending your reply in enclosed envelope which does not require stamp, I shall be under great obligation, and I know the prisoner will appreciate your kindness.

 Respectfully,

 Warden.

Letter to Johnstown chief of police from the warden on behalf of Sebastian Lima.

Johnstown Pa
April 13 1913

Dear Warden :

As my days they seem to be short on account of my poor health and destitution, since the day of my husbands sentence to the penitentiary of Leavenworth, Kansas, I find it necessary to liberate the father of my unfortunate children, Sebastiane Lima, who is now suffering in the said prison, the penalty inflicted upon his innocence.

The cry of his innocence comes from my heart and from all other hearts that know him, because they know that he is not guilty of any wrong doing and was unjustly taken away from home, and leaving me and my poor children heart broken without aid or support.

I could have proved his innocence if my financial condition would have permitted me to employ a good Lawyer, who at time of his trial, would have brought to light the very truth of the facts and would have established his innocence.

I was unjust and terrible to think of it, that Sebastiane was convicted because in searching my home they found a sheet of writing paper

Letter to the warden from Sebastian Lima's wife, Caterina.

which was later exhibited at trial and it look like the one which the prosecution showed for the defence.

A sheet of writing paper, that you cannot help to see the same one in every store, City, town or house that you may go to.

A paper that I was using it my self at the time and before my husband's arrest. Strange to say, that my husband never did use the paper. ~~becuse~~ because he always used tablet paper to write on.

Oh! if I could only give my life in place of the necessary funds that it takes to reopen the trial. I could then proove the moral quality of my husband, his good character and reputation and how hard a worker and industrious he was in his avocation.

From a broken heart friend
Mrs. C. Lima

So I beg for the sake of my poor children and their future, to pardon or parole our husban and father our ~~ol~~ only protector
Respectfully.

Caterina Lima, cont.

Dear Mr. Mcclaughry.

Wont you please, let my dear father come home, I remember how he was so dear to my sister and brother, and me and, and also to my dear mother, He is a good many and, I believe you are not to keep him in jail, we need him at home to take care of us, and, especial for my dear mother who she is always sick We have no money to buy our bread, and I am to little to work, I go to school. Hope to hear from you soon and, that you will send my dear papa back home. Wont you?

From a dear little girl
Annie Lima.

Letter to the warden from Sebastian Lima's daughter Annie.

Dear Mr. Mcclaughry:
Won't you please, let my dear
father come home, I remember
how he was so dear to my
sister and brother, and me and
also to my dear mother, He is a
good man, and I believe, you
are not to keep him in
jail, we need him at
home to take care of us,
and especial for my
dear mother who she is
always sick. We have no
money to buy our bread,
and I am too little to work,
I go to school. Hope to hear
from you soon and
that you will soon send
my dear papa back home.
Won't you?

From a dear little girl,
Millie Lima.

Dear Mr McLaughry,
Won't you please, let my
dear father come home, I
remember how he was
so dear to me, and to my
brother and, also to my
dear mother. He is a good
man, and I believe you
are not to keep him in jail,
we need him at home to
take care of us and especial
for my dear mother who
she is always sick we have
no money to buy our bread,
and I am too little to work
I go to school. Hope to hear
from you soon and that
you will soon send my
dear papa a back home.
Won't you?
From a dear little
girl
Mary Ignoffo

773 Heba St.
Johnstown Pa

Mr. R. W. Mc Claughry
Warden
Leavenworth Kansas

The innocence of my husband Joseph Ignoffo, who
was outraged the injustice of some false testimony, and of the
poor defence of his lawyers, and for which injustice he
is now in the Penitentiary of Leavenworth Kansas

And to think that on account of my poor financial
condition I could not obtain a new trial for my husband
the only father and protector of my three childrens
and myself. And for me to know that he was
innocent worrys me enough to take me to the grave.

Therefore god will not forget me in this case
he will be merciful for I have hope in him
And God will also bless you, as I beg you to use
your clemency in this case and to let me and
my childrens have back the husband and father even
in parole. Joseph Ignoff, deserves the liberty for
he is innocent, he has never done any harm or ever
done any thing wrong. He was arrested until he was
victim of a falsehood and the infamity for which
he is now in prison and far away from home, children
and wife who are now beging to suffer on account
of falsehood of others I hope you, to give a good record
of my husband and do something in your power to help
him so as we can have back our husband and father.
Very Respectfully Pietra Ignoffo

Opposite: Letter to
the warden from
Sebastian Lima's
daughter Millie.

Above: Letter to the
warden from Joe
Ignoffo's daughter
Mary.

Right: Letter to the
warden from Joe
Ignoffo's wife, Pietra.

March 11, 1914.

In re: Sebastino Lima, #6894,

Joseph Ignoffa, #6893.

Mr. F. H. Dushay,

President Boards of Parole,

Washington, D. C.

Dear Sir:

At the earnest request of Joseph Ignoffa, Register 6893, I am sending you the inclosed letter which he has just received from the former District Attorney who prosecuted him. The letter, as you will observe, does not really constitute a recommendation of Ignoffa's parole, but he so construes it, and I can see no harm that can come from forwarding it to you.

In this connection I think it is perhaps my duty to state that Sebastino Lima, Register 6894, who is Ignoffa's brother-in-law and who, like Lima, is serving a ten year term for Black-mailing, is apparently about to lose his mind. For several weeks past he has acted as though somewhat unbalanced, and on yesterday he suffered an attack which I think was hysterical in its character and during which he was apparently unconscious for several hours. His attendants say that he talks continuously about the sufferings of his wife and children, and he is also developing all the symptoms of a religious fanatic, imagining that he is being especially directed in all that he does by a supernatural power.

Statement regarding the mental status of Sebastian Lima.

Mr. F. H. Duehay, -2-
UNITED STATES PENITENTIARY, LEAVENWORTH, KANSAS
CARBON COPY FOR THE FILES

Ignoffa and Lima are two of the four men who still remain here of the eleven originally sentenced. It was, I believe, your intention to investigate somewhat their claims of innocence and also their statements that the Judge who sentenced them promised certain relatives that he would recommend their parole when they became eligible. I have no knowledge, of course, as to whether investigation has shown any basis for the claims made by these prisoners and have no information bearing on their guilt or innocence, but if anything is to be done in the case of Lima it would seem desirable that it should be done as soon as possible, for I am convinced that the man is rapidly drifting into an abnormal mental condition.

Respectfully,

TWM-S Warden.

Inclosure.

Sebastian Lima, cont.

I, Salvatore Lima, Register No. 6892, came to America in March 1906, aboard the steamship "North America" of the "LaVeloce Navigation Company." I went to work immediately with my brother-in-law Salvatore Greco, in the fruit business, in Pittsburgh, Pa., in 1907. I learned through a newspaper that a grocery store was for sale in Marion, Ohio. I investigated, liked it, and bought it for $800.00, through a contract drawn by lawyer Cutry, of Marion, Ohio. After three months I opened a fruit business at wholesale and at once bought animals, that is to say, two mules and one horse.

In this same city mentioned above there was a wholesale fruit firm under the name of S. Amocone & Co., consequently my business opposition bothered them, all the more so as after the period of two years my business was thriving while theirs was poor. On the 8th of June 1909, as I was in a grocery store, an italian boy came in and told me that a detective was in my house looking for me. I went there at once, was arrested, and was asked if I was the writer of a threatening letter written to Mr. Amocone. Naturally I was stupified with surprise and vehemently denied the charge, as I was as innocent of the charge as God Himself.

I was taken to Toledo, Ohio, when on June 9th I was released under $2000.00 bond. The Judge instructed me to return the 16th of the same month. Conscience free of having done wrong to any one and sure that my reputation as an honest man would be vindicated, I presented myself to the Court on the day designated (June 16th) and was shocked and surprised when my bail was at once raised to $6000.00, in default of which I was placed in jail.

The case was brought to trial on the last day of the month. My lawyer made but little effort in conducting my defense. Three times I asked him to let me take the witness chair. He opposed my

Statement by Salvatore Lima.

192

2...(Statement of Salvatore Lima #6892)

requeet. This was most unfair to me, as I am sure that, if I had
been allowed to recite my side of the story to the jury, which would
have convinced them of my innocence in the matter, I would not have
been found guilty and sentenced to prison. Fourteen were implicated
and accused in this affair. The jury found all guilty and made no
distiction as to degree of guilt, yet three of them were turned
free; five were given only two years each; others were sentenced
to amounts varying a few months and I was given sixteen years.
These men were poor, without business or the reputation that
through my honest and hard work I had gained in the city of
Marion. Was it fair that, granted that I was equally as guilty
as they, no more and no less, I should be given the awful sentence
imposed by the Court while the rest were treated so lightly? Had
I received the same sentence of one or two years, as the rest did,
I should not have abandoned my fruit business in Marion. I should
have returned. This, it is patent, would not have suited Amicone;
for well he knew that with 16 years of prison before me I would
be crushed and he would have a clear field before him.

 But, gentlemen, I am not the only human being that considers
he has been a victim of the machinations of his enemies. I do not
base my plea upon the incidents recited above. I have a wife,
a victim and sufferer from heart disease, who, during my affluent
days in Marion lacked nothing that a loving and hard working hus-
band could contribute to her comfort and well being. To-day,
sick as she is, she is forced to reside in a strange community
and perform the meanest menial work in order that she may support
our poor, innocent children. It is wrong to let them suffer

Statement by Salvatore Lima, cont.

3..(Statement of Salvatore Lima #6892)

when they possess a loving husband and father whose sole thought is of them. Guilty or innocent, the many years that I have already served in this institution should prove sufficient to satisfy the demands of Justice.

I pray you in the name of wife, children and myself, to give me the opportunity to make good. The opportunity that will enable me to prove to you that I am not the man that I have been painted to be. My wife, my children, and the years yet remaining of my sentence.that would act as a deterrent and influence my future life, should surely prove a guarantee to you that, if I am the man that I claim to be, society at large need not fear.

 Very respectfully,

 Register #6892

(N.B.- This is a liberal translation of the statement made
 and written by Lima in Italian.) #9539.

Statement by Salvatore Lima, cont.

RAFFAELE PURGATORIO
R. AGENTE CONSOLARE
R. CONSULAR AGENT

BELL PHONE 5095

NO. L897

Agenzia Consolare
di S.M. il Re d'Italia
Royal Italian Consular Agency
FRONTENAC. KANS.

OBJECT:
OGGETTO:

February 26, 1915

Warden of the United States Penitentiary,

Leavenworth, Kansas.

Dear Sir:-

REFERRED TO
RECORD CLERK.

Thos. W. Morgan
WARDEN.

 I am in receipt of a letter from the Italian Ambassador
Washington, D.C., and also of the Italian Consul General at
Denver, in regard to one Salvadore Lima who is confined in the fed-
eral prison on account of white slavery. There has been strong
requests made upon the Ambassador and Consul in behalf of this
party looking forward to having him pardoned or paroled and return-
ed to Italy, and the Ambassador is anxious to know what has been
the conduct of Mr. Lima since he has been confined in your insti-
tution and I have been directed to obtain this information and
send the same to him.

 Will you favor me with a statement showing the stand-
ing of Mr. Lima since being confined in the penitentiary and such
other statement in regard to him as you can give that would prob-
ably be of any benefit to the Ambassador.

 Thanking you for such information, I remain

 Yours truly,

R.P/E.W.

R Purgatorio
Italian Consular Agent

Letter to the warden from Italian Consular Agency.

Phones Main 3447 - A 3154 Res. Phone B 1261

A. LIMA
WHOLESALE
FRUITS & PRODUCE
202½ - 204 Washington St.

Portland, Oregon _March 18_ 1918

Board of Parole
Leavenworth Kansas
Dear Sir

I inform you that my family and self arrived in Portland. Next week I will commence to work for A Lima and will make good

I remain,
Very truly yours,

Salvatore Lima
718 Brooklyn St.

6892

Letter to the parole board from Salvatore Lima.

Record Clerk

San Francisco Cal.
February 7 1918

Thos. W. Morgan. Warden.
Leavenworth Kansas.

6892

Dear Sir!

Arrived in San Francisco
O.K. and met my Wife but she is in
the same condition. The doctor says.
within a month he will have to Operate
on her. At present I am home and
taking care of my Wife. And as soon
as the doctor Operates on her and
recovers I will move to Portland.
And I am trusting you for your
kind favors. in which you have
rendered me and I am giving you
my highly sincere word that I
will make good my promise
And I remain as ever
Your Truly
Salvatore Lima 6892
312½ Precita ave.

Letter to the warden from Salvatore Lima.

Above and opposite: Letters to the warden from Salvatore Lima.

San Francisco Cal.
　　　Jan 1st 1919
Warden of Leavenworth Kansas
　　　　Penitentiary
Dear Sir:
　　　　　I notify you
that I haven't received my
monthly report oyet.
　　　And I can't mail it
today, as I haven't received
it. But I assure you I am
doing and honest work
and am doing good.
　　　I bought the, Parkside Fruit
Store ; and Brown truck.
And working for my self.
on fruit commercial.
Last month I bought a carlo=
ad of potatoes and. Sold it

in San Francisco.
I'm working and
trying to support my fam-
ily.
 Sir, last month I made
an application to change
my best friend Mr. Mario
Montrezza, Portland, Ore, to
Mr. John Piazza, 306 Precita, ave,
 San Francisco, Cal.
 Please sent me my
monthly report, and I'll fill
it out, and mail it, Much
Oblige,
 Yours Sincerely

 Salvatore Lima

Letter to the warden from Salvatore Lima, cont.

NOTES

Introduction

1. Cordasco and Pitkin, *Black Hand*.
2. "Black Hand Is a Myth, Says King," *Cincinnati (OH) Post*, April 14, 1908.
3. "Divided," *Cincinnati (OH) Enquirer*, December 26, 1907.
4. "Vengeance of the Mafia, a Deep-Rooted Society that Laughs at the Law," *Inter Ocean* (Chicago, IL), April 26, 1903.
5. "The Bloody Mafia," *Daily Independent* (Hutchinson, KS), January 19, 1904.
6. "Murder of Italian by His Young Nephew," *Daily Examiner* (Bellefontaine, OH), April 9, 1908.
7. Catanzaro, *Men of Respect*.
8. "How the Sicilian Mafia Collects Toll," *Chicago (IL) Tribune*, February 26, 1905.

1. Fruit Dealers

9. "Banana-Cart Element," *The Indianapolis* (IN), October 27, 1893.
10. Ibid.
11. Passenger list for SS *Nord America*, May 3, 1906.
12. Inmate #6892, Leavenworth Inmate Case Files 1895–1957, National Archives at Kansas City.

13. Passenger list for SS *Weser*, June 29, 1893. Joe Ignoffo arrived with his father, Antonino, en route to Pittsburgh.
14. "Joe Ignoffo Will Go to Indiana for a Visit," *Marion (OH) Daily Mirror*, June 20, 1908.
15. "Shots Fired at Giofritta," *Marion (OH) Star*, April 3, 1905.
16. "Raid Is Made on Gamblers," *Marion (OH) Star*, August 28, 1905.
17. Meyers and Meyers Walker, *Ohio's Black Hand Syndicate*.
18. "Guiffritta Is Shot to Death," *Marion (OH) Star*, November 24, 1906.
19. "Black Hand Gang Meets Nemesis in John Amicon," *Columbus (OH) Sunday Dispatch*, June 27, 1909.
20. Ibid.
21. "Advertisement," *Chillicothe (OH) Advertiser*, December 25, 1891.
22. "Experience the Most Remarkable Growth in the History of the Commission Business," *Columbus (OH) Sunday Dispatch*, January 22, 1911.
23. "Advertisement," *Chicago (ILL) Packer*, March 18, 1911.
24. Agostino Iannarino appears on the ship manifest for the *Washington*, arriving in New York in 1891. His naturalization intent documents say he arrived on December 27, 1889. He was naturalized on October 7, 1895.
25. Iannarino family records.
26. Salvatore Cira's parents, Biagio and Chiara Crisanti, were forty-nine and forty-one years old when he was born.
27. Maria Demma was born on January 3, 1876. She was the daughter of Salvatore and Provvidenza Amodeo Demma.
28. Vicario family records.
29. Williams's Dayton Directory for 1903–4.
30. Passenger list for SS *Lahn*, April 1, 1902.
31. Sam DeMar was born on February 17, 1880. His father, Salvatore Demma, died before he was born. Salvatore was also the father of Maria Demma Cira. After Salvatore died, his wife, Providence Amodeo, married his brother Antonino. Joe DeMar was born from that marriage, making him half brother to Sam and Maria. Tony and Charlie Demma were cousins to each other and nephews of Antonino and Salvatore.
32. "Salvatore Cira & Co.," *Marysville (OH) Evening Tribune*, April 30, 1904.
33. "Threatened to Kill Someone," *Marysville (OH) Evening Tribune*, August 2, 1904.
34. *Daily Examiner* (Bellefontaine, OH), May 8, 1905. The Cira store was turned over to "S. Chichiaro," according to the newspapers. In 1904, a Francesco Chichiaro worked for Cira in Bellefontaine. The newspaper spelled his name as Chicchiaro and Chichiaro. On September 12, 1904,

he lost his foot in an accident while pushing a banana cart across the railroad tracks.

35. *Daily Examiner* (Bellefontaine, OH), February 23, 1906.
36. Vicario family records. The family pronounces pasta with a B: basta with sugu (pasta with sauce).

2. The Overcoat

37. Ibid.
38. Catanzaro, *Men of Respect.*
39. "Black Hand Suspect," *Cincinnati (OH) Enquirer,* June 10, 1909.
40. "Murder of Italian by His Young Nephew," *Daily Examiner* (Bellefontaine, OH), April 09, 1908.
41. "Cira Was Mixed Up," *Daily Examiner* (Bellefontaine, OH), April 11, 1908.
42. Ibid.
43. Merriam-Webster Dictionary definition of *tribute*: something given or contributed voluntarily as due or deserved. In Italian, this is often called *pizzo*—protection money that was paid to the Mafia.
44. "Will Rather Die than Benefit Black Hand," *Dayton (OH) Herald,* December 22, 1906.
45. "Joe Planned Going Away," *Daily Examiner* (Bellefontaine, OH), March 27, 1907.
46. Ibid.
47. "Deep Mystery in the Assassination," *Daily Examiner* (Bellefontaine, OH), March 25, 1907.
48. "Toni Jolli Pleaded Guilty," *Marysville (OH) Journal-Tribune,* September 28, 1904. Police arrested Tony Jolli, and he was tried and found guilty of theft and sentenced to time in the state reformatory in Mansfield, Ohio.
49. "Story of Tragedy," *Daily Examiner* (Bellefontaine, OH), March 25, 1907.
50. Ibid.
51. "Cira Greatly Excited," *Daily Examiner* (Bellefontaine, OH), March 25, 1907.
52. "What the Neighbors Say," *Daily Examiner* (Bellefontaine, OH), March 25, 1907.
53. "Joe Planned Going Away," *Daily Examiner* (Bellefontaine, OH), March 27, 1907.
54. "Demars Make Fierce Denials," *Daily Examiner* (Bellefontaine, OH), March 26, 1907.

55. "Interpreter Here," *Daily Examiner* (Bellefontaine, OH), March 26, 1907.

56. "Correction of Erroneous Reports," *Daily Examiner* (Bellefontaine, OH), April 13, 1908. A correction of a previous article that claimed Salvatore Cira had Joe DeMar's monument imported from Italy.

57. "Coroner's Inquest," *Daily Examiner* (Bellefontaine, OH), March 26, 1907.

58. "It May Have Been the Sicilian Mafia," *Daily Examiner* (Bellefontaine, OH), March 28, 1907.

59. "Italian Peddler Shot," *Dayton (OH) Herald*, July 1, 1907.

60. "Find Overcoat of Italians Slayer," *Dayton (OH) Herald*, July 2, 1907.

61. "Victim of Black Hand," *Dayton (OH) Herald*, September 2, 1907. The person responsible for the deaths of Costanino and Gregiolio was never found.

62. "Italian Consul to Investigate," *Dayton (OH) Herald*, July 10, 1907.

3. Ten Days to Live

63. "Charlie's Account," *Daily Examiner* (Bellefontaine, OH), April 9, 1908.

64. "Mrs. Cira Had Been Afraid," *Daily Examiner* (Bellefontaine, OH), April 9, 1908.

65. "Details of the Shooting," *Daily Examiner* (Bellefontaine, OH), April 9, 1908.

66. "Proof Beyond a Doubt," *Union County (OH) Journal*, April 16, 1908.

67. "Details of the Shooting," *Daily Examiner* (Bellefontaine, OH), April 9, 1908.

68. "Crowd Soon Assembled," *Daily Examiner* (Bellefontaine, OH), April 9, 1908.

69. "Former Marysville Italian Was Killed," *Union County (OH) Journal*, April 16, 1908.

70. "Carried Guns," *Daily Examiner* (Bellefontaine, OH), April 16, 1908.

71. "Gralbo Fined," *Daily Examiner* (Bellefontaine, OH), April 13, 1908.

72. "The Funeral of Salvatore Cira," *Weekly Index Republican* (Bellefontaine, OH), April 16, 1908.

73. There were numerous reports that Salvatore Cira ran at Charlie DeMar with a knife.

74. "Murder of Italian by His Young Nephew," *Daily Examiner* (Bellefontaine, OH), April 9, 1908.

75. "Proof Beyond a Doubt," *Union County (OH) Journal*, April 16, 1908.

76. "Murder Might Have Been Averted," *Daily Examiner* (Bellefontaine, OH), April 10, 1908.

77. Ibid.

78. "Proof Beyond a Doubt," *Union County (OH) Journal*, April 16, 1908.

79. "Deed of Black Hand," *Marysville (OH) Journal-Tribune*, April 11, 1908.

80. "Mano Nera," *Daily Examiner* (Bellefontaine, OH), April 10, 1908.
81. "Buffalo 'Black Hand' Letter," *Buffalo (NY) Sunday Morning News*, April 12, 1908.
82. "Burial at Calvary," *Daily Examiner* (Bellefontaine, OH), April 13, 1908. Salvatore Cira's family did not have any photographs of him, so one was taken, and for the purpose of obtaining a lifelike picture, the eyes were opened.
83. "Cira's Body," *Weekly Index Republican* (Bellefontaine, OH), April 16, 1908.
84. "Buried in Potters Field," *Weekly Index Republican* (Bellefontaine, OH), April 16, 1908. Potter's field was the north side of the road at the cemetery.
85. "Demar Held for Murder," *Daily Examiner* (Bellefontaine, OH), April 17, 1908.
86. Ibid.
87. "Court Begins Next Monday," *Daily Examiner* (Bellefontaine, OH), May 4, 1908.
88. "Murderer Demar Released from Jail by Grand Jury," *Daily Examiner* (Bellefontaine, OH), May 8, 1908.
89. Ibid. Frank Comella was married to Anna Demma, a half sister to Maria Demma.
90. Ibid.
91. *Defiance (OH) Crescent News*, May 11, 1908.
92. "Cut off Their Respect," *Indianapolis (IN) News*, April 30, 1908.
93. Tony Vicario's birth records show his name written as "Antonino."
94. Vicario family records.
95. Passenger list for SS *Sicilia*, October 6, 1906.
96. *Marysville (OH) Journal-Tribune*, September 1, 1908.

4. Dynamite in Columbus

97. "Italian Leaves City to Escape Black Hand," *Dayton (OH) Herald*, April 11, 1908.
98. "Frank Gentile, 82, Dies," *Dayton (OH) Herald*, May 26, 1948.
99. "Made Good a Threat in Part," *Dayton (OH) Herald*, May 5, 1908.
100. Ibid.
101. "Remorseless 'Black Hand' Tried to Kill Whole Family by Dynamite," *Columbus (OH) Evening Dispatch*, May 13, 1908.
102. Ibid.
103. "House Dynamited by Black Hand," *Columbus (OH) Citizen*, May 13, 1908.
104. Ibid.

105. "Policemen Guard Iannarino Home," *Columbus (OH) Evening Dispatch*, June 2, 1908.
106. Agata Iannarino was married to Giovanni Mercurio.
107. "Bonnanio Gets Black Hand Letter," *New Philadelphia (OH)*, June 4, 1908.

5. *The Directorate*

108. "Discredit Reports," *Nashville (TN) Banner*, June 9, 1909.
109. Passenger list for SS *Martha Washington*, October 27, 1908. Antonio was en route to Pittsburgh with his daughter Pietra (Lima) Ignoffo.
110. "The So-Called Roster of the Society of the Banana," *Marion (OH) Star*, January 28, 1910.
111. "One Line Extends as Far as South Dakota," *Baltimore (MD) Sun*, June 10, 1909.
112. "Advertisement," *Marion (OH) Star*, April 5, 1907.
113. "Witnesses in Black Hand Trial Break Silence," *Marion (OH) Star*, January 22, 1910.
114. "Hanging About Store," *Marion (OH) Star*, January 22, 1910.
115. "Black Hand Gang Meets Nemesis in John Amicon," *Columbus (OH) Sunday Dispatch*, June 27, 1909.
116. "Black Hand Letters and Their Authors," *Marion (OH) Star*, January 25, 1910.
117. "Extending Quest of Blackmailers," *Lincoln (NE) Star*, June 10, 1909.
118. Ibid.
119. "Italians Are Bound Over After a Hearing," *Chillicothe (OH) Gazette*, July 2, 1909.
120. "Advertisement," *Evening Republican* (Meadville, PA), January 18, 1909.
121. "Galbos Arrest Creates Stir," *Evening Republican* (Meadville, PA), June 21, 1909.
122. "Some Damaging Stories," *Evening Republican* (Meadville, PA), December 13, 1909.
123. Ibid.
124. "Held as Black Hand," *Morning News* (Wilmington, DE), June 22, 1909.
125. "Gangs Shrewd Mailing System," *Pittsburgh (PA) Daily Post*, June 21, 1909.
126. "Held as Black Hand," *Morning News* (Wilmington, DE), June 22, 1909.
127. Inmate #6895, Leavenworth Inmate Case Files 1895–1957, National Archives at Kansas City. Note: Orazio Runfola received mail from Dr. Romano of Cleveland.

128. Note: the *Daily Examiner* (Bellefontaine, OH) reported that Agostino Marfisi was the uncle of Charles and Tony Vicario.

129. "Leader Lived in Washington," *Morning Union* (Grass Valley, CA), August 11, 1909.

130. "Arrigo," *Cincinnati (OH) Enquirer*, July 24, 1909.

131. "Raids Made in This City," *Cincinnati (OH) Enquirer*, June 18, 1909.

132. Ibid.

133. Ibid.

134. Ibid.

135. Ibid.

6. Society Headquarters

136. "Marked Stamp Nemesis," *Indianapolis (IN) Star*, January 22, 1910.

137. "Rounded up as Black Hand Leaders," *Evening Star* (Washington, D.C.), August 7, 1909.

138. Ibid.

139. "Black Hand Clues in Petrosino Plot," *New York (NY) Times*, August 7, 1909.

140. "Safe Search at Marion," *Daily Examiner* (Bellefontaine, OH), June 9, 1909.

141. "Marion Is Headquarters for Black Hand," *Marion (OH) Daily Mirror*, June 8, 1909.

142. "Blackhand Leaders Trapped in Ohio," *New York (NY) Times*, June 9, 1909.

143. "Ghastly Signs," *Cincinnati (OH) Enquirer*, June 10, 1909.

144. "More Evidence Is Secured Against Suspected Black Hand," *Marion (OH) Mirror*, June 9, 1909.

145. "Ghastly Signs," *Cincinnati (OH) Enquirer*, June 10, 1909.

146. "More Evidence Is Secured Against Suspected Black Hand," *Marion (OH) Mirror*, June 9, 1909.

147. "Ghastly Signs," *Cincinnati (OH) Enquirer*, June 10, 1909.

148. Cangiamilla was sometimes found spelled Cangamillo.

149. "The Prosecution May Be Under State Law," *Marion (OH) Star*, June 11, 1909.

150. "Tells of Raid on Lima House Here," *Marion (OH) Star*, January 19, 1910.

151. "Ventola and Lima Quickly Furnish Cash Bonds," *Columbus (OH) Dispatch*, June 10, 1909.

152. "Result of Crusade Against Societies," *Marion (OH) Star*, June 10, 1909.

153. Ibid.

154. Ibid.

155. Wright, "Conflict with the 'Black Hand.'"

156. "Charles Viccarrio," *St. Louis (MO) Post-Dispatch*, June 9, 1909.

157. "Result of Crusade Against Societies," *Marion (OH) Star*, June 10, 1909.

158. "Vicario Sweated," *Courier-Journal* (Louisville, KY), June 11, 1909.

159. "Black Hand Gang Slays N.Y. Sleuth," *Dayton (OH) Herald*, March 13, 1909.

160. Joe Petrosino was born on October 23, 1860, in Italy. He became a patrolman in New York in 1885 and detective in 1895.

161. "Inspector Makes It Strong," *Daily Examiner* (Bellefontaine, OH), June 10, 1909.

162. "Vicario at Dennison," *Daily Examiner* (Bellefontaine, OH), June 10, 1909.

163. "Black Hander Not Guilty," *Daily Times* (New Philadelphia, OH), June 10, 1909.

164. "More Evidence Is Secured Against Suspected Black Hand," *Marion (OH) Mirror*, June 9, 1909.

165. "Letters Found in Trunks," *Sacramento (CA) Bee*, June 9, 1909.

166. "Rounding Up Black Hand Terrorists," *Los Angeles (CA) Evening Post-Record*, June 9, 1909.

167. "Black Hand Leaders Trapped in Ohio," *New York (NY) Times*, June 9, 1909.

168. "Creditors of DeMar Co," *Daily Examiner* (Bellefontaine, OH), June 10, 1909.

169. "Creditors Got Left," *Bellefontaine (OH) Weekly Examiner*, December 13, 1909.

170. "A Bomb Hurled Through Window," *Daily Examiner* (Bellefontaine, OH), June 17, 1909.

171. Local option laws forbid businesses to open on Sundays.

172. "Bomb Hurled Through Window," *Daily Examiner* (Bellefontaine, OH), June 17, 1909.

173. "Viccarrio Bound Over," *Daily Examiner* (Bellefontaine, OH), July 2, 1909.

174. *Weekly Index Republican* (Bellefontaine, OH), January 28, 1909. Note: more than eighty thousand people were believed to have been killed as a result of the earthquake of 1908 in Messina, Sicily.

175. "Due to Girls Love," *Daily Examiner* (Bellefontaine, OH), July 17, 1909.

176. Ibid.

177. "Don't Know It If He Is Watched," *Daily Examiner* (Bellefontaine, OH), July 23, 1909.

178. "Stock Closed Out," *Daily Examiner* (Bellefontaine, OH), July 10, 1909.

179. Ibid.

7. Trouble, Trouble, Trouble

180. "Round-Up," *Cincinnati (OH) Enquirer*, June 10, 1909.
181. "Evidence Against Ventola," *Columbus (OH) Dispatch*, June 12, 1909.
182. "Ventola Also Arrested," *Courier-Journal* (Louisville, KY), June 10, 1909.
183. "Ventola and Lima Quickly Furnish Cash Bonds," *Columbus (OH) Dispatch*, June 10, 1909.
184. "Another Raid Made by the Inspectors," *Marion (OH) Star*, June 14, 1909.
185. "Sebastian Lima Is Taken into Custody," *Marion (OH) Star*, June 15, 1909.
186. "Bound Over to the Grand Jury," *Marion (OH) Star*, June 29, 1909.
187. "Salvatore Lima Is Still Without Bond," *Marion (OH) Star*, June 17, 1909.
188. "Black Hand Gang Here from East with Its Plots," *Oregon Daily Journal* (Portland, OR), February 1, 1910.
189. "Another Raid Made by the Inspectors," *Marion (OH) Star*, June 14, 1909.
190. "Raids Made in This City," *Cincinnati (OH) Enquirer*, June 18, 1909.
191. Ibid.
192. "Black Hand Syndicate Arrest Here," *Pittsburgh (PA) Daily Post*, June 20, 1909.
193. "Galbos Arrest Creates Stir," *Evening Republican* (Meadville, PA), June 21, 1909.
194. "Black Hand Cases Are Up for Trial," *Evening Republican* (Meadville, PA), December 7, 1909.
195. "Letter," *Cincinnati (OH) Enquirer*, July 25, 1909.
196. "Arrigo," *Cincinnati (OH) Enquirer*, July 24, 1909.
197. "How Arrigo Was Caught," *Marysville (OH) Journal-Tribune*, July 29, 1909.
198. Unwanted babies were brought to foundling rooms, usually attached to a church or hospital. Someone would place the baby in an opening where there was a rotating wooden cylinder, they would pull a string to ring a bell and a nurse or nun inside would spin the wheel around, bringing the baby inside.
199. Salvatore Arrigo's first wife, Josephine Pusateri, died on August 31, 1877. He married Anna Gentile on December 8, 1877.
200. "Passing Counterfeit Money," *Evening Star* (Washington, D.C.), October 7, 1885.
201. "Leader Lived in Washington," *Morning Union* (Grass Valley, CA), August 11, 1909.
202 "Joe Ignoffo Goes to Toldeo," *Marion (OH) Daily Mirror*, December 2, 1909.
203. "Joe Ignoffo Is Arrested," *Marion (OH) Daily Mirror*, December 1, 1909.

204. "Trouble, Trouble, Trouble, Is Wail of the Sicilian," *Columbus (OH) Dispatch*, December 3, 1909.

205. Ibid.

206. "Brother of Black Hand Victim Also in U.S. Dragnet," *Columbus (OH) Dispatch*, December 4, 1909.

207. Ibid.

8. The United States of America v. Salvatore Lima

208. "Indictments Are Returned," *Marion (OH) Daily Star*, December 11, 1909.

209. "Both Sides Are Confident," *Marion (OH) Daily Mirror*, December 30, 1909.

210. "Some Witnesses Are Afraid to Testify," *Marion (OH) Star*, January 10, 1910.

211. Ibid.

212. "Both Sides Are Confident," *Marion (OH) Daily Mirror*, December 30, 1909.

213. "Black Hand Trials Are Begun Today," *Marion (OH) Daily Star*, January 10, 1910.

214. Ibid.

215. "Separate Trials Are Denied by the Court," *Marion (OH) Star*, January 18, 1910.

216. Blotter: A temporary record book.

217. "Both Sides Are Confident," *Marion (OH) Daily Mirror*, December 30, 1909.

218. "The Testimony Taken in Black Hand Trials," *Marion (OH) Weekly Star*, January 22, 1910.

219. "Threatened by Black Hand," *Marion (OH) Star*, January 21, 1910.

220. Ibid.

221. "Banana Was Given to Rizzo," *Cincinnati (OH) Enquirer*, May 13, 1909.

222. "Sleuth Exposes the Black Hand Methods," *Marion (OH) Star*, January 21, 1910.

223. "Telling of Paying Money Over to Band," *Marion (OH) Daily Star*, January 22, 1910.

224. Ibid.

9. We the Jury

225. "Black Hand Letters and Their Authors," *Marion (OH) Star*, January 25, 1910.

226. "How Letters Were Traced," *Marion (OH) Star*, January 25, 1910.

227. "Testimony," *Cincinnati (OH) Enquirer*, January 21, 1910.

228. "Sleuth Exposes the Black Hand Methods," *Marion (OH) Star*, January 21, 1910.

229. "Amicon Important Witness," *Marion (OH) Star*, January 25, 1910.

230. "Ink Dots," *Cincinnati (OH) Enquirer*, January 22, 1910.

231. "Black Hand Letters and Their Authors," *Marion (OH) Star*, January 25, 1910.

232. "The Black Hand Rule of Terror Is Exposed," *Daily Examiner* (Bellefontaine, OH), January 26, 1910.

233. "Marion Witnesses Give Testimony," *Marion (OH) Star*, January 27, 1910.

234. "Italians Hurried to Prison," *Daily Examiner* (Bellefontaine, OH), January 31, 1910.

235. Ibid.

236. "Black Hand Trial Will Soon Be Over," *Marion (OH) Daily Star*, January 28, 1910.

237. Ibid.

238. Ibid. Note: Francesco Lima was believed to be Salvatore Lima's brother, and his full name was Sebastiano "Francesco" Lima.

239. "Rules of Society of the Banana," *Marion (OH) Daily Mirror*, January 26, 1910.

240. Ibid.

241. "The Black Hand Rule of Terror Is Exposed," *Daily Examiner* (Bellefontaine, OH), January 26, 1910.

242. "Black Handers Found Guilty," *Marion (OH) Daily Star*, January 29, 1910.

243. "Hastened Away to Leavenworth Prison," *Marion (OH) Daily Star*, January 21, 1910.

244. Ibid.

10. Inmate Number 6892

245. "Government Has Heavy Guard at Black Hand Trial in Toledo," *Tribune* (Coshocton, OH), January 26, 1910.

246. "Running Down the Black Hand," *New York (NY) Times*, February 13, 1910.

247. "Joe Ignoffo Was Very Much Downhearted," *Marion (OH) Daily Mirror*, February 2, 1910.

248. "Black Handers Now in Prison," *Leavenworth (KS) Post*, January 31, 1910.

249. "Joe Ignoffo Was Very Much Downhearted," *Marion (OH) Daily Mirror*, February 2, 1910.

250. "Black Handers Now in Prison," *Leavenworth (KS) Post*, January 31, 1910.
251. "Emphatic Denial of Stories of Suffering," *Marion (OH) Star*, February 15, 1910.
252. Inmate #6893, Leavenworth Inmate Case Files 1895–1957, National Archives at Kansas City.
253. Inmate #6894, Leavenworth Inmate Case Files 1895–1957, National Archives at Kansas City.

11. Banana Kings

254. "John Amicon Stands Up to the Black Hand." The *Barquilla de la Santa Maria* is the bulletin of the Catholic Record Society, diocese of Columbus, Ohio.
255. Iannarino family records.
256. "John Amicon Stands Up to the Black Hand."
257. Note: A gold star banner/flag is a white flag with a red border and gold star in the center and is flown by American families who have had a family member killed in action during a war.
258. "Former P.O. Inspector Dead," *Clyde (OH) Enterprise*, June 1, 1916.
259. "Judge Tayler Dies Suddenly," *Marysville (OH) Journal-Tribune*, November 26, 1910.
260. "Slain Cleveland Physician Known by Mansfielders," *News-Journal* (Mansfield, OH), June 11, 1936.
261. Porrello, *Rise and Fall*.

12. Legitimate Business

262. "Declares His Brother Innocent," *Oregon Daily Journal* (Portland, OR), February 3, 1910.
263. "Police Arrest Three," *Marion (OH) Star*, March 19, 1923.
264. "Salvatore Rizzo," *Marion (OH) Star*, January 9, 1961.
265. "From Frying Pan to Fire," *Cincinnati (OH) Enquirer*, July 9, 1931.
266. "Obituary," *Cincinnati (OH) Enquirer*, February 23, 1947.
267. "Fruit Dealer Arrested on a Charge of Illegal Sale of Liquor," *Daily Times* (New Philadelphia, OH), December 6, 1944.
268. Anthony "Tony" Vicario Obituary.
269. Vicario family records. Joseph S. Vicario's nickname was "Weetie."

270. "Charles Vicario," *Weekly Index Republican* (Bellefontaine, OH), October 10, 1912.

271. "Charles Vicario," *Weekly Index Republican* (Bellefontaine, OH), October 30, 1912.

272. Richard Vicario, interview by Mary Lou McNamee, *Northwest Narratives*, March 27, 2007, https://www.ohiomemory.org/digital/collection/p16007coll30/id/100/rec/21.

273. Ibid.

274. "Richard Vicario Obituary," *Bellefontaine (OH) Examiner*, March 7, 2016.

275. *Columbus (OH) Evening Dispatch*, December 17, 1934.

276. "Obituary," *Columbus (OH) Evening Dispatch*, May 26, 1942.

277. "Whisky Plot Charge Made," *Lexington (KY) Herald*, April 23, 1922.

278. "Against Dry Law Violator," *Cincinnati (OH) Enquirer*, November 16, 1927.

279. "Frank Spadaro," *Cincinnati (OH) Enquirer*, March 9, 1948.

280. "Verdict For Traction Company," *Cincinnati (OH) Enquirer*, October 1, 1913.

281. Note: Salvatore Arrigo's wife, Anna Maria Gentile, died in 1901.

282. "Two Story Block for Pine Street," *Evening Republican* (Meadville, PA), March 31, 1914.

283. "Charged," *Kane (PA) Republican*, December 29, 1933.

284. "Eight Bogus Money Passers Sentenced," *Pittsburgh (OH) Press*, October 20, 1935.

285. Manhattan Marriage License Index, New York City Municipal Archives.

286. Antonio Lima Death Certificate and Antonino Lima Death Certificate, *Pennsylvania Historical & Museum Commission*.

287. "Boy Loses Life," *Pittsburgh (PA) Daily Post*, July 5, 1921.

288. "Lowell Grand Opera Company," *Lowell (MA) Sun*, April 21, 1971.

289. Reverend Father Joseph Lima Obituary, Find a Grave, https://www.findagrave.com/memorial/15901028/joseph-lima.

290. Lima family testimony.

291. "Sentence Commuted," *Cincinnati (OH) Enquirer*, February 25, 1916.

292. "Joseph Ignoffo Funeral Notice 1964," *Carew & English, Masonic at Golden Gate Avenues, SF, California*.

293. "Court Grants Lima 3 Month Probation," *Chico (CA) Record*, July 7, 1943.

294. "Supreme Court Reverses Lima Theft Conviction," *Chico (CA) Record*, December 31, 1944.

295. "A Sincere Announcement of a New Firm," *Oroville (CA) Mercury Register*, October 29, 1943.

296. The United States Federal Bureau of Investigation (1996), La Cosa Nostra San Francisco Division.

BIBLIOGRAPHY

Catanzaro, Raimondo. *Men of Respect*. Translated by Raymond Rosenthal. New York: Free Press, 1988.

Cordasco, Francesco and Thomas Monroe Pitkin. *The Black Hand: A Chapter in Ethnic Crime*. Totowa, NJ: Littlefield, Adams & Co., 1977.

"John Amicon Stands Up to the Black Hand." *Barquilla de la Santa Maria*, June–July 2019.

Meyers, David, and Elise Meyers Walker. *Ohio's Black Hand Syndicate: The Birth of Organized Crime in America*. Charleston, SC: The History Press, 2018.

Porrello, Rick. *The Rise and Fall of the Cleveland Mafia*. Fort Lee, NJ: Barricade Books Inc., 1995.

Train, Arthur. "The Story of the Camorra in America." *McClure's Magazine*, 1912.

Wright, William Lord. "Conflict with the 'Black Hand.'" *Wide World Magazine*, 1910.

INDEX

ABOUT THE AUTHOR

Shane Croston is a native of Bellefontaine, Ohio. He is a veteran of the U.S. Marine Corps and served as an anti-tank missileman with First Battalion, Eighth Marines. He holds a bachelor of arts degree in social studies from Dublin Business School (Dublin, Ireland). Shane's areas of interest include military history; the study of Middle Eastern, European, Appalachian and Native American histories and cultures; religion; photography; and travel. As a descendant of Tony Vicario, Salvatore Cira and Agostino Iannarino, he is also interested in Sicilian genealogy and history pertaining to the Black Hand.